T25503

GW00777015

30126 00096297 4

John Ruskin and
Rose La Touche

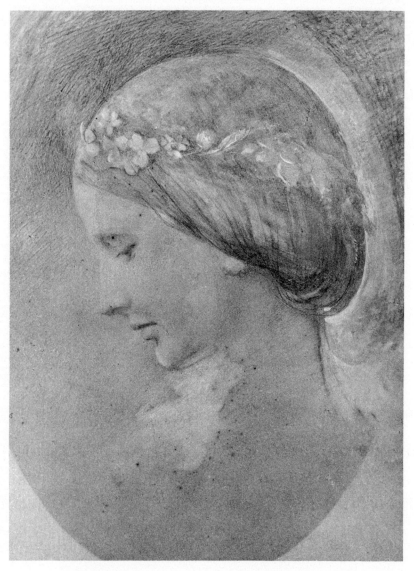

Rose La Touche with floral headdress, probably March 1862
Pencil drawing with Chinese white, by John Ruskin

JOHN RUSKIN AND ROSE LA TOUCHE

Her Unpublished Diaries of 1861 and 1867

INTRODUCED AND EDITED BY
VAN AKIN BURD

CLARENDON PRESS · OXFORD
1979

Oxford University Press, Walton Street, Oxford OX2 6DP

OXFORD LONDON GLASGOW
NEW YORK TORONTO MELBOURNE WELLINGTON
KUALA LUMPUR SINGAPORE JAKARTA HONG KONG TOKYO
DELHI BOMBAY CALCUTTA MADRAS KARACHI
NAIROBI DAR ES SALAAM CAPE TOWN

Published in the United States by
Oxford University Press, New York

© Oxford University Press 1979

British Library Cataloguing in Publication Data
La Touche, Rose
 John Ruskin and Rose La Touche.
 1. Ruskin, John – Relationship with women – Rose La
 Touche 2. La Touche, Rose
 I. Title II. Burd, Van Akin
 941.5081′092′4 PR5263 79-40389

ISBN 0-19-812633-6

Typeset by CCC, printed and bound
in Great Britain by William Clowes (Beccles) Limited,
Beccles and London

TO

Helen Gill Viljoen

1900–1974

Acknowledgements

My FRIENDSHIP with Helen Gill Viljoen began about 1955 when I read the manuscript of her first book, *Ruskin's Scottish Heritage*, truly a prelude to what would have been a great biography of Ruskin. In this work she showed modern students the importance of Ruskin's unpublished papers and the need to understand the limitations and often the bias of earlier scholarship on him. All her writing demonstrates the need to work from the Ruskin manuscripts, a principle which I have observed in this book. On one of my visits to her a few years later, she showed me her transcripts of the Rose La Touche diaries which immediately engaged my interest as they did hers when she first saw them in 1929. I was deeply moved when I found these transcripts among the papers which she left to me. I think that it was during the summer of 1958 Mrs. Viljoen visited our home, bringing with her a suitcase filled with some of the choicer drawings and manuscripts from the vast collection of papers associated with Ruskin and his circle, which she had inherited the preceding year from F. J. Sharp of Barrow in Furness. In preparing this edition of the La Touche diaries, I have been able to draw on the riches of this collection now deposited in the Pierpont Morgan Library. I dedicate this book to the memory of Helen Gill Viljoen, not only in gratitude for the gift of the transcripts and other papers which she gave me but also in recognition of her contribution to Ruskin studies.

My gratitude goes next to the institutions that have allowed me to study and quote from manuscripts in their possession. I thank the Trustees of the Yale University Library for permission to publish the numerous citations from the letters of John Ruskin to his father, and from the correspondence between the family of George MacDonald and the La Touches as well as Ruskin. Likewise I am grateful to the Trustees of the Pierpont Morgan Library for permission to quote from numerous letters, especially those in the F. J. Sharp collection. No one can work with Ruskin without

drawing on the magnificent collection of John Howard Whitehouse at the Ruskin Galleries, Bembridge, Isle of Wight. My citations from these papers are too numerous to list, but I shall mention the importance of the letters between Ruskin and his cousin Joan Agnew (later Mrs. Arthur Severn). For permission to use these papers I thank the Education Trust Ltd., Bembridge, and its chairman The Lord Lloyd of Kilgerran, C.B.E., Q.C. I appreciate the hospitality extended to me on several occasions in Oxford by the Bodleian, the Ashmolean Museum, and the Library of Christ Church; all these institutions, including the Governing Body of Christ Church, Oxford, have permitted me to quote documents in their collections. From the Bodleian I have cited the holographs of the family correspondence of Henry Acland. For use of information in the Oxford University Archives, I am grateful to the Keeper, Mr. T. H. Aston. I thank the Houghton Library, Harvard University, for permission to include quotations from the Charles Eliot Norton Correspondence preserved at the Houghton Library. The John Rylands University Library of Manchester has kindly allowed me to cite its collection of letters between Ruskin and the La Touches, and a letter from Ruskin to Marcus B. Huish. To the Trustees of the National Library of Scotland I am indebted for permission to quote two letters from Ruskin to Dr. John Brown. The Syndics of the Fitzwilliam Museum in Cambridge has allowed me to cite two letters from Ruskin to Edward Burne-Jones. The Huntington Library, San Marino, California, has contributed a letter from Ruskin to Susan Beever. I am grateful that the National Gallery, London, has allowed me to cite a letter in its archives from Ruskin to Ralph Wornum. Although I am not citing manuscripts from their collections, I wish to acknowledge my appreciation for the use of the resources at the National Library in Dublin and the library of the American Baptist Historical Society in Rochester, New York.

I am no less grateful to those individuals who have permitted me to to cite papers in their personal possession. I thank Esther K. Sheldon of Northport, New York, long a friend of Helen Gill Viljoen, for permission to quote the letters which she holds between Mrs. Viljoen and her

husband. Generously, Miss Olive Wilson of Windermere has allowed me to quote one of the letters she holds from Ruskin to Dora Livesey. Miss Janet Gnosspelius of Liverpool, a granddaughter of W. G. Collingwood, has permitted citation of the diary of her mother, Mrs. Barbara C. Gnosspelius and a letter from her grandfather. Through the courtesy of Mrs. Sheila Taylor of Poole I have cited the 'Memoir of Percy La Touche' and other papers in her collection.

I am indebted to Messrs. George Allen & Unwin Ltd. as the Literary Trustees of John Ruskin for permission to publish previously unpublished writings of John Ruskin. Sir Ralph Millais has approved my citation of a letter at the Morgan Library from Mary Millais, a daughter of Euphemia and John Everett Millais. I cite letters from Joan Severn with the permission of Sheila Countess of Birkenhead.

For permission to reproduce pictures in their possession, I thank the Ruskin Galleries at Bembridge; the Pierpont Morgan Library; Miss Janet Gnosspelius; Mr. Charles Balston of Covington, Cambridgeshire; and Mrs. Doreen Beaumont of Brannockstown. I am grateful to the Yale University Library for the facsimile of Ruskin's letter to Rose La Touche in Plate XI.

The Rev. Robert Dunlop, Pastor of Brannockstown Baptist Church, Co. Kildare, occupies a special place in my memory for the help which he sent me in his pamphlet, *Plantation of Renown* [1970], which describes the devotion of John La Touche to the Baptist Church at Brannockstown. My wife and I will never forget the hospitality of the Dunlops when we visited Brannockstown in 1976. Nor shall we forget the kindness of Mrs. Doreen Beaumont, the present owner of the Harristown Estate, in showing us through her house and grounds with which the La Touches and Ruskin will always be associated. Mr. James Dearden, the tireless Curator of the Ruskin Galleries, has my deepest gratitude for many hours of help. Mr. Timothy Hilton of Oxford has given me leads to manuscripts which otherwise I might have overlooked. My colleague, Professor Robert Rhodes, has been helpful on Irish sources.

I could not have completed this research without the aid of generous grants in 1974 from the American Philosophical

Society of Philadelphia and the Research Foundation of the State University of New York.

So much has Ruskin been a part of our lives that my patient wife must have thought at times that she had to share our home with his spirit. I am grateful for her encouragement and companionship on our many travels in search of his life and ideas. Mrs. Joyce Ellen Hicks, our daughter who grew up in the shadow of Ruskin, has been an intelligent listener to this manuscript.

V. A. B.

Cortland, New York
April 1979

Contents

List of Illustrations

xiv *List of Illustrations*

Abbreviations

QUOTATIONS FROM Ruskin's published works are taken from *The Works of John Ruskin*, ed. E. T. Cook and Alexander Wedderburn, Library Edition, 39 vols. (London: George Allen, 1903–12). References to this edition appear by volume and page number, thus: (*14.223*). Editions of Ruskin's diaries and correspondence are coded as shown below:

D: *The Diaries of John Ruskin*, ed. Joan Evans and John Howard Whitehouse, 3 vols. (Oxford: Clarendon, 1956–1959).

LMT: *Letters of John Ruskin to Lord and Lady Mount-Temple*, ed. John Lewis Bradley (Columbus, Ohio: Ohio State University Press, 1964).

LN: *Letters of John Ruskin to Charles Eliot Norton*, 2 vols. (Boston: Houghton, Mifflin and Company, 1904).

WL: *The Winnington Letters: John Ruskin's Correspondence with Margaret Alexis Bell and the Children at Winnington Hall*, ed. Van Akin Burd (Cambridge, Mass.: The Belknap Press of Harvard University Press, 1969).

Other forms of shortened address follow.

ALS: Autograph letter signed.

Bembridge: The John Howard Whitehouse Collection, The Ruskin Galleries, Bembridge School, Bembridge, Isle of Wight.

Houghton: The Houghton Library, Harvard University, Cambridge, Massachusetts.

Morgan: The Pierpont Morgan Library, New York, New York.

Yale: The Beinecke Rare Book and Manuscript Library, Yale University Library, New Haven, Connecticut.

A note on editorial practice

In reproducing Viljoen's transcript of the Rose La Touche diaries, I have italicized the heading for each day's entry, and I have introduced some paragraphing to mark the shifts of thought. I have added marks of accent to French words where necessary. I have preserved Rose's use of the dash, using a normal one within a sentence and a shorter dash between spaces where she uses this mark to separate sentences. I have bracketed any emendations to the text. I have not corrected peculiarities of punctuation where the meaning is clear.

The Introduction and notes to the diaries often cite manuscript materials. Here I have preserved any use of the ampersand. Superscript letters found in abbreviations have been brought down to the line. I have observed John Ruskin's use of the apostrophe to separate the words to be united in certain contractions, rather than to signal the omitted letter—as in *were'nt, could'nt*. A question mark in square brackets [?] indicates that the preceding reading is uncertain. Square brackets enclosing three spaced periods and a question mark [. . .?] mean that a word in the manuscript proved illegible. Editorial comments are printed in italics within square brackets, thus: [*Editorial*]. The notes identify the location of all cited manuscripts except for Ruskin's unpublished letters to his father, preserved at Yale, which are cited by date within the text. Unless otherwise shown, manuscript sources are unpublished.

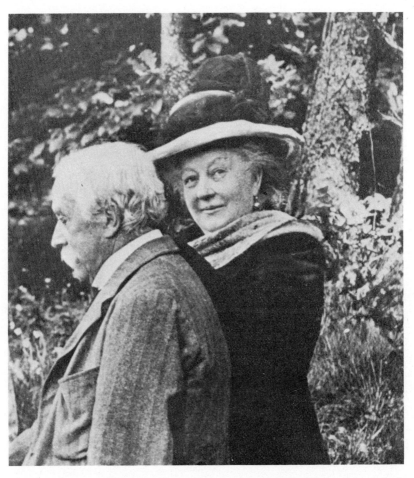

Joan and Arthur Severn walking at Brantwood, about 1920

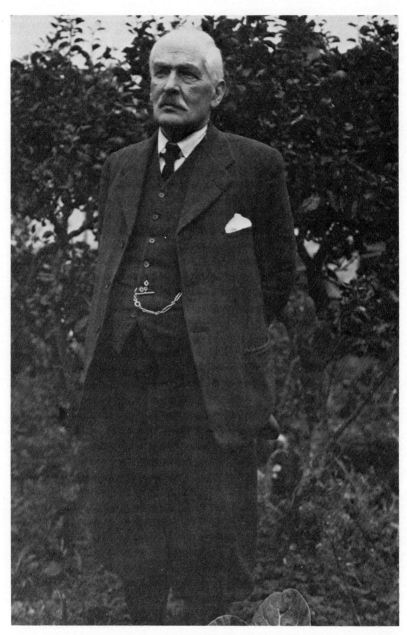

William Gershom Collingwood, 14 October 1928

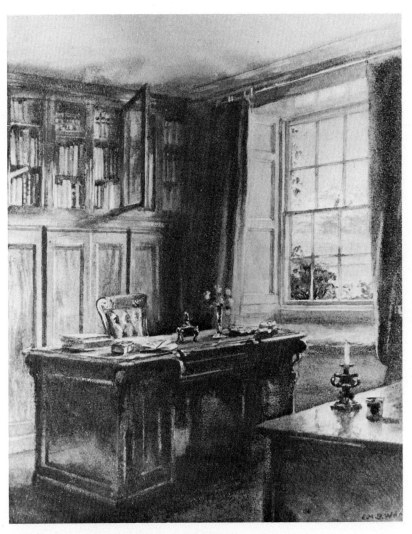

Part of Ruskin's study at Brantwood, about 1916
Drawing by Emily Warren

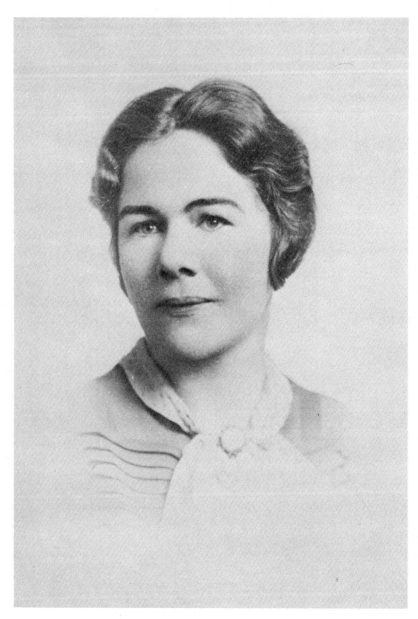

Helen Gill Viljoen, about 1928

Introduction

AMONG THE papers which Helen Gill Viljoen bequeathed to me in March 1974 is her transcript of the two surviving fragments of the diaries of Rose Lucy La Touche, the Irish girl whom John Ruskin had met in 1858 when she was yet a child and he later came to love and hoped to make his wife before her death in 1875. The survival of these fragments, one of which Viljoen titles Rose's Autobiography, appears to be an act of that Fors which Ruskin describes as chance, here most fortuitous. In *Ruskin's Scottish Heritage* (1956), Viljoen only mentioned her finding of these manuscripts in 1929 at Brantwood, Ruskin's home near Coniston, and her transcribing at least one of them in full before their disappearance at the subsequent auctions of Ruskin's papers.[1] Thereafter she reserved her copy of the diaries for use in her projected biography of Ruskin to which she gave much of her life but was unable to complete. Under the authority which Viljoen grants me in her Will, I am now making available for the first time these documents which add much to our knowledge of this girl who opened for Ruskin, as he said, a 'new epoch of life' (35.533).

Perhaps nothing in Ruskin is more difficult to understand than his love for Rose La Touche. A recent writer is correct in tracing our limited knowledge of the relationship of these two people to the unavailability of the documentary material.[2] That little has been known of Rose is not an accident. Ruskin's first biographer, his executors, and his editors deliberately suppressed information about this episode in Ruskin's life of which he himself was willing to speak and whose importance he recognized. Working often from hitherto unpublished materials, I shall provide a perspective for the diaries by recounting first the circumstances of Viljoen's discovery of the manuscripts; the luck by which

[1] *Ruskin's Scottish Heritage: A Prelude* (Urbana, Ill.: University of Illinois Press), p. 9.

[2] John L. Bradley, *An Introduction to Ruskin* (Boston: Houghton Mifflin Company, 1971), p. 74.

they escaped the executors who burned most of the primary documents on Ruskin and Rose; and the subsequent efforts of the biographers to understand her. Then I shall place the first segment of Rose's diaries, written in 1861, in the context of her experiences before that time, and review the circumstances which led her early in 1867 to write the autobiography contained in the second fragment. In the final sections, I shall highlight the tragic events leading to the death of Rose and the part she played in the turn of Ruskin's convictions about the nature of life and art.

A. THE DIARIES AND RUSKIN SCHOLARSHIP

1. *The discovery of the diaries*

VILJOEN WROTE four brief accounts of her visit to Brantwood in the autumn of 1929,[1] and several times discussed it with me, but her daily letters to her husband, Jan Augusto Viljoen (1898–196?), a bacteriologist then with the C. F. Burgess Laboratories of Madison, Wisconsin, are the best source of information about her discovery of the La Touche manuscripts. Again Fors seems to have been at work, this time in preparing her for her study of Ruskin. Little Miss Gill of Larchmont and Mamaroneck, New York, as she liked to describe herself in her youth, had majored in psychology and sociology at Smith College. Graduating in 1920, she undertook graduate work at the University of Wisconsin where she fell under the spell of the poet-professor, William Ellery Leonard, who made her realize that her real interests lay in English literature. 'In him I found a teacher who could arouse imagination while bringing poetry to life and developing a point of view which could lead to a religious faith that was not founded upon the Bible, literally accepted as the Word of

[1] *Ruskin's Scottish Heritage*, pp. 7–9; [H. G. Viljoen], *Ruskin Backgrounds, Friendships, and Interests as reflected in The F. J. Sharp Collection loaned by Helen Gill Viljoen* (Flushing, N.Y.: Queens College Library, 1965), pp. iv–v, 41–2; her paper, 'The Scholar and His Life', an unpublished address to the Queens College Chapter of Phi Beta Kappa, 9 Dec. 1960, the typescript of which is in the possession of Van A. Burd, Cortland, New York; and her letter to John H. Whitehouse on stationery with Queens College letterhead (of which the first page is missing, but probably dated Dec. 1949) now preserved at Bembridge, L 78. In these accounts Viljoen gives 1930 as the date of her visit to Brantwood, an error corrected here to 1929 through her letters to her husband.

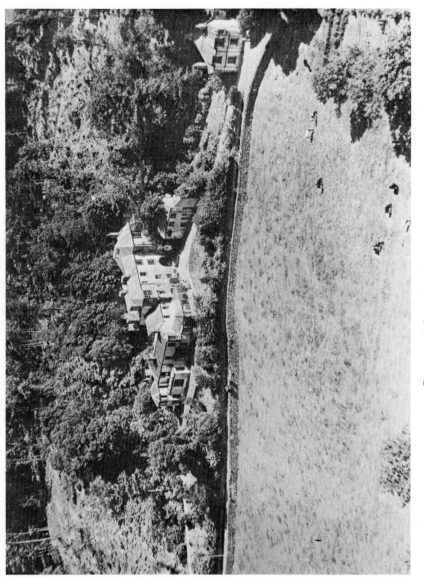

Brantwood from the air, about 1950

God', she writes in some notes on her life which she left with me. 'That was a faith which I had lost while studying at Smith, without being guided toward any substitute.' At twenty-two, she had undergone much of the same conversion which Ruskin had experienced only weeks before his first acquaintance with Rose La Touche and her mother, a liberalization of belief which Rose could never accept in him. Going to Berkeley, Helen Gill then took a Master's degree in English from the University of California. In 1922 she returned to Madison to begin her doctoral studies. For her dissertation on the sources of Ruskin's ideas in the first volume of *Modern Painters*, she found at hand two men well qualified to guide her research, Professors Arthur Beatty (1869–1943) and Frederick William Roe (1874–1962), the first well known for his work on Wordsworth and the second for his studies on Ruskin.

The happiness of her marriage in 1925 was brief as intellectual differences came to separate the Viljoens—much as they had contributed in 1854 to the break-up of Ruskin's marriage to Euphemia Chalmers Gray. Hoping to enrich her dissertation, Helen Viljoen planned a trip to Brantwood to examine the books in Ruskin's library to see what they might add to her knowledge of his literary sources. As her letters to her husband suggest, she also hoped that travelling alone she would gain a new perspective which might save their marriage. Thus her own experiences had prepared her to recognize the importance of a manuscript which sheds light on troubled persons in whose lives she could recognize parallels with her own.

Since Ruskin's death in 1900 Brantwood had lost much of its glory. In his Will Ruskin had requested his heirs, Arthur and Joan Severn (the latter his cousin who in 1864 had joined the Ruskin household at Denmark Hill as a companion for Ruskin's widowed mother and who later undertook the care of Ruskin at Brantwood in the many years of his last illness), 'never to sell the said estate of Brantwood or any part thereof ... but to maintain the said estate and the buildings thereon in decent order and good repair'.[1] The financial demands of

[1] 'Ruskin's Last Will and Testament', 23 Oct. 1883, p. 1. The Will is preserved in the Register of Wills, St. Catherine's House, London.

five children had prevented the Severns from carrying out Ruskin's wishes. Arthur, son of Joseph Severn (the friend of Keats), had followed his father as a painter, but with less distinction. Although his water-colours were in demand, he often had turned to the treasures in Brantwood for additional money. In 1887 Ruskin had written to a friend that he hoped none of his Turners 'may ever come into market, when Brantwood knows me no more'.[1] By the time Helen Viljoen arrived, however, many of them had disappeared, a Severn copy hanging in the place of an original. In the dining room was only a copy of the painting now in the National Gallery which Ruskin believed to be Titian's *Doge Andrea Gritti*. A few months after Ruskin's death the Severns had sold some of Ruskin's own drawings in America through the help of Charles Eliot Norton, one of Ruskin's literary executors. 'Of course', Joan wrote to Norton in 1903, 'we *shall* always keep a full & characteristic collection of everything the Coz [her pet-name for her cousin] had—Pictures, manuscripts, minerals &c. &c. books, & all else', but she went on to explain that they had been obliged to part with some things to pay the expenses of maintaining Brantwood.[2] In a sense she carried out this intent, the house in 1929 still containing a representation of Ruskin's interests as she had outlined them. Although the most important pictures and the bulk of the illuminated manuscripts of Ruskin's collection had disappeared, valuable pictures still hung on the walls. Ruskin's furniture, much of it brought to Brantwood in 1872 from his family home, still filled the rooms; most of his books were in their cases in the study. Ruskin's private papers, his diaries, and much of his personal correspondence were there. With the death of Joan in 1924 and Arthur's moving to London, however, the house had been neglected and had fallen into a sad state of disrepair.

In the summer of 1928 Haddon C. Adams, an admirer of Ruskin who was to be a buyer at the later sales of Ruskin's effects, visited Brantwood with his wife and through his

[1] Letter to Marcus B. Huish, Brantwood, 6 Jan. 1887 (ALS, Rylands English MS. 1254/77, The John Rylands University Library of Manchester).
[2] ALS, Brantwood, 19 June [1903] and 26 June 1903 (Norton Papers, Houghton). Passage cited in Sheila Birkenhead, *Illustrious Friends* (New York: Reynal & Company, 1965), p. 364.

letters to his father left a vivid picture of the house much as
Helen Viljoen was to find it the next year. The only occupant
of Brantwood was Violet Severn, Arthur's youngest daughter
who was a spinster in her late forties and (according to
Viljoen) quite uninformed about Ruskin and more than a
little eccentric. Adams found that the corps which had looked
after the gardens in Ruskin's day was reduced to the aged
Joseph Wilkinson who lived with his family in the Lodge at
the entry to the estate. His nephew, Miles Wilkinson, whom
Adams persuaded to show the house, was in charge of
Brantwood. 'The Severns seem in financial straits & the
house, with priceless Turners etc. on the walls is in disrepair—
paper peeling from ceilings—it is heartbreaking to see',
Adams writes his father. 'Upstairs in a bedroom from the
ceiling of which the paper was hanging because of damp,
were wonderful drawings etc.' In Ruskin's own bedroom
Adams saw some of Ruskin's clothes still in a drawer and
again noted the effect of the damp. In the dining room he
observed the fine oil portraits of Ruskin's mother by James
Northcote and Ruskin's father by George Watson, which still
hang there today, and two portraits of Ruskin which have
since vanished—the 'blue hills' portrait by Northcote and the
full-length water-colour of 'The Author of Modern Painters'
by George Richmond. 'Then into the study!' Adams tells his
father excitedly, 'his desk & the little ○ [circular] table where
he did so much writing. I saw the original notebook of a diary
& poems, some of the famous books referred to in his works.'
Following tea with the gardener's wife in the Lodge, Adams
and his wife visited the gardens and greenhouses, in one of
which, he says, they 'came upon Miss Severn & thought
it best to retire. ... I left my card. (I heard later that Miss
Severn saw the card, & expressed the hope that we had [been]
seen through Brantwood.)' Adams knew that Ruskin's first
biographer, William Gershom Collingwood, lived near
Brantwood at Lanehead, 'a mile away in the same lane, by the
lake. ... It must be heartbreaking to him to see the place so let
down.'[1]

[1] ALS, 25 June and 8 July 1928 (L 81, Bembridge), cited with differences in James
S. Dearden, 'The Haddon C. Adams Ruskin Collection at Bembridge', *Bulletin of the
John Rylands University Library of Manchester*, 55 (Spring 1973), 302, 305.

Arthur Beatty had given Helen Viljoen a letter of introduction to Collingwood whom he had come to know well during his frequent visits to Coniston, the most recent of which had been in the summer of 1929. Collingwood in a letter of 14 September assured Viljoen that he would ask Miss Severn to let her 'look at Ruskin's library—or such books as may be still at Brantwood. Since I saw Dr. Beatty's party I have been unfortunate in suffering a slight "stroke," which has made me partly unable to talk and write. I hope to be well enough by next month to tell you anything I happen to know.'[1] Although in his seventy-fifth year, he did recover to take a lively interest in Viljoen and to hold several conversations with her about Ruskin on which she duly recorded notes in the evenings.[2] Pleased with her enthusiasm about Ruskin he soon invited her to work in his study at Lanehead during the afternoons where she could bring the materials from her morning's work at Brantwood.[3] As a member of the Oxford School of Drawing, Collingwood had come under Ruskin's influence in 1872, and along with other students like Oscar Wilde and Alfred Toynbee had been one of Ruskin's diggers in building a road to serve the cottages near Hinksey Ferry. A painter of some distinction he soon joined the circle at Brantwood, became one of Ruskin's travelling companions, the editor of several of Ruskin's writings, including the *Poems* (1891), and the author of the official *Life of Ruskin* (1893). So close was 'Collie' to Ruskin that he jokingly referred to himself in Ruskin's presence as his Boswell.[4] Even on her first visit to Lanehead, Viljoen completely 'fell' for Collingwood's charm, she writes to her husband. She found him 'a dear old gentleman, partially paralyzed by a stroke. . . . He

[1] ALS, Van A. Burd. The diary of Mrs. Barbara C. Gnosspelius, daughter of W. G. Collingwood, shows that Collingwood had talked to Beatty and a party of Americans at the Ruskin Museum in Coniston on 28 June 1929 (MS., Janet Gnosspelius, Liverpool).

[2] 'Mr. Collingwood on Ruskin' (MS., Van A. Burd).

[3] Barbara Gnosspelius writes in her diary for 28 Oct.: 'Mrs. Viljoen started working on Ruskin research in White Room [of Lanehead] and every day following' (MS., J. Gnosspelius). Collingwood on this occasion presented Viljoen with a copy of *Ruskin's Philosophy* (Kendal: Titus Wilson & Son, 1922), an address by his son Robin George Collingwood. On the cover he wrote: 'Mrs. Viljoen / from W. G. Collingwood / Coniston, Oct. 28, 1929'. In possession of Van A. Burd.

[4] W. G. Collingwood, *Ruskin Relics* (London: Isbister, 1903), p. 11.

was all agog over my coming and very sweet to me.'[1] At the end of a week Collingwood apparently sensed that she had some heavy problem on her mind, and he took her for a walk in the hills. 'I need a father, he said. . . . He is a dear, kind, good man' (30 Oct.). Before she left, she had laid the basis for a lifelong friendship with Collingwood's daughter, Barbara, who also lived at Lanehead with her husband, Oscar Gnosspelius, a retired engineer.

Viljoen had arrived in Coniston by train on 24 October, a dark evening when the station was 'only one dim light'. Waiting in vain for a taxi in this village while everyone else who got off the train disappeared, she soon 'grabbed fur coat, umbrella, & suitcase and sallied forth in the general direction I'd seen my fellow-travellers take', she writes to her husband that night. 'Stygian blackness had nothing to what I went thru—over cobblestones, down a road that descended a hill in S curves, under a bridge—not a street light, not a house light—nothing. Then I met two little girls who told me to go on, and the first house on the left would be the Sun Hotel.' The proprietor, Mr. F. Stanley, was so startled on answering her knock that he let her carry her own suitcase 'around after him into every room in the house until he finally decided into which of the emptinesses' he would lead her. Her spirits recovered after a delicious supper ending with 'rice pudding & apple-sauce covered with cream so thick it was in great gobs', she learned that in the morning she would have a three-mile walk to Brantwood.

Not until the sunshine of the next day did she see the old stone houses of the village, the red foliage of autumn, the beauty of Coniston Water, and the Old Man to the west whose peak was covered with mist. Brantwood lies on the eastern side of the lake, Ruskin having purchased the house for its view of the full width of Coniston Water and the Old Man. Walking most of the way in intermittent rain, Viljoen first made a courtesy call on the Collingwoods at Lanehead and then walked the remaining mile for her first look at

[1]ALS, 25 Oct. 1929. The holographs of the letters from H. G. Viljoen to her husband, J. A. Viljoen, are owned by Esther K. Sheldon of Northport, New York. Subsequent citations from these letters in this chapter will be identified in the text by date sometimes within parentheses.

Brantwood. She could only suggest the scene to her husband, the loveliness of the snow now visible on the heights of the Old Man, the house 'gorgeously located—on a hillside above the lake.... It is a simple enough house—rather small— Ruskin bought without seeing it "because," he said, "any house opposite Coniston's Old Man must be beautiful" ' (25 Oct.).

At Brantwood she had her first meeting with Violet Severn. 'After much ringing and waiting [I] aroused Miss Severn. There's evidently a feud between Collingwood and the lady. She's about 50, quite deaf, and most unprepossessing upon first acquaintance', Viljoen confides to her husband in her letter of 25 October. 'Collingwood disapproves of her because she sleeps until 10 A. M. daily.' But after they toured the house and had tea that afternoon at the Sun (Viljoen having walked back to Coniston), she found Miss Severn to be a 'delightfully eccentric and humorous soul'. More interested in the wonders of her 800-day clock than Ruskin, 'she almost gets brain fever when asked to look up something in the Library Edition [of Ruskin's *Works*] of which she is the unhappy possessor – only after months of bewilderment did she learn how to use the index'. In a later letter (16–17 Nov.) she writes of Miss Severn's eloquence 'on the errors of the Library Edition, pointing scornfully to the footnotes and demanding in indignant tones what their use might be.... They were only confusing . . . by the time you finish reading One of them you've forgotten what the text is about.'

On their tour of the house, Viljoen took special interest in the rooms most closely associated with Ruskin. 'Ruskin's desk at which he wrote all his later work is in the study—', she writes to her husband (25 Oct.), 'and three walls are lined with books.' It was at this desk she was to work during her mornings at Brantwood, behind her (as shown in Plate IV) Ruskin's principal bookcase which was glazed above and cupboarded below. Little did she suspect on this first morning that in this room and in this bookcase was she to find the Rose La Touche diaries. Nor did she know that beneath the floorboards under another bookcase in one corner of a room off the hall which had been used as the dining room before Ruskin's remodelling of the house was Miles Wilkinson

(according to his own account) to find several bundles of Ruskin's love letters to his former wife.[1] Continuing her first impressions of the house, Viljoen tells her husband that in the drawing room the 'walls are covered with sketches by Ruskin—mostly architectural and very delicate & beautiful— with a few by Prout and Collingwood & Miss Severn's father'. Upstairs she visited Ruskin's bedroom and the small turret room which Ruskin had added to the house, with an entrance from his sleeping chamber. 'The little corner turret is large enough for a small table & chair and there Ruskin sat & watched the lake & hills. . . . The bedroom walls are covered with Turner water-colors and sketches by Ruskin, and one wall is lined with books.' Later, having won Miss Severn's confidence, Viljoen worked at least once in the dining room of Brantwood during the last week of her stay. How exciting it was to work 'in the old dining room by the table where Ruskin had entertained so many times so many famous people—', she writes to her husband on 16 November, 'in a room hung with his portraits—& copies of all his grand old pictures (for, alas, the Severns had sold all the originals of Titian, Botticelli, and others)—'. Hearing later that an agent from Sotheby's had arrived to appraise the contents of the house, she thought ruefully of the coming dispersal of this collection. 'There are manuscripts there of almost all of Ruskin's works, first editions of Scott, Dickens, Ruskin, a Blake illustrated edition of Young's *Night Thoughts*—a gorgeous thing, I saw it for the first time today—letters from some of the most famous men of the 19th century, and so on . . . a 13th century illuminated Gospel, a Greek manuscript of the Bible—' (16 Nov.). Like Haddon Adams, she also noted the disrepair of the house, finding buckets and saucepans on the floor to catch the water dripping through the roof. Collingwood bitterly blamed the Severns for this neglect. While Joan was truly devoted to Ruskin, the rest of the Severns 'worked' him, he told Viljoen. After Joan's death, 'nobody cared anything about Ruskin or anything connected

[1] Felix Barber, 'Mr. Wilkinson Stumbled: Ruskin's Secret Lay Revealed', [*London*] *Evening News*, 14 Jan. 1949, p. 2. In *The Ruskins and the Grays* (London: John Murray, 1972), Mary Lutyens raises questions about details of Wilkinson's discovery (pp. 263–4).

with him except for the money', her notes read of Collingwood's opinions.[1]

If Viljoen had confined her attention to her mission of examining the books in Ruskin's library, she would have finished her work in a few days. Even after the first day of her research at Ruskin's desk, she tells her husband that she was 'full of curiosity as to what the study holds'.[2] On the second day, 'off in a corner by themselves, [I] spied twelve bound volumes of manuscript—Ruskin's diaries' at which she took a surreptitious look. 'You can imagine how I longed to have time to read them', she declares that night in her letter. At Lanehead that afternoon she asked about the diaries. When Collingwood saw that she was 'keen to get at the diaries, he was as pleased as punch', and said that he would get them down to his house for her. Knowing that the diaries would soon be sold, he even suggested that she copy them! Now that she must lengthen her visit, Viljoen arranged to take a room with Mrs. Jeremiah Cowman at How Head, a farm that was close to the Collingwoods. Reading even the first volume of the diaries she realized the need for a new biography of Ruskin. 'If ever there was a chance to gather materials for a grand "life," it's here', she writes to her husband.[3]

The fact that some of the diaries were missing from the first group prompted Viljoen to explore the study even further. On 7 November came what she later declared 'the most momentous moment' of her scholarly life. Using the library ladder, she climbed up to remove a book from the topmost shelf of one of the bookcases.[4] There, 'tucked away behind a lot of books on a top shelf I unearthed—I don't quite [know] what, yet', she writes to her husband breathlessly that evening, 'for I haven't had a chance to read them—but certainly the missing diaries, and a bound volume of family papers . . . letters written by Ruskin's mother & father during his childhood . . . another volume of letters written by Ruskin to people concerned with Rose La Touche'. For an audience of Phi Beta Kappa in 1960, she described the cache as

[1]'Mr. Collingwood on Ruskin' (MS., Burd).
[2]ALS dated 28 Oct. 1929, the first of two letters of this date.
[3]The second ALS dated 28 Oct. 1929.
[4]'The Scholar and His Life', p. 5 (MS., Burd).

including, besides, the bound volumes of Ruskin's letters to
his father (now preserved at Yale University); the early family
letters (now at the Pierpont Morgan Library); 'many other
sets of letters resting hidden on that shelf—some of which
. . . have subsequently simply disappeared. . . . Finally, there
was an autobiography of the immeasurably pathetic Rose La
Touche . . . written in her hand, which I presumably was the
last to read while, thank Heaven, I was transcribing it entire.'[1]
This autobiographical diary, as she recalled for a correspond-
ent, was in a small notebook with a brown cover, measuring
about 4 by 6 inches.[2] Whether the diary for 1861 was in this
same notebook and whether she copied it in its entirety she
does not explain. On the evening of 10 November she writes
to her husband, 'I'm thru the worst of the work—have copied
Rose La Touche's journal—24 pages of paper this size [6 by
9 inches], crammed with a tiny script—and her writing was
the very devil to read—a few places I couldn't make out'.

On 20 November—four weeks after her arrival at Conis-
ton—she left for London, carrying her transcript of Rose's
diaries, her notes on many letters from Ruskin to Mrs. La
Touche, and the results of her studies of numerous other
manuscripts and books. From two letters which Viljoen
writes to her husband on 19 November, we learn that on the
last afternoon Miss Severn provided 'a huge super-excellent'
tea in Viljoen's honour, and at night the Collingwoods marked
her departure with a chicken dinner. She had found real
happiness in the work, she says, and her thoughts were filled
with the significance of her finds. The tragedy of Ruskin's life
was 'Rose La Touche's refusal to marry him and her
subsequent death'. From Viljoen's study of Ruskin's diaries,
she had written to her husband on 30 October, she perceived
that Ruskin's marriage to Effie Gray was 'absolutely loveless
& bound to be incompatible for both'. This judgement may
have been close to the decision which the Viljoens reached
about themselves after her return. Their marriage ended in
1930, and Helen Viljoen was free for a career of teaching and
scholarship devoted to Ruskin.

[1] Ibid., pp. 5–6.
[2] Viljoen in letter to Thomas J. Telford, 2 Feb. 1953. Carbon typescript in
possession of Van A. Burd.

2. The destruction of the Ruskin–La Touche papers

At a high point of Ruskin's despair for his hopes to marry Rose La Touche, he spoke of sending all of Rose's letters to Mrs. William Cowper (later Lady Mount-Temple), a friend who generally had taken his side in his differences with the La Touches, so that she might give them to Rose for her to destroy (*LMT.169*). But neither Mrs. Cowper nor Rose carried out this desperate measure, for he recovered the letters not long after Rose's death (*LN2.129*). He had the correspondence at hand in 1888 when he was writing the chapter on Rose for his autobiography. There he included as an illustration of her character what he called (erroneously) her 'first' letter to him, written from Nice on 18 March 1861 (*35.529–32*). For a later chapter which he did not complete he set up the text of her 'Star Letter' (as he called it in his diary), written from London on 26 December 1861.[1] Of Ruskin's letters to Rose we know only that at some point the La Touches returned them, and that according to Ruskin's principal editor, E. T. Cook, Ruskin preserved both sides of the correspondence significantly in a rosewood box (*35.lxxvi*).

In 1883 Ruskin made his will and appointed Joan Severn and Charles Eliot Norton as literary executors of his diaries, unpublished manuscripts, and private papers, giving them authority to publish or destroy any part of them. Norton had met Ruskin in 1855 and they soon became friends. This young American who was to become a distinguished professor of fine arts at Harvard had won Ruskin's admiration for his knowledge of classical literature and Ruskin's own writings. Impressed with Norton's candour and sensibility, Ruskin memorializes him in his autobiography as truly 'a gentleman of the world' (*35.521*). His appointment as Ruskin's executor was nevertheless surprising because the two friends were then in a rift over their views of the propriety of James A. Froude in his role as literary executor for Thomas Carlyle. Froude, in his biography of Carlyle, had suggested enough about Carlyle's sexual nature that Norton accused Froude of 'cynical

[1] Ruskin's editors refer to the letter and cite it in part (*35.638, lxix–lxx*). For the full text of this letter, see below, pp. 71–3. For Ruskin's allusion in his diary to this letter see the comment which he added later to the entry for 26 Dec. 1861 (*D2.559*).

treachery to the memory of one who had put faith in him'.[1]
Ruskin, long a friend of Froude, defended his integrity. To
his responsibility as Ruskin's executor, Norton was to bring
this same moral sense and that New England reticence about
a man's personal life. Portions of every man's life are
essentially private, he writes in 1893 for his edition of the
letters of James Russell Lowell, 'and knowledge of them
belongs by right only to those intimates whom he himself
may see fit to trust with his entire confidence'.[2]

As early as 1878 Norton had urged in a private letter that
Ruskin's heirs should 'make a holocaust of his correspondence.
I dread the vultures that are already hovering over what they
have long marked for their prey.'[3] Only a few weeks after
Ruskin's death in January 1900, he writes to Sir Leslie
Stephen: 'If it depended on me, there would be no further
word of Ruskin or about him given to the public. Enough is
known.'[4] Joan Severn meanwhile approached their duties as
literary executors with the greatest respect for Norton's
judgement. 'I'm sure that there is no one whom either the
beloved Coz or I could trust with his private papers', so she
writes to Norton on 24 February 1900. Advising Joan on the
publication of Ruskin's writings were George Allen (Ruskin's
publisher) and Alexander Wedderburn who had been
another of Ruskin's diggers at Hinksey, later editor of several
of his books, and in the view of one of the daughters of Effie
Gray by her second marriage—the chief 'Hush-Hush insti-
gator that nothing must be said against Ruskin'.[5] These two
gentlemen wondered whether they might announce that
Norton would do an official life of Ruskin. 'We all hope so',
Joan remarks (10 March 1900). She was depending on Norton

[1] Letter from Norton to Mrs. A. Carlyle, Ashfield, Mass., 5 July 1882, *Letters of Charles Eliot Norton*, ed. Sara Norton and M. A. DeWolfe Howe (Boston: Houghton Mifflin Company, 1913), II. 135.
[2] *Letters of James Russell Lowell*, ed. Charles Eliot Norton (New York: Harper & Brothers Publishers, 1894), I. iii.
[3] Letter from Norton to Dr. John Simon, Shady Hill, 5 Mar. 1878 (ALS, Norton Papers, Houghton). Letter cited with error in Kermit Vanderbilt, *Charles Eliot Norton* (Cambridge, Mass.: Belknap Press of Harvard University Press, 1959), p. 171.
[4] Shady Hill, 28 Mar. 1900, *Letters of C. E. Norton*, II. 291.
[5] Mary Millais, daughter of Euphemia and John E. Millais, in letter to the Hon. Clare S. Wortley, Harrogate, 11 Aug. 1939 (ALS, Bowerswell Papers, Morgan).

'to look over the beloved Coz's letters & diaries—& to decide what should be destroyed, & what kept'. W. G. Collingwood, she adds, would be 'of *great use*, as he knows where everything is, (much better than I do) having been so long a Secretary— & quick & helpful & kind in all ways' (18 March 1900). Her letters show that Norton spent a fortnight that year with her at Brantwood, beginning about the first of June.[1] Norton's respect for privacy prevailed with Joan, and they agreed to destroy the letters between Ruskin and Rose La Touche. They carried the letters, according to E. T. Cook's account, 'to the woodland garden above Brantwood, and gave them to the flames' (*35.lxxvi*). A few days after Norton's departure Joan recalled the scene to him. 'I went to his little woodland garden today—& over that sad little spot a wild rose is covering a rustic trellis—just what *he* & *she*, would have liked over so sacred [a] little spot.'[2] Cook may not have missed the irony when he recorded the judgement of the executors that Ruskin's letters to Rose were 'perhaps the most beautiful' he ever wrote (*35.xxxvi*).

Thereupon Mrs. Severn also agreed to screen the other papers at Brantwood for any documents about Ruskin and Rose that should be destroyed. As late as 1906 that super-secretary (as Sir Sydney Cockerell called her)[3] and friend to the great, Sara Anderson, was still helping Joan sift the papers in the drawers of the dining room. To Joan, then in London, she writes that she had just finished checking one group of letters '& burnt all those relating to the terrible Rosie times'.[4] The agreement did not prevent a misunderstanding between Norton and Joan. Soon after Ruskin's death, Allen and Wedderburn had worked out a plan with Joan for a collected edition of his writings. Collingwood later told Viljoen that he had disapproved of the project; Norton was unenthusiastic, lacking confidence in both Allen and Wedderburn.[5] In late

[1] The holographs of these letters from Joan Severn to Norton are in the Norton Papers, Houghton.
[2] Brantwood, 19 June 1900 (ALS, Norton Papers, Houghton).
[3] His obituary notice of Sara Anderson, *The Times*, 30 Oct. 1942, p. 7.
[4] 46 Warwick Gardens, Kensington [letterhead], 12 May 1906 (ALS, L 63, Bembridge). Passage cited with minor difference in S. Birkenhead, *Illustrious Friends*, p. 367.
[5] 'Mr. Collingwood on Ruskin' (MS., Burd); letter from Norton to Joan Severn, Shady Hill, 17 Jan. 1902 (ALS, Sharp Papers, Morgan).

1903, Norton refused Wedderburn's request for his collection of Ruskin's letters, and soon afterwards he apparently informed Wedderburn of his own plans to publish some of this correspondence. Joan expressed her surprise to Norton, and later shock, when she discovered that he had included in the two volumes a brief account of Rose La Touche—the first time her name had been given in any of the studies of Ruskin. 'I am sorry however for the introduction of poor Rose', Joan writes to Norton on 20 December 1904. . . . 'I thought when we made the little sacrifice in my beloved Deepie's [her pet name for Ruskin] little garden here, that we agreed to burn *all* letters bearing on that sad subject—& I have done so—& destroyed many since to myself, & other people.'[1] In the Preface to his edition of Ruskin's letters, Norton explained his reluctance 'to entrust the charge of selecting and editing [the letters] to any one' other than himself. He also indicated that he had deleted many passages from the correspondence as 'too personal, too intimate' because of his belief 'that there are sanctities in love and life to be kept in privacy inviolate' (*LN1.67*).

Norton's independence with his own letters may have led Joan to decide that she could reserve any La Touche papers that she regarded as her own. The La Touches and others, she tells Norton in the same letter of her complaint about his publication of Ruskin's letters, 'all gave & left me their letters to keep absolutely for myself—& to destroy what I pleased'. Of one such group Sara Anderson later wrote to Joan: 'I have done up Rosie's own letters to you, sealed them, & put "for Joan only" outside.'[2] Through her fondness for Joan, Mrs. La Touche may well have included the fragments of Rose's diaries among the papers she gave her. If so, Joan could have felt justified in preserving these manuscripts and later regarded them either as documents of little monetary value or mementoes with which she could not bear to part. In 1908 E. T. Cook who was collaborating with Wedderburn on the Library Edition of Ruskin's works, supplied an account of

[1] Letter written from Brantwood (ALS, Norton Papers, Houghton).
[2] 46 Warwick Gardens, Kensington [letterhead], 12 May 1906 (ALS, L 63, Bembridge). Passage cited with minor differences in S. Birkenhead, *Illustrious Friends*, pp. 367–8.

Rose which included mention of the manuscript of her
autobiography (*35.lxxii*). 'There is a diary of Rose's in
existence in which, ... she made, at the age of nineteen, a
review of her mental and spiritual life. There is many a
reference in it to Ruskin', and he cites three illustrations. The
manuscript then disappears from our knowledge until Helen
Viljoen finds it at Brantwood in 1929.

Through Collingwood Viljoen cabled a bid on Rose's diary
at the first auction of his letters and manuscripts held at
Sotheby's on 24 July 1930, but to her surprise the little
notebook did not appear among the items offered for sale.[1]
Nor was it listed for the second sale at Sotheby's on 18 May
1931, nor for the London sale at Arthur Severn's home on
Warwick Square conducted by another firm on 15 and 16
July. 'Wet, stormy', Collingwood's daughter writes in her
diary of the weather as the final three-day auction opened on
28 July 1931 in the garden at Brantwood, held by local
auctioneers who usually sold household furnishings and
livestock.[2] The catalogue which they had prepared for the
sale was incomplete. According to the local dealers Mr. and
Mrs. Thomas H. Telford, many uncatalogued items were
offered to buyers. Books were 'tied up in bundles of ten or
twenty, and sold that way. . . . The letters were not open, but
in sealed manila envelopes marked "Letters to and from
Ruskin".' The Telfords found that one or two of the parcels
they bought contained numerous letters from Mrs. La
Touche to Ruskin. The primary job of the auctioneers was to
clean out the house, 'to clear everything away', Mrs. Telford
recalls. 'I never saw a house so crammed with things.'[3] Viljoen
learned that a few months after the sale unsold manuscripts
were piled in the garden and burned.[4] Rose's diaries, then,
may have disappeared from the house before the sales began;
they may have been sold at the auction at Brantwood as

[1]The diary of Barbara C. Gnosspelius, entry for 24 July 1930 (MS., Janet
Gnosspelius). See also Viljoen's letter to J. H. Whitehouse, [Dec. 1949] (ALS, L 78,
Bembridge).

[2]For this diary, see note above.

[3]The cited letter is from Mrs. T. H. Telford to Viljoen, 17 Mar. 1953, typescript in
possession of Van A. Burd. See also letter from T. H. Telford to Mary Millais, 21
Feb. 1933, quoted in Mary Lutyens, *The Ruskins and the Grays*, pp. 262-3.

[4]*Ruskin's Scottish Heritage*, p. 9.

unlisted items, their present whereabouts unknown. Or they may have been in the final bonfire of Ruskin's papers in the garden.

3. *Views of Ruskin's relationship with Rose*

Norton's belief in the privacy of this romance dominated the early writers on Ruskin. In his autobiography, Ruskin admits that some 'wise, and prettily mannered, people' had told him that he 'shouldn't say anything about Rosie at all'. His account of the 'net of Love' which the Fates had woven for him is cautious. Identifying Rose only by first name, he recounts in a few pages how her mother had sought his instruction in art for her children, his first visit to their London house in 1858 when Rose was only ten years old, and their return visit to Denmark Hill to see Ruskin's collection of pictures. He also includes, as already noted, her letter of 18 March 1861 (*35.525–32*). Collingwood, in the first official biography, of 1893, confined his account to four paragraphs. This incident in Ruskin's life, he says, is 'too painful for more than a passing allusion', but 'his attachment to a lady, who had been his pupil' was an 'open secret'. The lady, whom he does not identify, was 'not at one with him in religious matters'. In the first edition he added that for the lady, the relationship 'cost her life', but deleted this judgement from the later editions.[1] Norton, in his volumes of Ruskin's letters to him, introduces her as Rose La Touche who became the mistress of Ruskin's heart, loved him, but 'refused to be his wife, because, holding a strict evangelical creed, she could not make up her mind to marry a skeptic' (*LN1.93–7*)—an epithet which Joan included among her objections to Norton's work.[2] Margaret Ferrier Young, who entered the La Touche family in 1877 as a governess for Mrs. La Touche's grandchildren, included in her volume of Mrs. La Touche's correspondence (1908) six letters from Ruskin to Mrs. La Touche. In her introductory 'Memoir' Young declares that Rose's 'friendship' for Ruskin had given so much pain to the surviving members of the family 'that very little need be said here. . . . Rose did not want

[1] *The Life and Works of John Ruskin* (London: Methuen & Co., 1893), II. 139.
[2] In her letter to C. E. Norton, Brantwood, 20 Dec. 1904 (ALS, Norton Papers, Houghton).

to marry Ruskin, but her parents could not bring her to see that continuing her friendship with him was encouraging his misplaced hopes.' Of Rose's character, Young asserts that 'She had grown up very beautiful, very intellectual, and not at all amenable to family traditions'.[1]

In his editorial work on the Library Edition, Cook had not felt free until 1908 to identify Rose but now, in the Introduction to the thirty-fifth volume, he announces that 'the time has come when the story [of Ruskin and Rose] may briefly be told'. Working largely from *Praeterita*, the works of Norton and Young, Ruskin's diaries and his letters to his father, Cook reviews the circumstances through which Ruskin met the La Touches, observes that Ruskin saw in her the ideal of girlhood which he describes in *Sesame and Lilies*, mentions his visit to the La Touche home in Ireland in 1861, and describes Rose's concern over his religious doubts. Cook was the first to reveal that in 1866 Ruskin proposed marriage to Rose, that she asked to delay her decision for three years until she would be twenty-one, and that at this time Ruskin began to number the days of his diary as they diminished towards the end of this waiting period. He also included some analysis of Rose's religious melancholy, her headaches and neuroses. In Rose's autobiography he finds a 'revelation of deep religious feeling overweighting the intellectual balance, and of mind and body alike tortured by questionings and perplexities'. After her death Ruskin became obsessed with her vision, Cook points out, as he identified her with St. Ursula of Venice and Dante's Beatrice. He reviews the healing in later years of Ruskin's relationship with Mrs. La Touche. 'Before such a tragedy as this', he concludes, 'silence is best' (*35.lxvi–lxxiv*). The following year Cook included in the two volumes of Ruskin's correspondence for the Library edition the only surviving letter at Brantwood from Ruskin to Rose, a document which escaped Norton's eye because it was buried among the volumes of Ruskin's correspondence to his father (*36.368–72*).

With this much information available, the biographers were not slow to recognize the ingredients of a dramatic story.

[1] *The Letters of a Noble Woman* (*Mrs. La Touche of Harristown*), ed. Margaret Ferrier Young (London: George Allen & Sons, 1908), pp. 20–1.

In 1910 Ashmore Wingate retold the romance with numerous errors, but concludes that Rose refused Ruskin 'because she considered herself a pious evangelical and him a brilliant freethinker'.[1] Ada Earland in the same year presented Rose as a 'bigoted religieuse' who rejected Ruskin.[2] The next year Arthur Benson described Rose as a precocious child 'with marvellous power of winning and returning love', but when Ruskin asked for her hand, 'she told him frankly and sweetly enough that she could not marry an unbeliever'. He concludes that it was vain to speculate 'why so bitter a cup' was forced to Ruskin's lips.[3] J. G. Swift MacNeill, in his memories of the La Touches (1925), believes that Rose may have been infatuated with Ruskin, but he finds it 'unthinkable' to believe 'that she could ever have had any idea of marrying this rugged man, who was old enough to have been her father'. He attributes her early death to Ruskin's persecution.[4] Amabel Williams-Ellis in her *Tragedy of John Ruskin* (1928) was the first of the biographers to suggest that Mrs. La Touche may have been in love with Ruskin. What was behind her sudden opposition to him after his proposal to Rose? 'Was Mrs. La Touche really aimlessly blind and cruel, or had there been for years a private and intimate emotion behind her previous encouragement of Ruskin?' Surprise, anger, and jealousy may have prompted her reaction to the proposal. 'Who knows what unacknowledged dreams and fancies were spoiled when Mrs. La Touche found herself to be without equivocation the mother of the woman whom Ruskin loved?'[5] Young objects to this conjecture as an 'extraordinary misrepresentation', but Williams-Ellis says that she had talked with Dr. Greville MacDonald, a son of the George MacDonald who had been a friend of both Ruskin and the La Touches, who claimed to have letters in his possession which supported this view.[6] In

[1] *Life of John Ruskin* (London: The Walter Scott Publishing Co., 1910), p. 141.

[2] *Ruskin and His Circle* (London: Hutchinson & Co., 1910), p. 285.

[3] *Ruskin: A Study in Personality* (London: Smith, Elder, & Co., 1911), pp. 148–9, 151.

[4] *What I Have Seen and Heard* (Boston: Little, Brown and Company, 1925), pp. 80–1.

[5] *John Ruskin* (London: Jonathan Cape, 1928), p. 265.

[6] 'Ruskin's Love Affair', [public letter from Mrs. Amabel Williams-Ellis to the Editors], *Spectator*, 142 (1929), 159.

her biography Williams-Ellis had offered as an alternative explanation the possibility that the La Touches had been informed 'of physical infirmities which made it impossible for them to consent to [Ruskin's] marrying Rose',[1] but she provided no supporting evidence for this speculation. In 1933 David Larg built on the conjecture that Mrs. La Touche was in love with Ruskin. 'There was a niche vacant in the heart of Mrs. La Touche, a niche occupied by a small cloud of romance. On that John came to rest as naturally as a butterfly. . . . In a very short time Rose pushed her mother aside and fell on her young knees in front of her idol.'[2]

After the death of Joan Severn came the gradual release of documents which revealed more of the facts about Ruskin's relationship with Rose. In 1924 and 1932 Dr. Greville MacDonald recounted the story of his father's role in the love affair but admitted a feeling of presumption in publishing the letters which his father had preserved, knowing that some people thought he 'would be wiser to consign all the letters [he held] to the flames'. Deciding that the letters would settle some of the gossip about Ruskin, MacDonald did include much of the correspondence, with the exception of Ruskin's letters to his father about Rose, because he was 'forbidden by [Ruskin's] late literary executor'.[3] Wedderburn indeed had opposed the whole project. 'Mr. Wedderburn thought the least said the better', MacDonald later wrote to C. Thurston Lilley, then the Librarian of the Ashmolean Museum.[4] By 1947 the Millais family had agreed to release the many letters in their possession between Ruskin and his wife (who subsequently married John Everett Millais) and the exchange of correspondence between Mrs. Millais and Mrs. La Touche in 1868 and 1870 when the latter decided to consult Mrs. Millais about Ruskin's determination to marry Rose. These letters give factual confirmation to the earlier conjecture of

[1] A. Williams-Ellis, *John Ruskin*, p. 265.

[2] *John Ruskin* (New York, 1933), pp. 111–12.

[3] Greville MacDonald, *Reminiscences of a Specialist* (London: George Allen, 1932), pp. 97, 101. His earlier book was *George MacDonald and His Wife* (London: George Allen & Unwin, 1924).

[4] The holograph of this letter, dated 21 Mar. 1935, is bound in the front of the Ashmolean Museum's copy of G. MacDonald's *Reminiscences*. I am indebted to Mr. Timothy Hilton for bringing it to my attention.

Williams-Ellis that the La Touches had been told that Ruskin
was unfit to consummate the marriage. 'From his peculiar
nature he was utterly incapable of making a woman happy',
Mrs. Millais writes to the La Touches. 'He is quite unnatural.'[1]

Derrick Leon in 1949 was the first to cite unpublished
correspondence from Ruskin, Rose, Mrs. La Touche, and
Joan Severn to the Mount-Temples, a group of letters then
(and partly yet) in private ownership, which reveals Ruskin's
agony as he learned of the revenge of his former wife, and
then his anger with Rose as she submitted to the will of her
parents.[2] Working with John Howard Whitehouse, who had
purchased Ruskin's diaries at the sale in 1930, Joan Evans
between 1956 and 1959 edited these diaries which disclose
much about Ruskin's feelings for Rose and her influence on
his mind after her death. The discovery and subsequent
publication in 1969 of Ruskin's correspondence with Mar-
garet Alexis Bell, that Cheshire schoolmistress in whom
Ruskin confided during the 1860s, made available still
another important source.[3]

Although these caches disclosed the main outlines of the
romance, particularly Ruskin's side of it, they still shed little
light on the development of Rose's character or the events as
she saw them. Among all these newly found papers, only
three more letters from Rose to Ruskin appeared. New
biographies of Ruskin followed each of the releases of his
papers, but no writer could know the revelations yet to come.
In all of these studies Mrs. La Touche's attitude on Ruskin
remains a matter for conjecture, and Rose a shadowy figure.
Using the MacDonald papers, R. H. Wilenski (1933) states
that Mrs. La Touche 'may have imagined that all the time
[Ruskin] had really been in love with her. She herself had
apparently been in love with him.' Rose, he says, was 'by
nature rather wild'. Like E. T. Cook, he believes her
precocious, subject to melancholy, a neurotic who continually
brooded on religion.[4] With the availability of the Mount-

[1] Admiral Sir William M. James, *John Ruskin and Effie Gray* (New York: Charles
Scribner's Sons, 1947), p. 255.
[2] Derrick Leon, *Ruskin the Great Victorian* (London: Routledge & Kegan Paul,
1949).
[3] *The Winnington Letters*, ed. Van Akin Burd.
[4] *John Ruskin* (London: Faber & Faber Limited, 1933), pp. 80, 81, 82.

Temple and some of the Millais papers, Derrick Leon (1949) wrote what is still the most complete account of the story. He concludes that neither of Rose's parents realized the nature 'either of Ruskin's feelings for Rose or of Rose's for Ruskin', and that Mrs. La Touche had 'persuaded herself that Ruskin's attentions to her daughter had been an expression of his devotion to herself'. Leon saw Rose as 'always balanced upon the edge of physical and psychic ill health', a girl of wit, exuberance, a penchant for morbid introspection, a combination of 'Ruskin's sensitive social conscience' and a 'fervent belief in dogmatic evangelicism'.[1] Peter Quennell, writing in the same year, believes that Mrs. La Touche 'was not in love' with Ruskin, 'but perhaps she thought she loved him'. He pictures Rose as 'an exceedingly clever girl' who had been 'illuminated by the strange Ruskinian fervour' but failed, sexually and emotionally, to mature.[2] Joan Evans, while editing Ruskin's diaries, also did a biography of Ruskin (1954) in which she describes Rose as 'a neurotic and over-sensitive child', and the tragic love affair as a 'strange affection . . . that provided a backdrop of feeling to the work of all Ruskin's later life'.[3] Neither she nor John D. Rosenberg, who wrote the next major biography, offers a commentary on Mrs. La Touche's relationship with Ruskin. Rosenberg (1961) sees Rose as a 'strange child' who wrote precocious letters but turned into 'a caricature of Ruskin's former . . . Evangelicism'.[4] When he gathered Ruskin's letters to the Mount-Temples (1964), John L. Bradley writes that he still found Rose, the main topic of the letters, 'singularly elusive' (*LMT.11*). In her study of the Severns (1965) Sheila Birkenhead taps the letters from Ruskin to Joan Severn but sees Rose as 'a strange, unworldly, almost unearthly, creature'.[5] Given the unavailability of certain documents, writes Bradley in 1971, the relationship between Ruskin and Rose still cannot be fully understood.[6]

[1] D. Leon, pp. 362–3, 390.
[2] *John Ruskin: the Portrait of a Prophet* (London: Collins, 1949), pp. 182, 154, 170.
[3] *John Ruskin* (New York: Oxford University Press, 1954), p. 289.
[4] *The Darkening Glass: A Portrait of Ruskin's Genius* (New York: Columbia University Press, 1961), pp. 148, 164.
[5] *Illustrious Friends*, p. 164.
[6] *An Introduction to Ruskin*, p. 74.

The diaries of Rose La Touche may be foremost among the documents Bradley had in mind, needed evidence from Rose herself on the issues which have been left so much to conjecture.

B. BACKGROUND TO THE DIARY OF 1861

1. *The beginnings of Ruskin's friendship with the La Touches*

VILJOEN ALMOST certainly assigned the present titles to her transcripts of the surviving sections of Rose's diaries. The first is indeed a 'Journal of Travels in France and Italy', Rose's daily record of her family's tour in the spring of 1861 to the resorts of southern France and northern Italy, an annual holiday for the La Touches. The title of the second section, 'Rose La Touche's Autobiography', as Viljoen pointed out,[1] is only partially accurate as a description of the contents of this diary of 1867. The entries of the first three days do make up a loosely organized essay of about 7,000 words in which Rose takes a retrospective view of her life, but the diary then continues with unrelated events. Rose does not intend the essay to be the full story of her life. Referring to her efforts as 'the history of my Child-life', she restricts her theme to the development of her religious views as a child and the role of the events of 1863 which she describes as the 'crisis of my mental life'. Her essay is thus a spiritual autobiography, a kind of writing which was popular among the churchly readers of *Good Words*, a periodical to which her mother considered sending some of her own literary efforts. Rose may never have intended these pages for eyes other than her own. Her diaries are disappointing in detail. Private notes, they lack polish. 'She writes a great deal at railroad speed', her mother complained of her daughter's need to take more care with her writing.[2] The diaries nevertheless add substance to the lady who, because of Norton's strategy, has been little more than a wraith for Ruskin's biographers.

[1] In her letter to J. H. Whitehouse [Dec. 1949], Viljoen refers to the diary of 1867 as 'what I habitually call Rose La Touche's "autobiography"', and she expresses the hope that Whitehouse 'will agree that my epithet names the significant' part of the manuscript (ALS, Bembridge, L 78).

[2] Letter to Mrs. George MacDonald, mourning stationery, Harristown, Monday, [21 January 1867] (ALS, Yale). Passage cited in D. Leon, *Ruskin the Great Victorian*, p. 361.

Rose's diary of 1861 is written at the awakening of Ruskin's love for her. Now a little more than thirteen years old, she has known Ruskin for at least three years. Ruskin's story of their meeting in *Praeterita* (*35.525-7*) needs only highlighting here with some correction from other sources. Mrs. La Touche had always taken pleasure in drawing, and her interests in art had long made her a reader of Ruskin.[1] She had met him several times, she said later, on her visits to their common friend, Louisa, Lady Waterford. Mrs. La Touche denied Ruskin's story in his autobiography that she had sought him out as art teacher for her three children. 'I would not have dared', she asserted.[2] Her eldest child was Emily Maria (1844–67) who had some artistic talents; then Robert Percy O'Connor (1846–1921) who in future years was to be a suitor for Joan Agnew before her marriage to Arthur Severn; and Rose, whose skill in drawing her mother thought especially worth cultivating. Ruskin, aware of Mrs. La Touche's interest in the artistic instruction of her children, had recommended William Ward, his protegé at the Working Men's College, telling him to 'Draw the ball' with Rose first and 'then casts'.[3] But Mrs. La Touche wanted Ruskin himself to call at their home in Mayfair near the Marble Arch, and she wrote him two 'kind & interesting letters', as she told Lady Waterford.[4] 'I thought I should rather like to', he writes in *Praeterita*, and on his first visit, apparently in January 1858, he found Mrs. La Touche at home with her daughter, Rose, who had to be

[1] To whom she alludes in her novel, *Lady Willoughby; or, The Double Marriage* (London: Hurst and Blackett, 1855), II. 288.

[2] 'Memoir of Percy La Touche', p. 12 (MS., Mrs. Sheila Taylor). The author is unknown.

[3] Letter from Ruskin to William Ward, Denmark Hill, 25 Jan. 1858 (*36.276*).

[4] Ruskin's letter to Lady Waterford, undated but apparently written in January 1858, in *Sublime and Instructive: Letters from John Ruskin to Louisa, Marchioness of Waterford, Anna Blunden and Ellen Eaton,* ed. Virginia Surtees (London: Michael Joseph, 1972), p. 20. The La Touches then were living at 10 Great Cumberland Place. The correspondence at the Morgan library from Mrs. La Touche to Miss Annie Dixon includes letters postmarked from this address in April and May; in a letter dated 14 Oct. [1858] Mrs. La Touche writes that they will be at their new address at nearby 24 Norfolk Street, Park Lane, when they return to London in late November. Ratebooks show La Touche as the ratepayer at the latter address from Christmas 1858 until Lady Day 1863 (Archives Department, Westminster City Libraries, London). Young apparently errs in giving Norfolk Street as the address for Mrs. La Touche's letter to Ruskin written in February 1858 (*The Letters of a Noble Woman*, p. 37).

summoned from the nursery. Ruskin recalls that he found
the mother a good deal more than he expected, 'and in all
sorts of ways'. A lady of thirty-three years, she was extremely
pretty, 'not at all too old to learn many things'. Ruskin, who
was Mrs. La Touche's senior by only four years, wrote his
impressions of her to Lady Waterford soon after making this
call:'What a wonderful creature that friend of yours seems:—
how quick—yet how quiet. I found I could not venture a
word carelessly before her—she saw so quickly when it *was*
careless.'[1] In his autobiography he leaves his memory of his
first impression of Rose when she entered the drawing room.
Her eyes were 'rather deep blue at that time, and fuller and
softer than afterwards. Lips perfectly lovely in profile:— ...
the hair, perhaps, more graceful in that curl round the
forehead' (35.525).

When Ruskin protested that he could not come to their
house to give regular lessons, Mrs. La Touche (he recalls in
Praeterita) 'asked what sort of a road there was to Denmark
Hill'. A visit to Ruskin's home soon followed when Mrs. La
Touche and her daughters were introduced to Ruskin's
mother and given a viewing of the family collection of
pictures, including the thirty Turners. Although the La
Touche house in Ireland was enriched with marbles and
pictures, Mrs. La Touche writes to Ruskin in her letter of
thanks:'You, who live with, and for Art, will not easily guess
how much enjoyment you afforded to me who am wholly
unaccustomed to such an atmosphere—out of Dreamland.'
How she wished that she could show him the Irish coast so
that he might tell the world about the Atlantic as he had
described 'the subdued sea that sleeps round the "Stones of
Venice"'. She knew of a rocky ledge on the West coast of
County Clare where he could see 'the hue of the advancing
wave before it breaks, and when you see the rainbow-tinted
and flying foam caught in the tangles of the red seaweeds,
purer and more beautiful than any earth flowers, you *feel* why
the Greeks brought their Aphrodite out of the sea-foam'.[2] In

[1] Ruskin's letter undated, but apparently written in February 1859, V. Surtees,
Sublime and Instructive, p. 30.
[2] 24 Norfolk St., Park Lane, Feb. 1858, *The Letters of a Noble Woman*, pp. 37–9. For
the address on this letter see n. 4, p. 24.

reply Ruskin says that he will call on the La Touches 'at ½ past one on Saturday unless it's very wet'. He is glad that Mrs. La Touche and Rose enjoyed their visit to Denmark Hill, and he apologizes that his mother will be unable to return their call because of her health. 'But I don't feel any necessity for seeing the sea of your coast—after having it so described to me', he adds.[1]

Mrs. La Touche was the wife of John La Touche (1814–1904), a descendant of a once powerful family of Dublin bankers, who in mid-career was to lose much of his fortune with the decline of private banks and finally the sale of the La Touche bank in 1870.[2] The great house of the La Touches had been founded by a Huguenot ancestor who had come to Ireland to fight with the victorious forces of William, Prince of Orange, at the Battle of the Boyne in 1690. William now firmly seated on the English throne, this La Touche and his fellow French Huguenots settled in Dublin where they introduced from France and the Low Countries the weaving of poplins and linens. With the wealth from these enterprises, the family founded the La Touche bank in Castle Street, and soon became the bankers for the Irish gentry and nobility with correspondents in most of the capital cities. Soon after the middle of the eighteenth century one of the La Touches acquired the vast demesne of Harristown in County Kildare, some twenty miles southwest of Dublin and near the town of Naas, and moved into the substantial three-storeyed mansion built of cut limestone a century earlier on a hill overlooking the right bank of the River Liffey flowing through the property. When John La Touche succeeded to Harristown House in 1844, he was able at least to begin his life here as a typical great landowner of the day, dividing his time between the bank and his passion for horses and fox-hunting. To this estate he brought his bride, Maria Price, the daughter of the Dowager Countess of Desart by her second husband, Captain Rose Lambart Price. La Touche had married Miss Price in 1843 when she was but nineteen, a local newspaper describing

[1] Ruskin's letter from Denmark Hill, undated (ALS, Morgan).
[2] As announced in circular from the La Touche Bank and published in *The Times*, 26 Jan. 1870, p. 6.

the ceremony at fashionable St. Peter's Church in Dublin as
a 'Marriage in High Life'.[1]
 Rose's diary shows new need to understand her father and
his quality of mind. Writers on Ruskin have taken their
estimates of John La Touche's character from Ruskin, Mrs.
La Touche, and her biographer, M. F. Young—all of whom
had reasons to be unsympathetic with him. According to
Young, Mrs. La Touche combined a deep love for Ireland
and its history with 'all that would promote culture and
intellectual observation', but her husband lacked appreciation
for Irish antiquities, was 'never a strong Churchman', and
inherited 'even more than one man's share of the narrow
evangelistic views held by his French relatives' as shown by
his decision to become a Baptist.[2] In the biographies, not
surprisingly, John La Touche appears as a bigot. Derrick
Leon, to cite only one of these writers, says that La Touche
practised his religion 'with the provincial-minded fanaticism
of the fundamentally obtuse'.[3] A return to the primary sources
on the La Touches—a step which the Ruskin biographers
have yet to take—will show the prejudices which have
fashioned this view of John La Touche. Behind Young's
charge, for example, that he was lacking in reverence for Irish
antiquities is the difference in opinion about his decision in
1884 to contribute the stones in the ruins of Harristown Castle
which stood on his property for the construction of Bran-
nockstown National School. Although this donation was
consistent with the philanthropy for which La Touche had
been known, writers in the *Journal* of the Kildare Archaeo-
logical Society periodically castigated him for the demolition
of the site. The castle, one contributor wrote darkly during
La Touche's lifetime, 'was ruthlessly demolished by a La
Touche'.[4] Although his wife joined the Society soon after its
formation, La Touche never added his name to the member-
ship list.

[1] *Freeman's Journal*, 18 May 1843, p. 2.
[2] M. F. Young, 'The La Touche Family of Harristown, County Kildare', *Journal of the County Kildare Archaeological Society*, VII (1911), 40; *The Letters of a Noble Woman*, p. 19.
[3] *Ruskin the Great Victorian*, p. 363.
[4] Archdeacon Sherlock, 'Some Notes on the Fords and Bridges over the River Liffey', *Journal of the County Kildare Archaeological Society*, VI (1909-11), 299.

Indeed he was not an intellectual, as Young describes his wife, but a humanitarian who was to demonstrate a remarkable independence of mind for a gentryman born in Dublin's Merrion Square into wealth and the Church of Ireland. Neither he, his twin brother Robert (1814–46), nor his younger brother William (1815–67) was 'academic' in interest. Although their father had been educated at Eton, the names of these boys do not appear on the lists of any of the leading public schools. Their minds instead ran to the practical and their love of the outdoors and animals. John and Robert tried a year at Oxford but found they had no heads for classical studies. Having first subscribed to their belief in the Thirty-nine Articles of the Church, the twins on 17 October 1833 were listed in the *Registrum Matriculationum* for admission to Christ Church, paid the requisite fees for battels and college dues, £21 for Caution money against breakage of plate, and entered at once into residence as gentleman commoners.[1] John managed during the first term to rate a 'satis' in the Collections Book for his struggles with Demosthenes and Cicero's orations, but his understanding of mathematics went down as 'nihil' and his ability to translate as 'vix' (with difficulty). The Hilary and Easter terms in 1834 went somewhat better, his record showing a balance of studies ranked as 'medio' and 'satis'. After the long vacation he scored 'satis' in his translations of Euripides and the Horation Odes and in his studies of logic, but his own ability to write Latin and Greek remained 'medio'. His brother's record was a mixture mostly of 'non mali', 'vix', and 'nihil'. The Collections Book closes the career of each boy at the end of Michelmas Term 1834 with a discreet 'Abiit' (he departed),[2] and the Cautions Book records the refunding of their cautions money the following May. Their problem apparently was aptitude, not misbehaviour which would have rusticated them from college. The Reports of the Oxford Police for 1834 tell of the usual difficulties of the police with students—gentlemen

[1] For the matriculation of the La Touche brothers, see Oxford University Archives, Matriculation Register, 1810–36, S.W./2/*Infra*/3. For their payment of fees, see the ledger known as *Names on the Books*, lv.c.2; Battels, x.c.350; and *The Cautions Book*, 1805–41, The Library, Christ Church.

[2] For the academic records of the La Touche brothers, see *The Collections Book*, 1810–41, pp. 324, 338, The Library, Christ Church.

throwing water from upper rooms, breaking the windows of public houses, knocking on the doors of common women in the quarter known as Jericho—but the names of the La Touches do not appear among the offenders.[1] It may have been now that John La Touche (perhaps his brothers as well) was given the Grand Tour of Europe.[2]

Their father having inherited Harristown in 1822 when his children were still young, the boys had come to know the country life. By 1836 they were all qualified for election to the Kildare Hunt Club. William is recalled as the best rider of the three brothers, one of the finest houndsmen of the time, and eventually an authority on the breeding of hounds. Robert is recorded as 'a brilliant horseman and one of the keenest sportsmen who ever rode in Kildare'. John La Touche was a 'good if not a dashing rider' and in his youth a fearless hunter, on one occasion leaving his horse to take the fox himself from the hounds. So conspicuous was his devotion to the hunt that in 1841 he was designated Master of the Kildare Fox Hounds. His wife, soon after their marrriage, used her skill with the heroic couplet for good-natured descriptions of the brothers. Addressing Robert as the 'child of frolic and of mirth', she writes of him:

> His thoughts, if thoughts he have, have taken flight,
> To some wild hunting country out of sight,
> In fancy listening to the much loved sounds
> Of horns and trampling steeds, and baying hounds.

She describes the approach of William, the 'sage' endowed with wisdom far beyond his age:

> Walking erect in native dignity
> In his dark eyes strange glimmering flashes glow
> Like watch fires set to scare away a foe,
> Now turned to view the turnip fields around,
> Now fixed in silent thought upon the ground.

Her husband she must leave to other bards for a less biased view of his virtues. 'And for his faults he has no faults to me.'[3]

[1] MSS. Top. Oxon. b. 132–3, Bodleian.
[2] 'Memoir of Percy La Touche', p. 16 (MS., Mrs. Sheila Taylor).
[3] The Earl of Mayo [Dermot Bourke] and W. B. Boulton, *A History of the Kildare Hunt* (London: The St. Catherine's Press, 1913), pp. 149–65. A photograph of William La Touche appears on p. 258.

In 1844, John La Touche held for a year the post of High Sheriff for the County. The gentry, now aware of his talents for public service, designated him Deputy Lieutenant and Magistrate in 1845, Chairman of the Poor Law Union for Naas soon afterwards—responsibilities which he carried for many years.[1]

Like his father, who had not found it necessary to have a University education, John La Touche was a man of the office and field, plain-spoken and public-minded—qualities which his neighbours admired in him. His wife was soon to see some of her husband's interests as his faults. Ten years his junior, she discovered in him, as she said later, 'the blighting narrowness of a life entirely given to sport'.[2] At Harristown the young wife found that she had little in common with the way of life of her husband and the local gentry, and she soon thought of 'Boetia' as a suitable epithet for the dull neighbourhood. In a public letter written in later years and still signed 'By a Dweller in Boetia', Mrs. La Touche wrote that for any one with a 'full share of wits and sensibilities, it is not altogether cheerful to live in a hunting country, where nothing is so much revered as sport.... Society in such a country is reduced to a clique.... If any intelligent outsider strays into the charmed circle—for instance, "a wretched fellow who writes poetry," ... —the hearty desire of his neighbours will be to "heave half a brick at him".' Of the man obsessed with fox-hunting, she writes that he will find that not only does it occupy about three-fourths of his time and cost him more than he can afford, but also the passion destroys 'his taste and aptitude' for many of the other pleasures of which he has deprived himself and his family.[3] In both her novels, *The Clintons* (1853) and *Lady Willoughby* (1855), Mrs. La Touche draws convincing portraits of men of this character. The cold, unimaginative, and tyrannical Lord Rosendale of the first novel thinks only of his hounds and the

[1] See *The Dublin Almanac, and General Register of Ireland, ... 1844* (Dublin: Pettigrew and Oulton, [1844]), p. 231; ibid. (1845), p. 244; *Thom's Irish Almanac and Official Registry... 1850* (Dublin: Alexander Thom, 1850), pp. 492–4, and succeeding volumes.

[2] Letter from Mrs. La Touche to Miss Young, Coniston, 20 July 1883, *The Letters of a Noble Woman*, p. 94.

[3] 'A Protest against Fox-Hunting', *Pall Mall Gazette*, 4 Dec. 1886, p. 4.

hunt. If it was true that in his youth John La Touche was reckless with money and nominal or less in his faith, she may have come even closer to her view of her husband's character in Alan de Vesci of the second novel. Not only a gambler at the Derby and Goodwood, de Vesci is also a man of 'shipwrecked faith'.[1] La Touche came to realize that he would have to give up his hunting. The sudden death of his twin brother in the racing stands in 1864 gave him reason to resign his post as Master of the Kildare Hounds, and he never rode again. A neighbour recalls that some time later, while exercising his own hounds, he observed La Touche's fondness for the dogs, and asked why he hunted no more. La Touche replied, 'I dare not, I dare not'.[2]

His 'rescue' from a life that was 'low' and 'selfish'—the words are his wife's[3]—came about through that prince of Baptist preachers, Charles H. Spurgeon. A writer paying tribute to La Touche during the last decade of his life testifies that he was never ashamed to confess that he had been converted by the Holy Spirit and 'born again'. When La Touche learned that adult immersion was 'the only Scriptural baptism', he was baptized by Spurgeon at the Metropolitan Tabernacle.[4] Another, also writing within La Touche's lifetime, dates this baptism in 1863, probably the early months when the family usually was in London. La Touche had begun listening to Spurgeon in the winter of 1857, and soon he was demonstrating his desire to serve Christ, as the same writer says, through his participation in evangelistic work in London.[5] Early that year *The Times* was reporting various efforts to rid the streets of prostitutes. On 4 February the paper carried a letter from a woman signing herself as 'One More Unfortunate', a former governess but now of 'that abandoned sisterhood', who pleaded pity for these women

[1] *Lady Willoughby; or, The Double Marriage*, I. 229.

[2] *A History of the Kildare Hunt*, pp. 165, 162.

[3] Letter from Mrs. La Touche to Miss Young, Coniston, 20 July 1883, *The Letters of a Noble Woman*, p. 94.

[4] Rufus Church, 'John La Touche, Esq., J.P., D.L.', *Irish Baptist Magazine*, XXII (1898), 184.

[5] 'A Sunday at Brannoxtown', *Freeman*, 5 Jan. 1883, p. 8. For the dating of John La Touche's first acquaintance with Spurgeon, see 'Memoir of Percy La Touche', p. 11 (MS., Mrs. Sheila Taylor).

walking the Haymarket at night, and reminded her readers that 'it was man who made us what we are'.[1] Two days later John La Touche, signing himself 'Amicus', placed a letter in *The Times* to inform this 'unhappy sister that no mortal on this side of the grave need call herself "lost" however far gone in sin'. If this woman would but send her name to 'L.J.', she would retrieve herself, 'and meet with a friend able and willing to help her'.[2] Following an appreciative reply from 'One More Unfortunate', Amicus publicly identified himself and added that since this exchange of letters he had received 'the most heart-rending tales of misery, rendered the more harrowing by the fact that the narrators were once in affluence and luxury'. He offered to disclose the 'sad particulars' to inquirers 'disposed to relieve the distressed and to rescue the fallen'.[3]

Apparently through his efforts the Female Mission Society was formed in London the same year to employ missionaries to assist prostitutes. By 1864, La Touche writes in a pamphlet of appeal for funds, the Society had rescued more than 500 young women 'from open sin'. At the same time he tells of his own work with 'the despairing sinner on the verge of self-destruction' and his visits to 'the dark and dismal garret, by the haunted death-bed of remorse'. Although he knows that sin 'will continue to abound in a world inhabited by fallen humanity', he acknowledges thankfully 'by the Divine blessing, my efforts have not been in vain'.[4] According to a Baptist source, La Touche also interested himself in the London City Mission, an organization devoted to benevolent work among the poor.[5] Through these organizations La Touche became associated with other wealthy men of London drawn into the evangelical movement, leaders like the merchant George Moore, the banker Sir Robert N. Fowler, the brewer and M.P. Robert C. Hanbury.[6] He probably knew the Earl of Shaftesbury who was an ardent

[1]'The Delicate Question', *The Times*, 4 Feb. 1858, p. 12.
[2]'To the Editor of The Times', *The Times*, 6 Feb. 1858, p. 10.
[3]Both letters appear in *The Times*, 6 Feb. 1858, p. 9.
[4]John La Touche, *The Sins and Sorrows of London* (London: James Nesbett & Co., 1862), pp. 10, 12, 5, 8, 6.
[5]R. Church, 'John La Touche', p. 184.
[6]J. La Touche, *The Sins and Sorrows of London*, p. 15.

supporter of the London City Mission and an admirer of Spurgeon.

La Touche probably had been listening to Spurgeon during those early years of his ministry in Southwark at New Park Street Baptist Chapel when he also conducted morning services in the palatial Music Hall in the Royal Surrey Gardens to accommodate the throngs that came to hear him. Hearing Spurgeon's sermons on faith and believers' baptism, La Touche may have begun to experience that spiritual regeneration which Spurgeon preached in 1857 as prerequisite for conversion. Through the Holy Spirit man 'is brought into a new state, there is a change wrought in him—as if a dead post standing in the street were on a sudden to find itself possessed of a soul'.[1] In his powerful sermon, 'A Call to the Unconverted', Spurgeon may have reached La Touche when he asked each in his audience, 'Art thou in Christ or art thou not? . . . Oh! thou that art out of God. . . . All is cursed to thee.'[2] Early in 1858 La Touche could have heard the series in which Spurgeon, an avowed Calvinist, discussed the doctrines of grace, the first on 'Particular Redemption'.

La Touche's embrace of Calvinism was no inheritance from his mother's relatives, as Young suggests, but a genuine response to Spurgeon's arguments. Where his mother's brother, the Archbishop of Tuam and leader of the evangelical party of the Irish Church, had opposed nearly all the political changes in Ireland including national education, La Touche's awakening widened the humanitarian interests that had already been his, opening his eyes to the need for major social reforms. He had long been concerned with the welfare of his farm tenants. During the great famine of 1845, so Young learned from local sources, La Touche had given all the deer in his parks at Harristown to the hungry and allowed only the plainest dishes on his table.[3] Now on intimate terms with John Bright, he supported Bright's proposals for Irish land reform when Gladstone came to office in 1868.[4] The intent of

[1]'The Work of the Holy Spirit', *The New Park Street Pulpit, containing Sermons Preached . . . by Rev. C. H. Spurgeon* (London: The Banner of Truth Trust, 1859), IV. 108-9.

[2]'A call to the Unconverted', 5 Nov. 1857, *The New Park Street Pulpit*, IV. 73, 77.

[3]*The Letters of a Noble Woman*, p. 17.

[4]'Personal Paragraphs', *Evening Telegraph*, 21 Sept. 1904, p. 2.

these measures was to ensure the Irish tenant's possession of the land he farmed as long as he paid his rent, compensation for permanent improvements, and the means of buying the property so that gradually he might become a landowner. La Touche's support of a national system of elementary schools, another of Gladstone's reforms, has already been noted.

It would have been much easier for a great landowner 'to float with the stream', as one Baptist writer said of John La Touche,[1] but the same independence which led to his liberal political leanings now showed itself in his evangelical work with the Irish Baptists who were then only a handful in County Kildare. He may have been the 'friend' whom Spurgeon praised in 1862 for scattering his sermons in Ireland. 'Working with great discretion, he sowed the seed so rapidly in each place, that before the foul bird, the Popish priest, could hasten to stop him, the work was done.... We shall, we are sure, hear of this sowing in years to come.'[2] By the early 1870s he was leading prayer meetings in a cottage near Harristown, and in 1882 he saw the opening of the Baptist chapel and manse which he had constructed at his own expense just outside the Brannockstown gate to his estate.[3] The local school, observed a picturesque writer in 1886, was 'the creation of the "lord of the manor" who has long ago forsaken the chief amusement of the country, the thrice noble sport of fox-hunting, for the pleasures less akin to the delights of this world. On Sunday the congregation of "saints" assembles twice for service at the Baptist chapel... ever attended by the venerable patron and founder of the colony.'[4] La Touche, according to local tradition, sat in the front pew facing the right of the pulpit. Near his feet was the baptistry sunk into the floor in front of the pulpit—the same position as the tank in which Spurgeon had immersed him in the Metropolitan Tabernacle—to which the local converts were led.

But Mrs. La Touche did not share the reality of her husband's conversion to the Baptists. His stand for Christ,

[1] R. Church, 'John La Touche', p. 184.

[2] 'Preface', *The Metropolitan Tabernacle Pulpit, Sermons ... by C. H. Spurgeon ... 1862* (London: Passmore & Alabaster [1863]), VIII. vii.

[3] *Freeman*, 5 Jan. 1883, p. 8.

[4] [Unsigned], 'Day Dawns on the Liffey / From a Tourist in Lotusland,' *Pall Mall Gazette*, 3 Sept. 1886, pp. 4–5.

one writer recalled in a Baptist source at the time of La Touche's death, 'cost him much, even from his own relatives from whom he received no sympathy whatever'.[1] Mrs. La Touche was nevertheless grateful for the change in her husband's character. 'I really do twenty times a day bless Mr. Spurgeon for rescuing the "Master" [Mr. La Touche]', she writes Young in later years, '... enabling him to see the beauty of things he never gave a thought to when young.' However, she adds half playfully, she had 'far rather it had been the Archbishop of Canterbury or even Cardinal Manning'. She learned to enjoy Spurgeon's company when they sometimes met on their winter holidays in Mentone. He may not be in Debrett, she tells Young, 'but wit and wisdom make any man good company: and earnestness about unseen things *always refines*'. Mrs. La Touche could be impatient with some of her husband's charity. '"The Master" has just made me crosser by going and buying at a bazaar for his pet Home for Invalid Ladies a whole sack full of china!' she confides in Young.[2] In 1878 she asks Joan Severn to change the time of her proposed visit because of her husband's appointments with candidates for the ministry of his Baptist flock in Brannockstown. The Master, she says, 'is hunting everywhere for his piggy Baptist minister ... & judging from the conduct of a piggy now sitting close to me ... they come much later & stay much longer than one expects or intends'.[3] Her husband, she observes to another correspondent, was a sort of Pope in Brannockstown.[4] On Sunday they went their separate ways, she to Carnalway Church near which stood the La Touche mausoleum and he to his Gothic chapel for the Baptists about a mile distant.

2. *Mrs. La Touche and Ruskin; the La Touche tour of March 1861*

Maria Price brought to her marriage a background as

[1] 'Death of John La Touche Esq., D.L.', *Irish Baptist Magazine*, XXVIII (Oct. 1904), 231.

[2] The cited letters are dated Coniston, 20 July 1883, and Mentone, [1885], *The Letters of a Noble Woman*, pp. 94, 108.

[3] Letter dated 14 Jan. 1878 (ALS, The John Rylands University Library of Manchester).

[4] Letter to Miss Bishop, Harristown, June 1909(?), *The Letters of a Noble Woman*, p. 164.

different from her husband's as her temperament. In her
youth she had had the advantages of association with the
Cuffes, the family of her mother's first marriage. A titled and
cultivated family devoted to public life, they had held a grant
of lands in County Kilkenny since the days of Cromwell.
Maria had spent her girlhood at Desart Court, where she had
been born in 1824, because her father, Captain Price, the son
of a wealthy and educated Cornish family, had died soon
after her birth. Twice widowed, the Countess of Desart now
gave herself to her two children, the first a son by her first
husband (the Second Earl of Desart), providing each of them
with the best of educations. This half-brother was the
companion of Maria Price's youth, and it was to him that she
dedicated *Lady Willoughby* in memory of the happy days
which they had spent at 'The Old Place'. When he died in
1865, she wrote the George MacDonalds that Otway had
been 'the object of all my faith & adoration for half my life.
There certainly never was a more beautiful youth than his, or
a truer or simpler nature.'[1]

Their cousin who lived nearby, William O'Connor Morris,
recorded his memories of Desart House with its Italianate
façade of Kilkenny marble, the 'large gardens and far
extending avenues, the favourite Irish beeches dotting the
adjoining lands, and edged at one side of the park by a forest'.[2]
The ground-floor, according to another source,[3] included a
wainscoted hall hung with the family portraits and a library
whose books were protected by wire doors over the presses.
Morris recalled that in her house the Countess set a high
standard of taste. Although she had much company, the
living was devoid of 'vulgar displays of extravagant finery'.
The house was famous for its private theatricals.[4] The two
children must have owed much of their love of literature to
these years, as Mrs. La Touche acknowledged.[5] In her novels
she quotes extensively from the poets ranging from Petrarch

[1] Harristown, postmarked 21 June 1865 (ALS, Yale).
[2] William O'Connor Morris, *Memories and Thoughts of a Life* (London: George
Allen, 1895), p. 41.
[3] *A Page from the Past: Memories of the Earl of Desart by Himself and His Daughter
Lady Sybil Lubbock* (London: Jonathan Cape, 1936), p. 188.
[4] W. Morris, pp. 42–3.
[5] *The Letters of a Noble Woman*, p. 8.

to Wordsworth, Byron, Shelley, and Tennyson. Otway Cuffe, in later years, was to trace his love of poetry to his father.[1] The Countess had sent her son to Eton and then Oxford where he had matriculated with Ruskin for Christ Church in October 1836, Ruskin recalling him as a youth of 'bright promise' (*35.209*).

Under the provisions of her second husband's will, Lady Desart was to have their daughter spend six months of every year in England, a stipulation which the Countess carried out by spending the winters in Brighton for Maria's education. Here she provided her daughter with the best masters Brighton could produce, and the graces which came with the social life, including some association with Royalty when they were in residence at the Chinese Pavilion. Botany, drawing, languages, and writing poetry were among Maria's early interests. Like her neighbour, Frances Power Cobbe, who was also educated at Brighton during these years, she suffered from the strain of her studies and ended her formal education, although only fifteen, following a tour on the Continent in 1839. Again like Miss Cobbe, she then furthered her studies independently.[2] In 1842 she had a fashionable 'coming out' in London, accompanied by a series of balls at Almack's and presentation to the Queen. She may have met John La Touche the same year when she and her mother moved to Wicklow.

Of these parents Rose was born on 3 January 1848—this date established through her diary.[3] Mrs. La Touche provided her daughter with the same kind of private education which she had received. Like the children of most upper-class families, Rose spent her infancy and early childhood with

[1] W. Morris, p. 79.

[2] For Miss Cobbe's recollections of Brighton, see *Life of Frances Power Cobbe, By Herself* (Boston: Houghton Mifflin, 1894), I. 49 ff.

[3] I have been unable to locate any other record of her birth. Parish records in St. Patrick's Church, Carnalway, which Mrs. La Touche attended, fail to list Rose's date of birth or baptism. Both the Public Record Office and the Registrar General, Dublin, inform me they have no record of her birth. Her age has been hitherto a source of confusion for the biographers. Ruskin in telling of his first acquaintance with Rose makes her a year younger than she was in fact when he states that on 3 Jan. of that year she was but nine years old (*35.525*). M. F. Young may have taken her clue from Ruskin when she erred in giving 1849 as the year of Rose's birth (*The Letters of a Noble Woman*, p. 6).

nurses in the small world of the nursery and school room in
Harristown House, where she traces her first glimmerings of
religion to the pious books for children by Lucy Barton.
When Rose was four years old, she writes in her diary, Miss
Bunnett entered the household as governess, a cultivated
woman 'of great sense and power', so Ruskin describes her,
whom the family came to appreciate for her 'native wit and
strength of character'. She was loved by Mrs. La Touche as
well as the children, the mother often placing herself in the
schoolroom 'no less meekly' than the children—partly in play,
Ruskin observes, but genuinely impressed by 'the clear
insight of the fearlessly frank precepteress into her own faults'
(*35.528*). It was Miss Bunnett, according to Rose, who first
taught Rose the significance of Christian love, and led her to
quell the naughtiness of her earlier impulses. Although Rose
did not think of herself as 'quick' in her studies, and Ruskin
asserts that she was not precocious (*35.533*), her diaries and
her letters show that she had more than common interests in
reading and writing poetry and allegorical stories, and that
she was well instructed in French, German, music, dancing,
drawing, and later in some branches of natural science. It
seems probable that during their annual visits to London in
the winter Mrs. La Touche established the pattern of
employing specialized tutors for her children. They also had
the advantage of frequent foreign travel.

 Rose lived her childhood through years of stress between
her parents. When Ruskin in the early months of 1861 was
telling Mrs. La Touche something of his rejection of the
Calvinist views of his youth and his new religious doubts—
'terrible discoveries', so he describes to Norton the investiga-
tions he was making 'into grounds of old faith'[1]—he found in
Mrs. La Touche a listener who was well prepared to
understand the struggles of the soul to find and hold its own
grounds. Although she had persuaded her husband to give
up his interests in hunting, she was still aware of their
differences, and she remained unreconciled to the life of their
neighbours. The Rector of her church recalls she was
'certainly not understood in Kildare', she lived in a different
world of thought, 'and like most persons of genius, very much

[1] Letter from Ruskin, [Denmark Hill], 25 Feb. 1861 (*LN1.106*).

alone'.[1] Not even close friends could conceive the kind of existence which had always been hers at Harristown, she tells Mrs. MacDonald later. In another letter she speaks of the starvation from which her life had suffered. 'I cannot care for the people I am obliged to exchange visits and dinner with. It's not because they are stupid, but because they are not simple. They are like the Tom-cat & the Hen in the story of the Ugly Duck.'[2] Her new conflict with her husband over Spurgeon's influence enabled her to understand the withering constraints of which Ruskin complained in the Calvinist religion of his mother. Thinking of the Calvinist stress on the utter depravity of man, Mrs. La Touche uses a derisive tone in telling Mrs. MacDonald in 1865 of their having met an Arab in Scotland who had been brought up 'a sort of Christian' but recently had been 'converted' and taught 'how badly God made him'. And like her husband, she adds, 'he is not very much the worse for his mistake'. She had always been hostile to religious narrowness and exclusiveness, so her Rector observed.[3]

At the same time she had ever been a lover of the Church of Ireland, a loyalty which would alert her to the dangers of Ruskin's doubts. In both her novels suitors of little faith try to lure into marriage beautiful but devout young ladies who are saved only by their faith. The reckless Sir Aubrey Howard of *The Clintons* 'endeavoured to keep all his promises, save his baptismal vows. Of these he never thought.' The dutiful Alice Clinton, following prayers in St. George's Chapel, turns down Sir Aubrey's proposal for marriage. '"Alice," he said slowly and falteringly, "is it then all over? will you *never* bid me hope?" "*Never*," was her firm and distinct reply.'[4] In a sub-plot of *Lady Willoughby*, the profligate atheist, Alan de Vesci, pursues the beautiful Florence Moray, a devout Scottish Episcopalian. Florence, overhearing Alan argue with her brother about the latter's religious faith, is stunned when she hears Alan declare that as a non-believer he sees nothing

[1] *The Letters of a Noble Woman*, p. 19.
[2] Both letters from Harristown, 14 Mar. [1865] and Tuesday, [probably 1866] (ALS, Yale).
[3] *The Letters of a Noble Woman*, p. 20.
[4] *The Clintons: or, Deeps and Shadows of Life* (London: Richard Bentley, 1853), I. 182, 211.

sacred in the vows of marriage. Paralysed by the fearful meaning of these words, Florence feels a 'sudden night' fall upon her soul. 'He must not think that I would marry an infidel', she writes her confidante. Still she agrees to a secret engagement until her father reminds her that Alan is not a Christian. In her farewell note to Alan which leads to his suicide, she writes: 'A light is wanting in your life—a higher light than any human happiness.'[1] Although Mrs. La Touche told George MacDonald that her novels were crude and had little to recommend them, she clearly regarded her writing as a reflection of her inner convictions.[2]

Unable to win over his wife to the Baptists, John La Touche turned to his youngest child as a 'true prize' —Spurgeon's epithet for a convert. In Rose, already a lover of religion as she described herself, he found an attentive conscience. 'I listened,' she writes in her diary of these early years, 'and took in all my father's doctrines.' The key for Spurgeon's beliefs was the Bible, 'the writing of the living God: each letter ... penned with an almighty finger', as he had declared in an early sermon.[3] La Touche told his daughter that in the Holy Word she would find the 'one rule for conduct' and purpose in life. 'Papa said that the Bible was the great, important study, and in my playtime, ... I sat and read it.' The search for the Holy Spirit through prayer, the desire to live in holiness—common themes in Spurgeon's sermons—dominated her thoughts. Coming down from the playroom to her father's room, she told him of her experiences with prayer, her loss of satisfaction with the games of childhood, and her discovery of the sinfulness of many of her earlier pleasures. Her one aim, she writes in her diary, was that 'of being perfect'. Gradually she learned that within herself were 'two natures' whose struggle gave her headaches. 'I was not often happy', she observes in her diary.[4]

La Touche's influence over Rose could only have deepened his wife's alienation. Mrs. La Touche's diaries have since disappeared, but Young observes that during the early 1850s

[1] *Lady Willoughby*, I. 201, 229–30; III. 56, 62.
[2] Undated letter postmarked Newbridge, 10 Oct. 1863 (ALS, Yale).
[3] 'The Bible', sermon preached 18 Mar. 1855, *The New Park Street Pulpit*, I. 110.
[4] *Rose La Touche's Autobiography*, see below, pp. 173–4.

they were little more than records of her children's education. Her other interests which 'were not likely to find general favour', as Young notes, went unmentioned. In her isolation Mrs. La Touche tried to form a small society of the more intellectual ladies in the neighbourhood who affected classical names, Mrs. La Touche calling herself Alethea perhaps to suggest her truthfulness, until local ridicule made them disband.[1] Beside her novels, written during these years, her private poetry seems to be a key to her unrest. She composed in 1856 a long poem which even seven years later she would not show to the MacDonalds because (she told them) they 'would understand it too well' and would be 'too rightly shocked at the tale it tells'.[2] 'Scenes by Moonlight' is the poet's vision of an anguished lady with a secret lover. If the story is literally Mrs. La Touche's recent life, it suggests that during these unhappy years she found a lover or yearned for an earlier suitor she would have preferred to John La Touche. The lady of the poem throws herself upon the moor and pours out her grief.

> Her tears fell fast upon the withering heath blooms,
> And in the cool green moss her feverish hands
> Made wild destruction. 'Twas a mood of madness
> Of fierce rebellion against destiny,
> Of passionate regret that could not hope.

The lover, ''Tho he had sinned & lived among the sinning', yet was 'good & true', and resolves never to cast 'One tainting shadow on that soul whose radiance / Albeit so faint & flickering, was to him / A revelation'. Now, after five years of this vain pursuit, the lovers realize that they must part, unable to bear the 'fatal strife' any longer.

> 'Twas a conflict
> So dark & terrible no words of mind
> That anguish could record—but it was over:
> They had resolved: and now their hallowed love,
> A white robed martyr rose to meet her doom.[3]

To Lady Waterford only four years later Mrs. La Touche

[1] *The Letters of a Noble Woman*, pp. 16–17.
[2] Letter from Mrs. La Touche to George MacDonald, 10 Oct. 1863 (ALS, Yale).
[3] 'Scenes by Dreamlight', Mar. 1856 (MS., Yale).

compared her life to that of a black beetle crouching in the shadow.[1]

John La Touche shared his wife's concern about Ruskin's new ideas. La Touche, Ruskin writes Norton on 25 February 1861 in a passage which the latter omitted from his edition of Ruskin's correspondence, was 'a staunch—narrow—unimproveable evangelical of the old school' who 'fears my influence over Rosie'.[2] Although Mrs. La Touche, according to her Rector, believed that 'there is something to be said for most heresies',[3] confronted with these dangerous notions in Ruskin she began to extract promises from him that at least he would keep his ideas to himself. Her caution had not stopped his advances. To Norton in the same letter of 25 February he writes (in another passage which Norton largely excised) that he did not know what would have become of him 'if a little child . . . had'nt put her fingers on the helm at the right time; and chosen to make a pet of herself to me; and her mother to make a friend of herself'. He found Mrs. La Touche 'certainly the ablest and I think the best—woman I have ever known. She has been watching me carefully; and I've promised her that I'll never do anything to vex her, or make little Rosie sorry in her after life that she had once been my pet.'[4]

Mrs. La Touche in the spring of 1858 had been sitting for her portrait by the miniaturist Annie Dixon with whom she seems to have had some affinity of spirit. 'I want to sit *with* you as well as to sit *to* you—& abuse London & talk of butterflies. I mean those that have not fashions, but wear the same plumed wings now as when they were created. There are butterflies enough here, but not the Psyche sort', she writes to Miss Dixon on 13 April. Her mood is even more apparent in her letter of 5 May: '. . . if I wrote you out of my inner self, I would see the ghost of it in your face & it would frighten me'. For this sitting in her home, she assures Miss Dixon that 'if people come whom you don't want to look, they shall not

[1] Augustus J. C. Hare, *The Story of Two Noble Lives* (London: George Allen, 1893), III. 80.

[2] [Denmark Hill] (ALS, Norton Papers, Houghton).

[3] *The Letters of a Noble Woman*, p. 19.

[4] Norton Papers, Houghton. Partially cited in *LN1.107*.

obtrude themselves in your realm—& we will take our chances together of Mr. Ruskin's attention!'[1] But Ruskin's interest in the family seems to have developed slowly; only in later years did he write 'The Beginning of Sorrows' as a footnote to the London address of John La Touche which he found at the end of his diary for 1858.[2] His correspondence and his diaries for that year and the next contain almost no allusions to the La Touches other than those letters marking the start of his acquaintance. The diary of John James Ruskin for 1859 records only one visit of the La Touches at Denmark Hill, a lunch on 20 April.[3]

During 1858 Ruskin's attention had been on the herculean task of sorting the many drawings in the Turner bequest which were mildewing in the National Gallery, and then on his studies for the last volume of *Modern Painters*. Each project had included a disillusioning discovery, the first that among the sketchbooks of his idol were drawings which Ruskin and Ralph Wornum, Keeper of the National Gallery, considered obscene. In December the Keeper decided to burn them. Ruskin, convinced that Turner could have made the sketches only in moments of a kind of insanity (so he wrote Wornum later),[4] agreed to witness the conflagration—a rash destruction which seems to have haunted his dreams even a decade later.[5] The second project included one of the turning points in Ruskin's life. Travelling alone that summer, he was in Milan at the Palazzo dell' Accadèmia, viewing Veronese's painting, *The Queen of Sheba before Solomon*. He was overcome, he said, by what he called 'the old article of Jewish faith, that things done delightfully and rightly were always done by the help and in the Spirit of God'. Within the hour, his 'evangelical beliefs were put away, to be debated of no more' (*36.496*).

[1] ALS of both letters, Morgan. Miss Annie Dixon (1817–1901) exhibited the miniature of Mrs. La Touche at the Royal Academy in 1861 (Algernon Graves, *The Royal Academy of Arts. A Complete Dictionary of Contributors . . . 1769 to 1904* (1905–6; rpt. New York: Burt Franklin, 1972), I. 336).

[2] From the MS. of Ruskin's diaries, Vol. II, 117, MS. 11, Bembridge. Passage omitted from *The Diaries of John Ruskin*.

[3] MS. 33, Bembridge.

[4] Letter dated 3 May 1862 (ALS, The National Gallery, London). Cited in *Turner News* (Apr. 1976), p. 43.

[5] Entry for 7 Dec. 1869 (*D2.690*).

The resolution had brought him no happiness. Purpose was lacking in his life, he writes to Norton in December 1858, and he was beset by melancholy (*LN1.77*). He had no expectations of love. 'I shall never devote myself to any woman—feeling, whether erringly or not, that my work is useful in the world and supposing myself intended for it', so he writes to a lady correspondent.[1] He gave the following year to further studies for his book, travelling abroad in the summer with his parents to acquaint himself with the German picture galleries. Norton is his only friend, Ruskin tells him in August. 'I don't believe in Evangelicism—and my Evangelical (once) friends now look upon me with as much horror as on one of the possessed Gennesaret pigs' (*LN1.84*). Back home by October he soon wrote to Lady Waterford that he was 'every way out of heart. Would you kindly send me Mrs. La Touche's address in Ireland? I want to write her' (*35.325*).

On 26 January 1860 Thackeray's daughter wrote in her Journal that Ruskin had told her that day: 'I am perhaps one of the most unhappy men in the world just now.'[2] But in the La Touches, who had returned to London for the winter months, Ruskin found the attention which he needed. Now he saw more of the family. The diary of John James Ruskin shows that in April 1860 John La Touche called at Denmark Hill, and for a family visit two weeks later it reads: 'La Touches here'.[3] Meanwhile his son was forming a dislike for John La Touche, telling other correspondents as early as February 1860 that he was a 'staunch Evangelical of the old school'. Ruskin could see that his influence was causing dissension within the family. 'Rosie, believing in him [her father], & her mother & me, is growing up quite a little Cerberus, only her mother and I make two heads bark one way; but the third barks loudest.' She would believe Ruskin, he adds, if he 'did not every now and then say much out of the way things'. Meanwhile she petted him 'as she would a panther that kept its claws in—always looking under the

[1] Letter to Mrs. Hewitt, n.d. (ALS, Morgan).
[2] Hester T. Fuller and Violet Hammersley, *Thackeray's Daughter* (Dublin: Euphorion Books, 1959), p. 145.
[3] MS. 33, Bembridge.

claws to see that the velvet is all right & orthodox'.[1] At some
point in 1860 Ruskin, perhaps as reassurance, presented Rose
with a small fifteenth-century Primer from his growing
collection of manuscripts. Ruled with gold lines and written
in silver ink, the four folios begin with the alphabet and then
provide the text of several prayers in Latin including the
Pater Noster and the Apostles' Creed. The initials of some of
the verses are illuminated in blue and gold, the lower margins
are decorated with elaborate line swirls of silver—a precious
gift that would attract the eyes of this artistic and devout child
of twelve.[2]

Although Mrs. La Touche feared the direction of Ruskin's
doubts, she had found in him an ally in her conflict with her
husband over Spurgeon and his Calvinism. While the great
preacher had been making his way to John La Touche, he
had quite another effect on Ruskin who also had been among
his listeners. 'Very wonderful', Ruskin writes in his diary
after hearing Spurgeon in February 1857 (*D2.526*), and he
sent the preacher a copy of the recently published fourth
volume of *Modern Painters*, inscribed 'with the author's
sincerest regards' (*36.297*n.). The following January, the
month of his first visit to the La Touches, he had a change of
mind. Spurgeon's doctrine, he tells the Brownings, 'is simply
Bunyan's, Baxter's, Calvin's, and John Knox's—in many
respects not pleasant to *me*, . . . Evangelicism . . . is, I confess,
rather greasy in the finger; sometimes with train oil; but
Spurgeon's is olive' (*36.275–6*). In the succeeding weeks, as he
again writes to the Brownings, he finds Spurgeon in his
sermons on grace 'a little bit emptier than he was at first: he
ought to be shut up with some books . . .' (*36.279*). Ruskin was
taking little care to conceal his antipathy for Evangelical
doctrine. Of the Revd. Daniel Moore, the incumbent of
Camden Chapel in Camberwell, he demands in 1859 how he
could think of 'going primly up to that tidy pulpit of yours
. . . to tell, every Sunday—your prim congregation how God
managed the Atonement— . . . I believe the whole modern

[1] Ruskin's letter to the children at Winnington Hall, Denmark Hill, 19 September
1860(?) (*WL.226*).

[2] Plimpton No. 287 (MS., Columbia University Library). For provenance and
description of this manuscript, see James S. Dearden, 'John Ruskin the Collector',
Library, XXI (June 1966), 147.

doctrine of Salvation to be an accursed lie.'[1] But Ruskin's differences with Rose's father did not thwart his growing feelings for her. 'I've got a dear little one however whom I'm really *very* fond of ... who writes for me the prettiest little poems you ever heard', he writes in a private letter of April 1860 (*WL250*).

The winter and spring months were fruitful for Ruskin, as he prepared the last volume of *Modern Painters* for the press and wrote the four brilliant essays on political economy titled *Unto This Last*. He spent the summer of 1860 sketching in Switzerland with the young American artist, W. J. Stillman. At the same time he was exchanging letters with Rose who was now at home in Ireland. Another letter from Rose, he confides to friends that summer, in which she says, '"I'm so *madly* glad to get home"' (*WL266*). These were sensitive days for her mother. 'I have been longing to watch the awaking of the world on a summer's morning', she writes to the Countess of Desart in July. 'So last night when everybody was put by, I went into an empty dismantled room, and there I sat courageously alone till 2 A.M., when I stole down, unbarred the door and got out. . . . It was delicious.'[2] A dreary autumn lay ahead for Ruskin at Denmark Hill. On 4 September his father records in his diary: 'Mrs. Ruskin fell on Dressing Room steps, fracture[d] neck of thigh bone.'[3] By October Ruskin describes himself in a 'languid state of mind and evil state of temper'. A prisoner of his parents he is now 'fastened' at home (*WL272*).

The La Touches, again in London for the winter, became frequent visitors at Denmark Hill. On 8 January 1861, according to the diary of Ruskin's father, Mrs. La Touche, her daughter and their governess, Miss Bunnett, called. The next Sunday Ruskin went to church with them. On the 25th the La Touches had lunch and tea at Denmark Hill. A few days later Ruskin dined at their house. His counsel on Rose's education was going beyond instruction in drawing, as he urged her to study geology and attend the lectures of Sir Richard Owen at the British Museum. Impressed with

[1] Letter from Brussels, 22 May [1859] (ALS, Morgan).
[2] *The Letters of a Noble Woman*, pp. 40–1.
[3] MS. 33, Bembridge.

Ruskin's scientific knowledge, Rose gave him the pet-name of 'Archigosaurus'. More pet-names grew out of their intimacy, Rose dubbing Ruskin 'St. Crumpet' as a parallel to 'Bun', her pet-name for her much-loved governess. Ruskin named Rose his 'Rosie-posie' or 'Irish roses', and in her confided his private thoughts. She knew of his mood at home where he sat like a sulky kingfisher on a branch. 'Don't be kingfishery dear St. Crumpet', she would caution him in her letter of 18 March 1861. On his plan to part with some of his paintings, she comments in the same letter: 'how good it was of you to give yr Turners that you love so much to the Oxford Museum' (*35.531*). Thus, as Ruskin says in *Praeterita* of this winter, 'things went on' (*35.529*).

In March the La Touches planned their usual sojourn on the Riviera, touring by railway from Calais to Paris and then to Marseilles and Toulon where they would post to Fréjus, Cannes, and Nice. This year they were to extend their tour into Italy to visit Mentone, Genoa, and Florence. Twice during February, according to the diary of John James, the La Touches visited Denmark Hill, once for tea and a few days before their departure Mrs. La Touche and the girls for dinner. Ruskin busied himself telling the girls which of the paintings by Titian and Veronese they should see in the Louvre, the statues—particularly the Venus of Melos; and he prepared them for some of his favourite views in southern France, especially the beautiful pass of the Estérel mountains above Fréjus. He and Rose agreed to exchange long diary letters during their separation. For Ruskin there was 'the comfort . . . that Rosie was really a little sorry to go away', he recalls in *Praeterita* of her departure; 'and that she understood in the most curious way how sorry *I* was' (*35.529*).

Rose begins her diary on 7 March, the day of the family departure to Dover. On 18 March she writes from Nice the letter to Ruskin which he includes in *Praeterita*, the first long letter he had received from her as he later told Mrs. La Touche.[1] The diary and the letter should be read together. Although Viljoen's transcript of this section of Rose's diary

[1] In his letter to Mrs. La Touche from Brantwood, 5 Dec. 1881 (J. H. Whitehouse, 'Ruskin in Old Age: Some Unpublished Letters', *Scribner's Magazine*, 62 [1917], 741).

carries the notation in her hand, 'My copy from her Diary', her transcript, in my judgement, is incomplete. Only the later diary of 1867 does she say she copied complete, as already shown. Comparison of the first diary and her letter to Ruskin suggests that Viljoen copied from the diary mostly those sections which add information not included in the letter. The entries for 14 and 15 March, for example, begin with long dashes, probably Viljoen's signal for an omission, and only the ending phrases of sentences. Where the letter begins the story of the tour from Dover, the diary tells of preceding events, and adds detail about the crossing to Calais. The diary shows more of Rose's immediate responses to the pictures and statuary at the Louvre. Since the letter tells of the railway ride to Toulon and the sunrise the next morning, the transcript includes only details about these days. The diary adds to Rose's account of their visit to Fréjus and the Estérels. In her letter she despairs of describing the beauty of the Pass. '*You* the author of M-Ps cd describe it Irish roses can't.' From the diary we learn of her experiences after 18 March.

Both the diary and the letter reveal the charm which Ruskin found in Rose. Her sincerity, fervour, daring, and whimsicality, her intelligence, love of literature and nature, her facility with language, her feeling for grace and the ideal—all of these qualities come through her writing. She was 'a very lovely girl', one of her acquaintances recalls after her death, one who chose 'all knowledge for her province, ... She was very brilliant in conversation, and had an encyclopaedic memory.'[1] Ruskin later wrote that any girl 'of real power' could write about art and nature as Rose did, but her sympathy for the reader was the unique quality of her letters. 'There is not a sentence in which the child is thinking of herself. She knows exactly what *I* am thinking, and thinks only of that, without a shadow of vanity, or of impulsive egoism' (*35.533*). In her diary she records her thoughts of Ruskin as she travels to Dover. At the Louvre, she keeps in mind what 'Mr. Ruskin' told them to see. 'Who but the golden-mouthed author of Modern Painters could describe the scenery?' she asks as she thinks of the road to Genoa. In Ruskin's letter to Rose, he apparently had written of his unhappiness, his wish that he could be her parrot (not

[1] *The Freeman's Journal*, 27 Nov. 1906, p. 7.

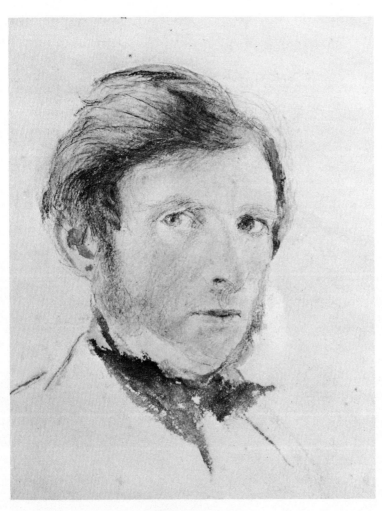

John Ruskin, 1861
Self-portrait

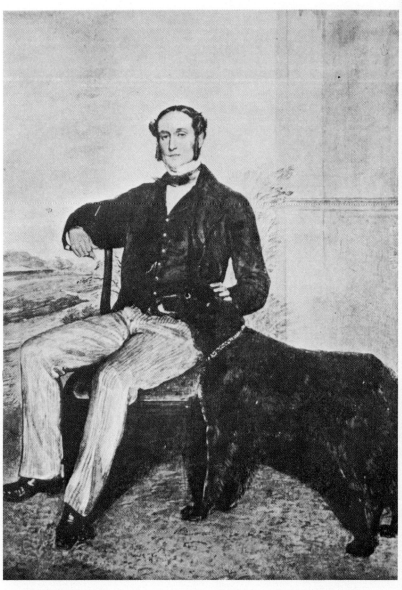

John La Touche, Master of Fox Hounds for Kildare, 1841–46

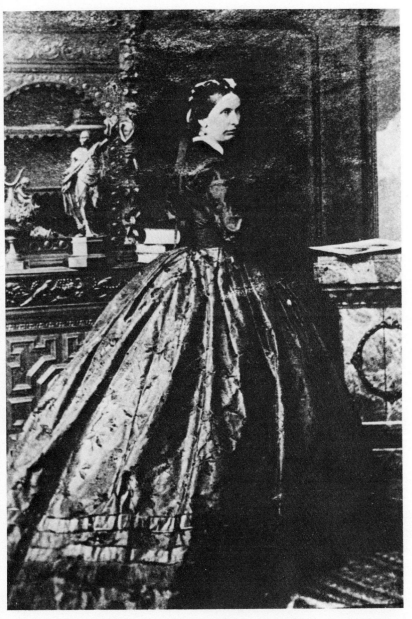

Mrs. Maria Price La Touche (undated)

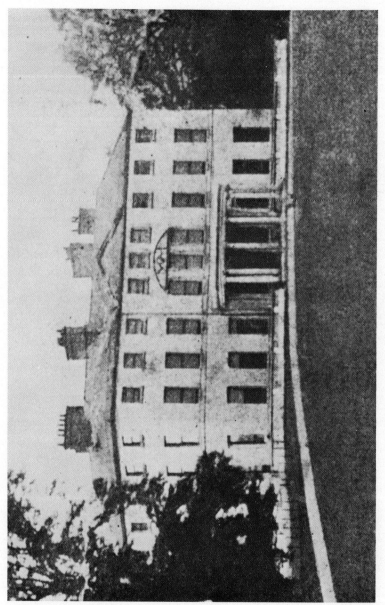

Old Harristown House, destroyed by fire in 1891

her father's, he comments acidly later). 'Oh St. Crumpet I think of you so much & of all your dearnesses to me I wish so very much that you were happy—God can make you so', she writes to Ruskin. They had all thought about him on the journey. Aware of his interest in sea-waves which he had been unable to pursue in the fifth volume of *Modern Painters* (7.7), they had studied the waves as they crossed the channel. If he had asked her to draw them, 'I'd have tried to do it St. Crumpet—'. The sunset at Nice made them think of Ruskin's drawing of the sunset over the towers of Beauvais (7.*Plate 66*). 'How can you wish to be a parrot—', she asks, 'are you not our saint[?]' Knowing that among her friends Mrs. La Touche was nicknamed 'Lacerta', Rose writes to Ruskin of the lizards they saw at Toulon. '. . . oh Archigosaurus we saw so many Lacertas there; again we thought of you—'. This nickname signified that Mrs. La Touche 'had the grace and wisdom of the serpent, without its poison'. Ruskin made this graceful explanation in *Praeterita* (35.529), where he chose to forget the painful years when he had tasted the venom of Mrs. La Touche's revenge.

C. BACKGROUND TO THE DIARY OF 1867

1. *Ruskin's visit to Harristown in August 1861, his promise to Mrs. La Touche*

ON New Year's Day, 1867, when Rose at Harristown began writing her autobiography, Ruskin at Denmark Hill wrote '733' opposite his diary entry for that day to record the number of days left before Rose would become twenty-one years of age and free to make up her mind about the proposal for marriage which he had made to her on 2 February of the preceding year. At the same time he opened his Bible to Hosea 3:3 where Jehovah tells the prophet that he is to have a second marriage, and Hosea assures his beloved, 'Thou shalt abide for me many days'.[1] For Ruskin it was a time of waiting and hope. For Rose, approaching her nineteenth birthday on 3 January, it was a time of renewed resolution as

[1] D2.607. For the numbering of the diary entry, see the MS of the diaries at Bembridge, vol. 14, opp. fol. 45, MS. 14, Bembridge.

she chose for her text for the year, 'He that is faithful in that which is least is faithful also in much' (Luke 16:10). On her birthday she hung up the illuminated maxim which she had just received as a gift from Joan Agnew, 'God *is* your Guide'— to her a reminder of the lesson she had learned from the crisis of her mental life (as she calls it) of 1863 which she has been analysing in her diary. Having come up from the pit of tensions brought on by Ruskin and her parents, she has reason to record in her diary her mood of thanksgiving.

Ruskin's visit to Harristown in late August 1861 deepened his feelings for Rose and brought to a head Mrs. La Touche's determination that Ruskin should curb his attacks on religion. His visit also could have fanned John La Touche's apprehension about Ruskin's influence over his daughter. By mid-May the La Touches had completed their travels on the Continent and were back in Ireland. Ruskin and Rose were exchanging weekly letters. In March he spoke to his father of Rose as his 'only pet' (*WL.207*). By July he referred to her correspondence as 'Rosie's love-letters'.[1] Ruskin went to Boulogne in June for a rest of several weeks, his mind alert to reminders of Rose. 'The first fishing boat I saw in Boulogne harbour was "Rose Mysterieuse" ', he writes seven years later to Joan. His first sketch there, he also recalls, was at the 'Port d'Amour'. Now he would take the irony 'with the rest of life as a jest, or a dream'.[2]

Only one letter in Ruskin's hand to Rose is extant, and only half exists as he intended to send it to her, the other half surviving as his copy of the original. Writing from Boulogne on 22 June, where he had gone for a rest of several weeks, Ruskin tells his father that he is enclosing 'half of a letter begun to Rose last night, but so ill written: half asleep, and with a mistake in it besides of Christ's words Mark 4:28 for St Pauls that I can't send it'. By 25 June he had rewritten the letter and thinking that 'Mama may like to have the continuation' encloses for her his copy of the other half.[3]

[1] Letter to his father, Boulogne, 14 July 1861 (ALS, Yale). Subsequent citations from Ruskin's unpublished correspondence with his father at Yale usually will be identified in the text by date, sometimes within parentheses.

[2] Abbeville, [26] Aug. 1868 (ALS, L 33, Bembridge).

[3] Ruskin's editors present the letter as a whole in *36.368–72*, but without note of Ruskin's intention of correcting the error in his commentary on Mark. The passages

(continued)

Much of the letter is a charming account of his friendship with the Hurets, a fisherman's family near Boulogne, and particularly of his attentions to the two girls who were only a little younger than Rose—a friendship which was to arouse Rose's jealousy. The letter also contains a subtle justification of the changes in Ruskin's religious faith. In his parables on the Kingdom of God, Jesus had dramatized the faith of maturity. From the seed comes 'first the blade, then the ear, after that the full corn in the ear'.[1] Ruskin tells Rose, 'We thought the green was good—but it passes: we thought the gold was good but the winds carry it away and it is gone.' Only the white grain that survives the millstone at the last is good. Significantly, on the other side of the road from the wheatfield which had suggested these thoughts was a rose hedge which also led Ruskin 'into some reflections upon the symbolism and destinies of Roses; but as these could not be of the slightest interest to you, Pet, I shall not set them down'.

Ruskin disturbed his father in July with the news that he had received 'a very earnest invitation from the La Touche's for the month of August,—after the fuss of the court visits are over'. Two days later, 23 July, he explains that he did not mean that the invitation was *for* the month but *in* it. 'But I have no intention, in any case, of going for more than three or four days. . . . I know well, much too well, that I am 42 and that neither riding nor dancing is good for me.' The court visits were the arrival of the young Prince of Wales in late June for several weeks of military training on the plains of the Curragh a few miles from Harristown, and on 22 August the landing of the Queen at Dublin. The Prince, only nineteen but commissioned a lieutenant-colonel in the Grenadier Guards, was the centre of attention in his scarlet uniform and bearskin cap. Through their friendship with General Alexander Gordon, then in command at the Curragh, the La Touches could have been introduced to the Prince.[2] Mrs. La Touche and her daughters kept Ruskin informed about the

cited above from this letter are taken from the original in Ruskin's letters to his father of 22 and 25 June 1861 (ALS, Yale). Plate XI reproduces the first page of the first half of this letter.

[1] Mark 4.28.

[2] *Letters of a Noble Woman*, pp. 88n., 92.

excitement. On 12 July Emily (whose correspondence with Ruskin has been overlooked) writes to him that 'To-morrow we are going to a review at the Curragh to see the Prince of Wales. Did you ever see the Curragh? It is a large plain with soft green grass which is very nice for riding upon. . . . I am sure you would like to see the chargers rear, you can't think how beautiful they look.'[1] Mrs. La Touche in late July tells Ruskin: 'I have had people constantly coming to dinner and rustling about in silk gowns . . . and there's a review every Wednesday and people want to be taken to it.' Ruskin writes to his father that he wishes the Prince were farther away from Harristown. He gets 'Rosie to go and play croquet with him— (a kind of light racquet)—and he's coming to lunch with them, and the house is always full of company'.[2] When Ruskin read of the death of Longfellow's wife who had accidentally set her dress on fire, he sent the clipping 'to Rosie by way of warning, as they have to be always in white muslin now'. On 30 July, so Ruskin writes to his father that day, he received letters from both Emily and Rose, the first girl assuring him that Rose would tell him all about the Prince of Wales; but coquettishly Rose told him 'nothing but about her new kitten'.

The Prince visited Harristown in August, some time before the field day at the Curragh on the 24th when his mother reviewed the troops. Ruskin, writing to his father the day after his arrival at Harristown on Wednesday, 28 August, remarks that the La Touches have given '*déjeûner* to eighty people, and allowed a quantity of the villagers to come on the lawn to see the Prince besides feeding them, and making everybody happy' (*36.383*). The Prince had tried to avoid public attention, the Dublin papers complaining of their difficulties in learning how he was spending his time at the Curragh. 'The sum of all they can tell about him is, that he minds has own business and would be obliged if other people would let him alone and mind theirs', so *The Times* had commented.[3] His host at Harristown could have been

[1] [12 July 1861] (ALS, Morgan).

[2] Letter to his father, 29 July 1861 (ALS, Yale). Ruskin cites Mrs. La Touche's letter.

[3] 11 July 1861, p. 7.

impressed by the apparent innocence of the Prince's character. Only six months ago had he been given permission to smoke under certain conditions, and not long before that had his Tutor told him the facts of sex. John La Touche would not have realized what is now well known, of course, that in his evenings in his quarters at the Curragh, through the co-operation of his fellow officers, the Prince was giving his maidenhead to the actress Nellie Clifden. Mrs. La Touche was not so flattered by the attention of the Prince. Five years later, when her husband thought of offering their house to the Prince for the winter hunting season, Mrs. La Touche wrote to Mrs. MacDonald that she did not want the Royal visitors. 'They are such *racketty* people & so reckless in their ways that they are sure to have horrid servants who will break & scratch everything.'[1]

Ruskin was not in a good mood at Holyhead before boarding the steamer for Dublin. He was depressed, he writes Carlyle: 'the great questions about Nature and God and man have come on me in forms so strange and frightful' (*36.382*). Accompanied by his valet Frederick Crawley, he found the ferry disagreeable with its 'enormous fires vomiting volcano-fuls of smoke continually through two funnels nearly as big as railway tunnels', so he writes to his father the next day. He thought Dublin far 'the melancholiest place' he had ever entered. With forty minutes at the Kingsbridge railway station, he dispatched Crawley to send a telegram to his father while he crossed the street for tea at the Terminus Hotel, an establishment which he found 'ale-housy, nasty, ignoble—'. He expressed no interest in the towns they passed on the way to Harristown—Glondalkin with its ancient round tower, Hazelhatch, Straffan, Sallins. Leaving the train and still eight miles from the La Touches, he and Crawley took the side seats in an Irish jaunting car to the estate, coming up the gravel drive to the Ionic portico of the La Touche mansion at nine-thirty in the evening. His late arrival caught the family somewhat by surprise. John La Touche received him, probably the meeting which Ruskin later recalled as his first glimpse of his host with a green popinjay half hidden in his waist-coat (*35.526*). The children had all gone to bed, he tells

[1] Harristown, [Autumn 1866] (ALS, Yale).

his father, 'but not quite into it—', and Percy who was home from Harrow 'scampered down bare-footed like a little Irishman; Rosie followed presently in tiny pink dressing-gown; and Wisie [Emily] like Grisi in *Norma*'. Mrs. La Touche, he notes, 'looks well, notwithstanding severe work in receiving Prince of Wales'. The happiness of the children did not escape his attention (*36.382–4*).

The next morning Ruskin was impressed with the estate, although he had no appreciation of John La Touche's financial troubles in maintaining it. The competition with the new joint stock banks was undermining the personal fortunes of the family. La Touche still owned, in 1878, over 11,000 acres in County Kildare and smaller holdings in Counties Dublin and Leitrim, but he had been obliged to apply to the Bank of Ireland in 1856 for a loan of £30,000 for which he mortgaged his property at Harristown. In 1861 he had been unable to pay off the debt.[1] Although the estate was not what it had been in the past, the house was still a splendid mansion. When John La Touche's forebears acquired the demesne in 1768, the house, which had been built a century earlier by the Lord Chancellor, was in need of repair. Once described as 'the most beautiful seat in that part of Ireland', an unknown poet had said of it with some awkwardness: 'How nature strives to beautify in dress / The many charms that Harristown possess.' Originally the front terrace had commanded a fine view of an extensive lake skirted by woods and furnished with a pleasure ship. By 1790 the woods had disappeared and the lake had become a ploughed field.[2] With the restoration of the old house, John La Touche's grandfather, the artistic member of the family, filled it with marbles and pictures from his Italian travels.[3]

The high entrance hall into which Ruskin would have stepped from the front entrance suggested a temple, two Ionic columns supporting a beam across the ceiling to divide the

[1] V. H. Hussey de Burgh, comp., *The Landowners of Ireland: An Alphabetical List of Owners of Estates of 500 Acres or £500 Valuation and Upwards* (Dublin: Hodges, Foster & Figgis, [1878]); and F. G. Hall, *History of the Bank of Ireland* (Dublin: Hodges, Figgis and Company, 1949), pp. 250–5.

[2] 'Historic Irish Mansions', *Weekly Irish Times*, 12 Apr. 1941, p. 3.

[3] M. F. Young, 'The La Touche Family of Harristown, County Kildare', *Journal of the County Kildare Archaeological Society*, VII (1911), 39.

room, the sanctuary at the rear containing a large Carrara
marble of three young girls which was to win Ruskin's
admiration.[1] Throughout the spacious corridors and rooms
were family busts and statues including a 'Diana', a 'Psyche',
and a 'Sleeping Beauty'. On the chimney piece by Antonio
Canova in the billiard-room youths were picking and
crushing grapes. A Roman mosaic decorated another fire-
place. Family portraits by Angelica Kauffman hung on the
walls, paintings by the early nineteenth-century Bartolomeo
Pinelli, known for his copies of the Italian masters, other
pictures by the Renaissance painter Giulio Romano, whom
Ruskin in *Modern Painters* had deplored for his realism
(*6.447*). Ruskin's own work was represented, his drawing of
the Apennines from Parma in 1845 then hanging in Emily's
room. The stucco ceiling of the music room was the work of
the same Italian artists who had decorated the La Touche
homes in Dublin. From his bedroom on the first floor at the
rear of the house Ruskin could see the gardens with terraces
descending to the river which, according to Mrs. La Touche's
description, could shine in the early morning like a silver
sheet. Lined with willows and banks which blossomed in the
spring with primroses and marsh marigolds, the river took its
purple colour from the peat bogs from which it rises. Even
from the three bow windows of her bedroom, also at the rear
of the house, Rose could always hear the waters rippling over
the stones.[2] 'The place is frightfully large—the park, I mean.'
Ruskin writes to his father in the morning before coming

[1] The group had been ordered in Rome by a Col. Keating for Narraghmore, an
estate south of Harristown which John La Touche's father had purchased in 1813.
The marble, representing the Colonel's daughters, all of whom died young, was
intended for Narraghmore Church, but had been buried in the churchyard because
the incumbent considered it unsuitable. Robert La Touche had moved the
monument to Harristown ('Memoir of Percy La Touche', pp. 28–9 [MS., Mrs. Sheila
Taylor]).

[2] These details of Harristown House come from *The Letters of a Noble Woman*, pp.
41, 136; M. F. Young, 'The La Touche Family of Harristown', p. 38; letter from Mrs.
La Touche to George MacDonald, 11 Apr. 1863 (ALS, Yale); letter from Rose La
Touche to Mrs. MacDonald, Harristown, 21 Aug. [1872] (ALS, Yale); letter from
Emily La Touche to Ruskin, [12 July 1861] (ALS, Morgan); 'Memoir of Percy La
Touche' and newspaper clippings describing the fire at Harristown on 3 Mar. 1891
(Collection of Mrs. Sheila Taylor); and from personal observation. The Carrara
chimney-piece is now in the Chinese drawing room at Harristown House, the
Roman mosaic upstairs in the River Bedroom.

downstairs. 'The stream—brown and clear—is pretty.... This is just no end of trees and park, with peeps of Wicklow hills in the gaps' (*36.383*).

Harristown resembled the homes of many of the Anglo-Irish gentry, the establishment complete with hunting lodges, gamekeeper, gardeners, butlers, footmen, cooks, a lady's maid for Mrs. La Touche, governesses and nurses for the children, domestic workers of long service like Mrs. Butt whom Mrs. La Touche describes as embedded there in 'a semi-fossil state'.[1] Ruskin seldom enjoyed his visits to great houses, but he did adjust to the life at Harristown. With his habit of rising early and using the morning for his own work, he was not an easy guest. On even the first morning, so Ruskin tells his father, Rosie was 'very angry at my insisting on staying in my room and doing letters and geology till lunch time which takes away all hope of her escaping any of her lessons' (*36.384*). He had brought with him some German books on geology, and a map which he had been drawing of Mont Blanc. A decade later he recalled breaking off his work on the map as he looked through his window to watch Rose at play on the lawn below. 'She threw up her mallet to me—calling me to come down', Ruskin writes Joan Severn. 'I would not, for I said I must finish my map. I did not go down. But I did not finish my map. *That* one will never be touched more.'[2]

Coming down for lunch, he learned that the children were going 'to build a bridge across the Liffey, as I used to do at Coniston', he tells his father of plans for the first day (*36.384*). That afternoon he also took a walk with Mrs. La Touche, the governess, and the children, probably the mile-long walk by the river, which Mrs. La Touche called the 'Trivial Round' as it was supposed to 'furnish all she ought to ask by way of a change'.[3] Percy, Ruskin observes to his father the next day (30 Aug.), 'is a gentle and clever schoolboy: the two girls are the most wonderful combinations of deer and frog that ever naturalist was puzzled to define. They took every ditch (and nearly every fence[)] with flying leaps—(Rosie doing seven feet clear level without apparent effort—I'm going to measure

[1] *The Letters of a Noble Woman*, pp. 51–2.
[2] Brantwood, Tuesday, 10 [Mar. 1874] (ALS, L 39, Bembridge).
[3] 'Memoir of Percy La Touche', p. 41 (MS., Mrs. Sheila Taylor).

the place to day to make sure:)—and walked up the middle of
every stream, and under bridges instead of over them.' On
Friday the children succeeded in drawing him down from
his room in the morning to continue work on the bridge. It
was lucky he had been in the sea at Boulogne as preparation
for these exploits which required him to stand in the river
with water above his knees. 'The Liffey is a sweet warm
stream, and being in it for an hour did me a great deal of good
and I felt more springy in the afternoon for it', he assures his
father. After lunch they had some rowing 'and running
aground, and playing at ducks and drakes—with Mama
however in the boat to enforce my authority when needful—
as it certainly was, sometimes'. Then a walk until 'schoolroom
tea'. Saturday's excursion was a pleasant ride in the afternoon,
'Mrs. La Touche driving her husband and me in their two-
white-poney chaise – it is always pretty to see a lady driving'.
Of the estate Ruskin tells his father on 31 August, 'The place
is so large that I have not half seen it yet'.

Other outings followed the next week. On Monday they
drove to the Polaphuca Falls on the Liffey, Ruskin riding
with Mrs. La Touche and the groom behind her two ponies,
the children and the governess following in a jaunting car.
Viewing the craggy precipice and whirlpool probably from
below the falls, Ruskin and the children had 'a grand scramble
among the rocks', he writes to his father on 3 September.
Several years later Mrs. La Touche took Joan Agnew to this
same spot where Rose recalls for Joan the time 'Mr Ruskin
she & some others' had gone there. Rose took special pleasure
in telling the 'dangerous part', so Joan writes to Ruskin's
mother afterwards, when 'St. C. insisted on going over to try
her skill in climing [*sic*], but she was determined (even at the
risk of her neck being broken) not to be beaten'.[1] After this
adventure, Mrs. La Touche took Ruskin and her party to tea
in a nearby summerhouse, so Ruskin continues in his letter
to his father of 30 September, '—an old Irish piper outside,
with Rose standing beside him to order tunes, making a
pretty picture with backgound of rock and waterfall'. The
excursion left a deep impression in Ruskin's memory. Over

[1] Harristown, 17 Apr. [1866] (ALS, L 55, Bembridge), cited in part in S.
Birkenhead, *Illustrious Friends*, p. 166.

twenty years later he writes to Mrs. La Touche, 'You have always your Wicklow Hills and Phoca-Poola—place of which I remember—not—the name'.[1]

The visit was going well. That same morning Mrs. La Touche sent Ruskin's mother a letter of thanks for some scarfs which she had made for the children and entrusted to Ruskin. 'Your son is making us all very happy—so much so that I don't know what we shall all do when he leaves us.'[2] During the next day or two John La Touche asked Ruskin to stay another week. Meanwhile they took Ruskin through all the house 'seeing all holes & corners, and family portraits & things'. He also received word that Mrs. La Touche's mother was again reading his book, *The Two Paths*. 'I pray God to bless him and to fill him with such love towards Him as may make him happy now and for ever', the Countess told her daughter.[3] Wednesday evening was doleful for the family circle assembled probably in the drawing room occupying the west end of the house. Mrs. La Touche, so Ruskin writes to his father on 6 September, tried to enliven them with a reading of a humorous letter in *The Times* on domestic servants. A county gentleman telling of his difficulties finding a new butler and cook declared that '"All play and all pay" is the cry, and "meat meals five times a day and port and sherry kitchen wines," the only maxim of the servants' hall!'[4] He was shy about the friends of the La Touches. On the last evening the La Touches had a dinner engagement but failed to persuade Ruskin to join them. 'Even with the La Touches—', he tells his father later, 'I never would go near them on their great dinner days—knowing myself strange and inferior in all society-ways.'[5] He was not sorry to spend the evening in the care of the children and the aged butler. 'Rose ordered dinner', Ruskin writes to his father the next morning. 'We turned ourselves into Lords and Ladies. Lady Emily and I took head & foot of table—Lady Rose & Lord Percy for quatrefoil – we

[1] Abbey of Talloires, 15 Nov. 1882 (ALS, BX, Bembridge). Passage published with minor differences in John H. Whitehouse, 'Ruskin in Old Age: Some Unpublished Letters', *Scribner's Magazine*, LXII (1917), 744.

[2] Harristown, [Sept. 1861] (ALS, Morgan).

[3] Cited in Ruskin's letter to his father, Harristown, [4 Sept. 1861] (ALS, Yale).

[4] 'The Real Social Evil', *The Times*, 3 Sept. 1861, p. 8.

[5] Geneva, 14 Aug. [1862] (ALS, Yale).

behaved superbly – after dinner, duets as many as I liked; two games of chess with Rose & Percy in council against me—and a canto of Marmion: eleven o'clock & the carriage came too soon' (6 Sept. [1861]).

The conversation was serious during some of the long rows on the river and the walks about the park. On his Sunday at Harristown Ruskin took three walks, he writes to his father on 2 September, 'one after another, with Papa first—then with Mama—then with Rose'. He found John La Touche 'nicer' than he had expected, 'less worldly and with more heart than evangelicals have usually. But a park with no apparent limit, and half the country round paying rent, are curious Paraphernalia of Christianity.' Ruskin probably reserved for Mrs. La Touche talk about his religious doubts. With her husband he could have shared his admiration of Spurgeon as a personality and speaker, keeping to himself his views of the preacher's limitations. The following October, for example, Ruskin tells his father that Spurgeon was lacking in education. 'If Spurgeon had been nobly trained, taught natural history in its great laws, and made to feel what was dignified in language and hearing, he would not make jests for a mob on a stuffed Gorilla' (*36.385*). Still Ruskin's interest in Spurgeon was shown the next year in his request that they meet for a personal chat, as they had done at least once before. He probably had been in the Metropolitan Tabernacle on 23 November 1862 to hear Spurgeon speak on 'The Voice from Heaven', a dramatic sermon which was especially successful in winning converts. Ruskin would return soon to Switzerland, telling Spurgeon half playfully, 'being too much disgusted with your goings on—*yours* as much as everybody else's—to be able to exist among you any longer' (*36.425*). Apparently this was the meeting which Spurgeon often described in later years when Ruskin chided him for his views on immortality and the waste of his talents on the crowds in the Tabernacle.[1] Ruskin's probable reticence on these matters may explain the change in La Touche's attitude

[1] T. Moore Smith, 'Ruskin and Spurgeon', *Irish Baptist Magazine*, XXIV (1900), 66–8. See also Spurgeon's sermon of 27 Mar. 1864, *Metropolitan Tabernacle Pulpit*, X. 189.

which Ruskin observed soon after this Sunday walk. 'I really think he begins to like me very much', Ruskin writes to his father on 4 September. 'Mr. L. certainly likes me better than he did', he writes again the next day. La Touche must have noted Ruskin's participation in the family prayers at Harristown, an incident of which Ruskin dreamed long later.[1]

La Touche would have shared his wife's concern had he listened to the probable themes of Ruskin's walks with her which led to Mrs. La Touche's extracting from Ruskin a promise to publish nothing on his religious views for at least ten years. Conversation with Ruskin, Mrs. La Touche observed later, was pleasant but demanding, like a game of shuttle-cock.[2] Something of what he said to Mrs. La Touche may be surmised from remarks he confided to others during these months. To Norton in June of 1861 he writes that he was in Byepath Meadow and that Rose was 'terribly frightened' about him (*LNI.111*). He tells his father on 22 November that in the common sense of the word he was 'now pretty nearly "infidel"'. He no longer believed in the Fall of Man except as '"every man is his own tumbler"', he writes on 22 October. How could a clergyman imagine himself a messenger of the Holy Ghost, he asks his father with sarcasm (15 Dec. [1861]), and think that Socrates and Plato were damned 'for not having sat in pews at Camden chapel and heard the Word of God in its purity there'? The following summer he tells his father that he no longer believes in the immortality of the soul (31 July [1862]). When William Rossetti saw Ruskin in February 1862 he found 'the whole tone of his thought on religious subjects changed, and the ardent, devout Protestant figured as total disbeliever in any form of Christian or other defined faith'.[3] Mrs. La Touche saw the danger in these new views and particularly of Ruskin's intention to publish them. Ruskin, later describing her to Holman Hunt as 'a lady whose general judgement deserved greatest respect', tells how she 'restrained me from doing so, and made me promise not to act on this impulse for

[1] See entry in Ruskin's diary for 8 Apr. 1879, *The Brantwood Diary of John Ruskin*, ed. H. G. Viljoen (New Haven: Yale University Press, 1971), p. 167.

[2] Letter to Mrs. Burke, Dublin, 15 Aug. 1905, *Letters of a Noble Woman*, p. 225.

[3] W. M. Rossetti, *Some Reminiscences* (London: Brown, Langham, & Co., 1906), I. 183.

ten years'.[1] His father was delighted with the promise, as Ruskin notes. 'I am very glad you are glad of it—it was not one I would have given for money, nor for Turners . . ., but it was the only thing I *could* do for Mrs. La Touche, and she would do all she could, for me.'[2] On 28 June of 1862 Ruskin was thinking of his promise to Mrs. La Touche when he assures his father that he would 'certainly write nothing for nine years—(one of the ten I said I would wait for is gone)'.

In his hours with Rose, Ruskin must have noticed her devotion for her huge dog Bruno (her husband, so Mrs. La Touche would refer to it derisively five years later) and Swallow, her 'silver-crested cream-coloured pony', as her mother described it.[3] Apparently he went with Rose to visit some of the cottages of the poor, an interest which she attributes in her diary to Ruskin's teaching. 'She has the run of all the cottages and cabins about, gets fed from the labourers' dinners and is an exception to every rule and custom of society', her mother tells Mrs. MacDonald somewhat later of these visits.[4] Arriving with a basket of Baptist tracts from her father, Rose would read the Bible to the cottagers and help them when they were ill, she recalls in her autobiography. These visits also reflected, of course, the humanitarian interests of her father. 'Sympathy [with the poor] *is especially a Christian's duty*', Spurgeon was to declare in a sermon.[5] In his conversations with Rose, Ruskin said that everybody, women as well as men, should learn Greek. 'Rose did'nt say anything at the time', Ruskin writes to his father a few weeks later ([1] and 4 Oct.); 'but as soon as I was gone—to work she sets'. He was astonished when she told him that she mastered the alphabet in three hours. In her Sunday walk with Ruskin she was especially grave—'like patience on a monument—', he writes to his father on 2 September, 'she walked like a little white statue through the

[1] W. Holman Hunt, *Pre-Raphaelitism and the Pre-Raphaelite Brotherhood* (1905; rpt. New York: AMS Press, Inc., 1967), II. 266.

[2] Ruskin's letter from Mornex, 2 [Feb. 1863] (ALS, Yale), published with error in *36.435*.

[3] Mrs. La Touche in letters to Mrs. George MacDonald from Harristown, [Sept. 1866], and Friday, [Summer 1866] (ALS, Yale).

[4] Letter cited in G. MacDonald, *Reminiscences of a Specialist*, p. 103.

[5] Sermon of 9 Nov. 1862, *Metropolitan Tabernacle Pulpit*, VIII. 627.

twilight woods talking solemnly'. Her image was like a picture to him. 'Rosie is very bright, bare-headed in her Irish sunshine—(purest wild rose-colour, with threads of gold – literally if one had to paint her hair it would have to be done as Perugino used—with real gold here and there', Ruskin wrote to a friend the morning after this Sunday walk.[1]

Thoughtful too would have been his talks with 'Wisie', Emily whom Ruskin recalls in *Praeterita* for her beauty and serenity. At Harristown he saw her with Bully, her pet goldfinch, hovering in the air above her head holding a tress of her long hair (35.527). Emily had been a participant in the discussions which his letters would evoke. 'Miss Bunnett quite agrees with you about people not being made to work at what is painful to them', she had written to him before his visit. 'Up to sixteen they are almost too young & afterwards they are almost sure to like some of the things they have to do – over the duties they don't like, they *must* use their self-denial.' Lacking Rose's whimsy, she was no less earnest. 'When I was out this morning I looked up & saw on the tree above me, a black crow, it might have been a raven but he did'nt say "Nevermore" because he was too young, perhaps when he gets older he will, but Nevermore is not *really* Nevermore it only means not in this world & then comes Evermore.'[2]

Near noon on Friday, 6 September, Ruskin and Crawley left by train staying only long enough in Dublin to visit the museum recently completed at Trinity College, 'quite the noblest thing ever done from my teaching', Ruskin confides to his father the next day about its architecture.

2. *Events from September 1861 through June 1862 : the beginning of Rose's illness ; her letters to Ruskin ; the La Touches' break with Ruskin*

These were months, Ruskin said later, when he lived for his love of Rose.[3] On his way home from Dublin he made several

[1] Letter to Mrs. John Simon, [Harristown], 2 Sept. 1861 (Typescript, Viljoen Papers, Van A. Burd).

[2] Harristown, Saturday, [1861] (ALS, Morgan).

[3] Ruskin in letter to Dora Livesey, Denmark Hill, 25 Oct. [1867] (ALS, Miss Olive Wilson).

other visits but he could think only of Ireland. 'All is confusion
and discomfort when one stays with people—Harristown of
course excepted', he writes to his father from Oxford (11 Sept.
1861). After a brief stay with his parents he set off for the
Continent in another effort to shake off his depressed spirits.
Rose and her mother would use Saturdays for writing him,
and he devoted much of the midweek to his replies. At
Boulogne, so he notes in his diary, he 'Staid from opera to
write to R[ose]' (*D2.552*). Sad and alone, he recalled later, 'I
had my weekly letter from R[ose] and vague hopes—at all
events possibilities of hope.'[1] At Bonneville, following a wet
day when he had been confined indoors, his dreams brought
him what he later believed to be a premonition of Rose's first
illness. 'The faces of watches ought to be made black, as well
as the hands', someone said and showed him a black watch.[2]
This was the night of Wednesday, 25 September, exactly a
week before Rose's illness on 2 October—the first attack
leading to the crisis of 1863 which she describes in her diary.

Although some of the servants at Harristown thought that
Rose eventually died of tuberculosis, her doctors, family, and
Ruskin believed that her problems originated in some
disorder of the nervous system. Dr. Frederic C. Skey, the
well-known London surgeon of whose opinions Ruskin held
high regard, told his medical students that these disorders
were 'most prevalent in the young female members of the
higher and middle classes, of such as live a life of ease and
luxury, ... persons easily excited to mental emotions, of
sensitive feeling, often delicate and refined'. The disease
which he identifies as *hysteria* occurs not among individuals
marked by 'excess of vitality' but more commonly those of
'reduced or exhausted power'. Ultimately its symptoms are
related to the mind 'which appears to exercise some mysterious
or occult influence over them'.[3] Ruskin's parents were quick
to surmise Rose's attack as psychic. 'What makes mama and
you anxious about Rose's *brain* particularly—Did you hear or
notice anything making you fear head-disease?' he asks his

[1] Ruskin in letter to Joan Severn, Brantwood, 10 [Mar. 1874] (ALS, L 39, Bembridge).
[2] Letter to his father, Lucerne, [24 Oct. 1861] (ALS, Yale).
[3] F. C. Skey, *Hysteria*, 2nd Amer. Edit. (New York: Moorhead, Simpson & Son, 1868), pp. v, 60, 110.

father on 13 October. Mrs. La Touche's letters gave substance to the fears of the parents, making Ruskin realize that the affliction was a periodical attack with some loss of consciousness. 'She seems perfectly well every day till about 5 o'clock, at that hour her countenance changes and she seems unable to occupy herself in any way, and very often at bedtime she has a slight return of the attack during which her consciousness is slightly impaired', so Mrs. La Touche writes to Ruskin.[1]

His parents, knowing the disastrous effect of excessive studying on their son while he was a student at Oxford, suspected that Rose's determination to learn Greek may have precipitated the attack. Just about the time of this attack, she had been studying Greek verbs and had written Ruskin a letter with her first salutation in Greek, 'Peace be to thee' (*WL.333*). He assured his parents that they were both wrong in thinking that Rose should not learn Greek. 'She should'nt overwork at anything—', he writes to his father, 'but if she learns any language at all, it should be that. ... If she is to be a Christian, she can only read her Bible with complete understanding in the Septuagint and Gk te[xt.] ... To have learned *one* Greek verb accurately will make a difference in her habits of thought for ever after.'[2] Meanwhile he had been writing out the forms of the Greek verb for her (*D2.553*). He may have realized the wisdom of his parents' counsel when the doctors brought an end to her studies. Perhaps the therapy which handiwork had given him during his own illness led to his proposal that Rose take up cookery in a *cool* place. 'Rosie sends you her love', Mrs. La Touche writes to him in a letter which he received on 22 October, 'and I am to tell you she began to cook the moment she had read your letter ... and she has made a cake, and wishes so much you were here to eat it.'[3]

On his sketching walks around Geneva and Lucerne he invented child's rhymes, as he called them, for Rose. Coming down from the Môle on Sunday afternoon, 14 October, he

[1] As Ruskin transcribes Mrs. La Touche in his letter to his father, Lucerne, [24 Oct. 1861] (ALS, Yale).
[2] Bonneville, 12 Oct. 1861 (ALS, Yale). Cited with differences in *35.lxvi–lxvii*.
[3] Cited in Ruskin's letter to his father, Lucerne, 22 Oct. 1861 (ALS, Yale).

composed these plaintive lines which he later copied for his parents:

> Rosie, Posie—Rosie rare,
> Rocks, & woods, & clouds, and air
> Are all the colour of my pet:
> And yet, & yet, & yet, & yet
> She is not here—but, where?[1]

These 'play-rhymes', Ruskin explains to his father on 24 October, are 'entirely pure, accurate, classical English, . . . The rocks,—the woods,—the clouds, the air, are all—the colour of my pet:—(rose colour:).' The first night at Lucerne he thought of Rose and Harristown as he watched the moonlight on the river and listened to the chimes of the town clock.

> Rosie pet, and Rosie, puss,
> See, the moonlight's on the Reuss:
> O'er the Alps the clouds lie loose,
> Tossed about in silver tangles
>
>
>
> Tower and steeple, chiming sadly
> Say (or else I hear them badly)
> 'Good night, Liffey—bad night, Reuss—
> Good night—Rosie—Posie—Puss'.[2]

His letters to Rose usually discussed more serious matters. Before he learned the full extent of her illness, he was ready to post (as he writes to his father on 13 October) 'a long examination of the words *Life* and *Death*, from Greek downwards; & chiefly . . . dwelling on the last word'— probably an etymological study much like those he liked to write the children at Winnington Hall which often ended in challenges to Calvinistic teachings. In late October Mrs. La Touche cautioned him 'not to write the grammar or divinity letters just now—but not to write *only* in play', he admits to his father on 25 October. Already his parents had asked whether his relationship with Rose could be the cause of her upset. Ruskin agrees with his father in the same letter of 25

[1] From Ruskin's postscript, Geneva, 14 Oct., in his letter to his father from Bonneville, 13 Oct. [1861] (ALS, Yale). The lines were published with changes in *35.lxvii*. For the dating of the writing of the poem, see entry for 14 Oct. 1861 (*D2.554*).

[2] Cited in Ruskin's letter to his father, Lucerne, 17 Oct. 1861 (ALS, Yale). Verses badly misquoted in *35.lxviii*.

October that he must be careful what he writes to her, keeping 'as much to the childish tone as I can, because I can use terms of endearment which I could not in more serious letters'. But he denies that he could be the cause of her distress. 'Rosie's illness has assuredly *nothing* to do with any regard she may have for me. She [likes] me to pet her; but is in no manner of trouble when I go [aw]ay. her affection takes much more the form of a desire to please *me* and make me happy in any way she can, than of any want for herself, either of my letters or my company.'[1]

Rest was the prescription for Rose's illness, but she tried at first to continue her letters to Ruskin. On 28 October he received a two-sheet letter from her which gave a cheerful account of her activities restricted to reading, drawing, and cooking. 'She does'nt find it difficult to get through the day at all', Ruskin writes to his father on 28 October. Although she was now forbidden to write any letters, Ruskin received on 1 November a note in her hand. He had told her mother that he expected no letters from Rose, only her signature at the bottom of Mrs. La Touche's notes (*36.385, 386*). The enforced rest appeared to be effective. 'Rosie quite well as long as she's idle', he assures his father in early November (*WL.337*). The La Touches meanwhile began to plan their annual journey to London, and on 19 November Ruskin tells his father that he 'had a nice letter from Rosie—idle enough—& very full of her cat'. Ruskin was writing to her regularly. On 1 November, according to his diary, he took a beautiful walk on Mount Pilatus and noted the singing in a village chapel (*D2.555*). The following day he wrote an account of it for Rose, sending it first to his parents to read and to forward to her. A few days earlier, crossing a pine wood on the road to Stansstad, he had gathered for Rose some oxalis, his favourite Alpine plant of whose trefoil leaves he knew the religious symbolism, 'Pain du Bon Dieu' as the flower was known locally (*3.175n.*). Understanding the significance of this gift, Rose soon sent Ruskin some shamrock, that Irish symbol of the Trinity which St. Patrick had used to cleanse the isle of its serpents. 'And so now A Dieu, St C', she had closed her letter to Ruskin, 'and the shamrock will tell you anything else, if you

[1]Lucerne, 15 Nov. 1861 (ALS, Yale). Letter cited with differences in *36.386*.

ask it.'[1] In the future Ruskin was to search Rose's gifts of flowers as a secret language by which she could speak sentiments she was forbidden to write.

Rose's letters to Ruskin, most of them preserved only because he copied them out for his parents, are an open index to her feelings and temperament. On 7 December Ruskin copies 'a bit or two' from what he describes as 'Rosie's last', one of her delightful 'yowling' letters in which she feels sorry for herself because of the impending departure from Harristown. Yowling is only for self, she tells Ruskin in a later letter. Writing on a Saturday morning (probably 23 November) from the drawing-room where her sister is practising her Schubert, seated in the same chair which Ruskin had used for sketching the vista from the rear windows, she pays him another 'visit' by letter. 'Eliza M.' appears to be among the poor families whom Rose visits; 'Ellen', the children's nurse whom Rose compares to Ruskin's Ann Strachan still serving the family at Denmark Hill. I have bracketed Ruskin's parenthetical explanations for his parents with which he interrupts his transcription of Rose's letter.

Dearest St C; Though you have not returned my last visit, for you hav'nt had time, I am coming again, for it takes *such* a long time to get an answer, I wont wait: But you hav'nt written to me now for such an age. My last letter was all about cats; this one won't be, for one reason why I write is because I want to yowl to some one. Emily is playing 'Die Klage' while I write; and it's very—Ah—I don't know why—but going away gets worse and worse, and this year its terrible. It seems horrid to say so to you;—but you know that yr coming to see us, & all that, I like so much; only for the rest I would rather, so much, be sitting at this table, by the window, (just exactly where you sat to draw the poplars by the river) telling you about the cats and things, and getting your letters, than in that Schoolroom in London, feeling you at Denmark Hill, not writing to us but towney-business letters—And now Mama will say I'm stupid: but I think it's a fact. I don't think I'd ever go away, if I had what I liked to do, [she means, if she were allowed to do what she liked; J.R.] and of course that would be stupid and foolish; but I do think that one reason why going away is so unhappy, is that every one one sees

[1] As Ruskin transcribes Rose's note in his letter to his father, Lucerne, 10 Dec. 1861 (ALS, Yale).

about is sorry: I mean chiefly the poor people: and they sympathize so when I tell them I don't like London; I am going to see my Eliza M. to day, to take her mother a little grey and scarlet shawl I've made: and they will be very sorry to hear we're going away before Christmas: and then Ellen, who answers to your 'Annie', at D. Hill, then comes into my room, and gets so dreadfully unhappy in the evening: when I take off my shoes she picks them up, and hugs them, and says, 'Two little white shoes;— two little white shoes, and the feet that's in them,— what'll I do? what'll I do?' And she has done it three years now, and so have I, and custom does not commonly make things easy— [Rosie in Irish confusion, I believe, between, Custom commonly makes things easy—& Custom does not, to us, J.R.[1]] It's all for the best.

The next Monday morning she continues with a revealing account of her mother's efforts to waylay Ruskin's letters. She closes this portion of her letter with a quotation from *The Princess*.

(Monday) Is'nt it strange—there's Emily playing die Klage again; but I won't yowl any more. I got your letter, St C. on Saturday morning, after I had written the first part of this, just as I was going out riding. So I cd only give it one peep, and then tucked it into my riding-habit pocket and pinned it down, so that it could be talking to me while I was riding. I had to shut up my mouth—so tight, when I met Mamma, for she wd have taken it and read it if I'd told her, and it wd'nt have gone on riding with me. As it was, we ran rather a chance of me, and pocket, and letter, and all, being suddenly lodged in a stubble field, for Swallow, (that's Emily's animal, that I always ride now) was in such tremendous spirits about having yr handwriting on his back, that she took to kicking and jumping in such a way, till I felt like a Stormy Petrel riding a great wave—so you may imagine I could not spare a hand to unpin my dear pocket, and had to wait in patience, till Swallow had done 'flying—flying South' [Tennyson—J.R.] and we were safe at home again.

To please his mother Ruskin chooses as the last 'bit' from Rose's letter her allusion to the shawl which Mrs. Ruskin had sent her the last summer. 'It was *so* cold yesterday, going to Church, that I put on my little (Mrs. Ruskin's) shawl—scarf, I mean, under my jacket, and I was so nice and warm. *I* like

[1] I have been unable to identify the source which Ruskin seems to be quoting, a variation on the proverb, 'Custom makes all things easy'.

the lilac and white very much. I don't think it looks washed out!'[1]

As the time approached for Rose to make the dreaded move to London with the family, she weakened again. 'Rose not well again', Ruskin writes to his parents on 8 December. By the 15th they had arrived in Norfolk Street where Ruskin that day asks his father to send some flowers, 'or anything nice—to Norfolk St—they're there now, and Rose is not well'. That week, however, the La Touches called at Denmark Hill only to learn from the maid that no one was at home. 'Was it not, however, rather stupid in Lucy to send away the La Touches the first time they called?' Ruskin asks his father in his letter of 22 December. With astonishing blindness to the relationship which she was encouraging, Mrs. La Touche meanwhile continued her own letters to Ruskin, adding to one of them Rose's 'best love'. To this he wrote back to Rose (so he tells his father) that he 'would'nt have anything of the kind'. She might as well send her compliments—'there was no "best" nor "worst" in love'. Rose promptly informed Ruskin:

It was Mamma's invention, that, about my best love; I never sent a bit of it. [I hardly] ever send a message, if I can help it: I like to say it myself, and did I *ever* send my best love? as you say, one's love is'nt best or worst—and, St C, if you please, if you've got my love already—how am I to send it?— No, I only write this to remind you of it,—and to wish you a happy Christmas; if it does nothing more, my wishing it won't make it unhappier—please have it, as much as you can.[2]

To the pleas from his parents and Rose that he return for Christmas Ruskin did not listen, determined to stay away from London until the end of the month. Although Mrs. La Touche wrote most of the letters, it seems to have been now that she began to sense her secondary place in Ruskin's interests. Shortly before they left Harristown she sent Ruskin a disturbing letter ostensibly written by Emily but actually by herself—as Ruskin noted later in his diary. Whatever its

[1] Ruskin's letter to his father, 7 Dec. 1861 (ALS, Yale). Most of the paragraph from that section of Rose's letter written on Monday was published with differences in *35.lxviii*.
[2] Cited in Ruskin's letter to his father, Lucerne, 22 Dec. 1861 (ALS, Yale).

content, the letter showed Ruskin 'what light things women were', brought him a sleepless night and the occasion to remind his diary of the Duke's aria from *Rigoletto*, 'La donna è mobile' (*D2.558*). Very likely this was the letter that caused Ruskin the physical pain which he described to his father a few months later, leaving his left foot 'up to the ancle, quite white and numb for half a day' (24 Aug. 1862). It was just 'a word or two' in one of Mrs. La Touche's letters 'that hurt', not that she had 'any idea that it *would* hurt: . . . but it happened to surprise as well as to hurt me', he explained (30 Aug.). Mrs. La Touche, after their arrival in London, sent Ruskin what he describes to his father as 'a funny little dialogue' between Rose and herself.

Mrs. L. Rosie, dont you wish St C would come home?
Rosie. Yes, indeed I do. How tiresome of him.
Mrs. L. Do you think he wants us at all?
Rosie. Well—perhaps he does. I think he wants to see me, Mamma.
Mrs. L. And does'nt he want to see me?
Rosie. Well—you know—well—Mamma, I think he likes your letters quite as much as yourself, and you write so very often—and I can't write often. So he *must* want to see *me*.[1]

The little jealousies which Ruskin's letters to Rose may have kindled in her mother may only be surmised.

The text of Rose's 'Star-letter' of 26 December, hitherto unpublished in its entirety, comes from the proof sheets corrected in Ruskin's hand for the continuation of his autobiography.[2] In a projected chapter 'Faeries' Hollow', named after one of his favourite haunts above Chamouni, he planned to recall his stay there in 1874 and to include 'Rosie's last letters', presumably those written in her final illness which he received during this visit. Apparently he also planned to include others like the treasured 'Star-letter', probably one of those he carried for years in a silk wallet

[1] Lucerne, 21 [Dec. 1861] (ALS, Yale). Passage published with differences in *36.399*.
[2] *Praeterita* corrected Proof and Manuscript, III, 671–4 (MS, Yale). Some part of this letter was printed with variants in *35.lxix–lxx*. Ruskin also copied this letter with minor variants for Joan Severn in a letter of 25 Dec. 1877 (ALS, L 41, Bembridge).

between two plates of fine gold in his breast-pocket.[1] At Basle
on the 26th, where Ruskin had gone to begin his return
journey, the evening star (so he notes in his diary) was
'inconceivably bright' (*D2.559*). From her window in London
that night, Rose makes the same observation of Venus—'the
brightest light of all'. In her long opening paragraph she
moves skilfully from her thoughts of Ruskin writing to her
from a cold room in Lucerne to her dream about him; from
the star as the guide of the wise man to the symbol of the
heavenly light of peace available to those who accept God as
their Comforter—that gift which Rose saw as the only balm
for Ruskin's spiritual illness. The 'P.R.P.' with which she
signs the letter are the initials of another of Ruskin's pet-
names for her, 'Posie-Rosie-Posie'. The signals for footnotes
and the notes to the letter are Ruskin's. I have placed his notes
at the end of the letter rather than within as they appear on
the galleys, and I have bracketed them.

Dearest St. C.,—it is the day after Christmas Day & have just got
my Christmas letters; and though I dont know yr address I have
been wanting to write to you so much that I am answering it
directly—& first St C you know you sdnt write to me when you
ought to be getting yourself warm; could'nt you have thought of me
just as well running up a hill and getting nice & warm, like a good
St Crumpet, than sitting cold writing; you know you need'nt write
to tell me you have not forgotten me; need you St C. & yet I can't
help saying I was looking for a letter, I wanted so much to know
what you were doing and thinking (I mean a very little bit of it) this
Christmas day; This (I mean your letter,) did not reach me on
Christmas eve, but that did not matter. I have told you I can see
some things quite plain, and I have been living at Lucerne all
Christmas week, am I not there still, talking to you, though I did'nt
'yowl' you know I only call 'yowling' feeling like a dog with his nose
up in the air outside a shut door, because someone has kicked, or
perhaps because some one has not stroked you. yowling is only for
self; I do not call it yowling to be sorry for those who are suffering,
yowling is only right sometimes, but there is *always* something to be
sorrowful about for other people—*sometimes* also a great deal to be
yowlful about for self, & even in Christmas times. But I did *not* yowl
about Harristown,* hardly thought about it, it was almost all

[1] *35.lxxvi*; *D2.711*. One of the gold plates and the wallet are preserved at Bembridge.

Lucerne, only just dreamt about home, and our cats, and the people, last night, and that was somehow joined on to a dream about you. So our thoughts are crossing I suppose St C. & I thought particularly the day before Christmas, and Christmas day evening, is it not curious. I think our rooms were not so very different. I have a large squarish room with a great window [*sketch*] like that; & I had a bright coal fire flickering and making shadows on the cieling [*sic*] opposite to the window where I looked straight at the dark night, & one star Venus glowing straight in front. When I leant my head a little I cd see the long line of lamp lights with a sort of bright haze over them getting smaller in the distance but Venus was the brightest light of all. I did not see Orion, or any other star, only her. and then I was thinking of you it made me think of the guide of the wise men His star in the East, only this shone in the West. She looked down so brightly over the gas lights as if it was intended we sd see how much purer and brighter though at such—such—a distance, is the Heavenly light if we wd only look for it, than our rows of yellow gaslights that we think so much of. Yes we have a strange Peace on earth, because earth or its inhabitants do not all of[1] them like the Peace that our Prince can give, do not all want it, do not all believe in it. Some think that Pleasure is Peace, & seek it for themselves, some think that following Satan is Peace, and some think there is no Peace given on earth, that God gives work to do and strength to do it, sore with sorrow and pain, but peace is only in heaven I mean while there is no rest, and certainly no happiness, but they are ready to give up their lives in his service, and live without joy, if it is His will. They are faithful noble souls, but though they cd die for God, they are beaten back and tossed with the waves of temptation and sorrow; they will not believe in the hope and joyful parts of Christianity & by rejecting God as the Comforter they reject all Peace. I believe we don't *believe* in that Peace rightly. 'The Lord hath anointed me to preach good tidings to the meek, he *hath sent me to bind up the broken-hearted*[,] *to comfort all that mourn*[,] to appoint unto them that mourn in Zion[,] to give unto them beauty for ashes, *the oil* of joy for mourning, the garment of praise for the spirit of heaviness[.]' & why?[2] 'That they might be called trees of righteousness, the planting of the Lord, *that he might be glorified*[.]' Are these not good tidings of great joy not that we are not to mourn for sin, but to follow Him in comforting those that

[1] The proof sheet reads *off*, an obvious slip.

[2] The proof sheet reads: heaviness '& why.' I have corrected the error in the placement of the quotation marks, and I have changed the period to a question mark. In this passage Rose has been paraphrasing Isaiah 61:1–3.

mourn and binding up the broken (hearts) but *first of all* to let Him bind *up our broken hearts and comfort us who mourn.* Sorrow and tears we know are right on earth for sin & as sympathy for others sorrows and tears, but this we know that joy is His gift, everlasting and our tears will pass with Sin, not cast roughly off but wiped by God's own hand, as right in their time, as blessed because without them we should not have received His comfort, but the Joy that was His Gift on Earth shall increase and abound to His Glory throughout all Eternity.

Dont [*sic*] think my one idea of goodness is happiness. it isnt[.] did not all the good & great men in the Bible grieve—not always some of them I think not often, but they did. & Jesus did. but think of Jacob, Moses, Isaiah, David, Hubbakuk [*sic*], St John, St Paul especially & had they not all joy too—& peace & that greater than the sorrow—particularly those of the New Testament.

I have been writing so badly & I am so sorry St C & yr letters are always so neat & unblotty & so nice; Pep** is sitting reading by the fire. I have asked him if he has any message but he only said 'my love' so there it is St C. He is I believe really very sorry† but he is a Lacerta & dosent [*sic*] show it[.] He gambols so very merrily and laughs just the same but he *is* sorry—it comes out in evening talks with Wisie & Mama & I know he is ashamed, only I hope it will not be forgotten directly—Wisie's & my love, and please St C forgive me for this untidy letter perhaps you won't get it— A Dieu yr affecate

<div style="text-align:right">P.R.P.</div>

[*Her home; she is writing from London, where she was never happy.
**Percy.
†He had been idle at school, and a little rebellious.]

In time this letter made a deep impression on Ruskin's thinking. It may have been 'the most precious' of her letters, recovered from the La Touches after Rose's death, which he seems to have taken as a sign from her spirit and a call to faith, a summons which he was soon to heed (*LN2.129*). The letter first reached him, however, in the midst of much thought about his future conduct to the La Touches. For him to have returned to London as soon as they arrived would not have been right, he tells his father on 23 December. What he needs is to find out 'if possible—whether Rosie was what her mother and you think her, an entirely simple child—or whether she

was what *I* think her, —that is to say in an exquisitely beautiful and tender way, and *mixed* with much childishness, more subtle even than Catherine of [Bologna]'.[1] His association of Rose with the humility of the charitable St. Catherine, a lady of wealth who put on sackcloth and went out to beg for the poor and who held the infant Jesus as a mark of the Virgin's favour, shows Ruskin's view of Rose at work with the poor. He is not *quite* sure yet of her character, he adds in his father's letter, but he is keeping in mind the simple judgement of her by one of the peasants whom he met on his visit with Rose to the cottagers around Harristown. He realizes that he cannot work properly because he wants to see the La Touches, he admits to his father on 26 December; but he also knows that it 'is very bad for me to come home & see the La Touches: ... and afterwards I shall have just another four weeks depression'. The tone of Rose's star-letter would only enhance his conception of her saintly character, but Ruskin—apostate and iconoclast as he had recently described himself (*36.384*)— was not prepared to receive the spiritual peace which she offered. Christmas had been a day of glorious weather at Lucerne, Mt. Pilatus appearing to be 'constructed of frosted silver' like filigree, Ruskin writes to his father that morning. Significantly, he had spent an hour throwing stones at icicles in a great ravine. 'It had all the delight of being allowed to throw stones in the vastest glass and china shop that was ever "established," and was very typical—to my mind—of my work.'[2]

At Denmark Hill he was home—at least the place which 'ought to be home', he writes to Norton—but he found little peace. His father was now suffering from the painful spasms of gravel, the urinary disease from which he was to die, and his mother, now eighty-one, was virtually immobilized with arthritis. Ruskin spent his time drawing, studying Latin and Greek. 'I don't speak to anybody about anything', he tells Norton; 'if anybody talks to me, I go into the next room' (*LN1.123*). On Ruskin's insistence, his birthday, usually the

[1] Lucerne, 23 Dec. 1861 (ALS, Yale). In the holograph Ruskin writes *Boulogne*, an apparent slip for *Bologna*.
[2] Lucerne, [25 Dec.] 1861 (ALS, Yale). Passage published with differences in *17.xlv*.

occasion for a festive dinner, went unnoticed. 'Observance of
the 8th Feby is dropped', his disappointed father had to write
W.H. Harrison, one of the usual guests.[1] 'I've stopped the
dinner, & mean to forget the day', so Ruskin writes to another
family friend, Mrs. John Simon.[2] His father's birthday was
no less dreary. 'The 10 May passed as few of my Birthdays of
late years have', John James Ruskin again writes to Harrison.
'We dined alone. Mrs. Ruskin ... can scarcely come to
Table.'[3] Thinking of the Swiss landscape, Ruskin laments
the loss of the countryside around Denmark Hill, 'the fields
around me all built over, and instead of being refreshed and
made able for work by my long holiday, I only feel more
discontented', he tells Norton (*LN1.123–4*). In recent weeks
Froude, now the editor of *Fraser's Magazine*, had invited him
to contribute some articles on political economy. He had
prepared in 1860 a series on his new views for *Cornhill*, but
outraged readers had obliged the editor abruptly to terminate
the essays. The subject always unpopular with his father,
Ruskin could not put his mind to the task, although he did
ready the *Cornhill* papers for publication as a book under
their original title, *Unto This Last*. He visited Rossetti, in
January sitting for a portrait which Norton had requested,
and later thought of renting a room there (*36.412*). Meanwhile
he discovered that the authorities at the National Gallery had
allowed some of the Turner drawings to mildew, and once
again he gave time to restoring them. He knows that his
parents love him, he writes to Lady Trevelyan, but he lives in
a state of 'subdued fury' when he is at home. He is in constant
disagreement with his father 'about all the Universe' (*36.414*).
Summoning Carlyle's imagery, he realizes that he is only
beginning to walk 'through the Rue St Thomas de L'Enfer
on the way to "das ewige Nein"', so he tells Norton (*LN1.125*).
His middle age hung over him. He has more instincts of
youth about him than when he was young and had wasted his
time on metaphysics. Now he is miserable because he cannot
'climb, run, or wrestle, sing, or flirt—. . . . Wrong at both ends
of life', he declares to Dr. John Brown (*36.404*).

[1] Denmark Hill, 5 Feb. [1862] (ALS, Sharp Papers, Morgan).
[2] [Denmark Hill, Feb. 1862] (ALS, Sharp Papers, Morgan).
[3] Queens Hotel, Norwood, 12 May 1862 (ALS, Sharp Papers, Morgan).

Keeping no diary for these dreary months, Ruskin later wrote in above the entry for his return to Denmark Hill: '1862 begins. Spring in London, seeing R[ose] as usual. The tea when they all three sat on the floor by me—her mother, Emily, and she' (*D2.560*). This tea may have been the occasion which John James records in his diary for 14 February: 'Mrs. L. T. party'.[1] For her fourteenth birthday Ruskin gave Rose one of his illuminated manuscripts, a Liège Psalter of the thirteenth century, writing on a fly leaf:

Posie
with St C's love
3rd January, 1862

In addition to a Calendar, the Psalter, and the texts of a Book of Hours, the manuscript also contained some prayers, including one which may explain Ruskin's choice of this gift for Rose, an Ave to the Virgin written in the Liège dialect and rhymed couplets beginning 'Ave rose florie et de roial lingnie'.[2] Some time in February he took a walk on a windy day, 'R[ose] maintaining it would do me good', he explains to Mrs. Simon, but it brought him only a headache. 'It's the East wind I suppose', and then he adds, thinking perhaps of Rose's starletter, 'There used to be Stars in the East once – No For me—the Wind is always in the east—& the Star in the west.'[3] Later that month he told the headmistress at Winnington Hall that Rose had been in town but he believed in his broken state that for him she was 'more harm than good' (*WL.350*). Planning a visit to the school in Cheshire he did not know how he would explain his absence to Rose. 'Not that she really wants me a bit, as long as she's got her cat and her siskins', he wrote to the expectant children at the school; 'but I shall get scolded for all that' (*WL.352*). On 9 March John James notes in his diary that his son, in connection with his daily visits to the National Gallery, was also seeing the La Touches.[4]

[1]MS. 33, Bembridge.
[2]*Psalterium Davidis et Horae*, No. 32 on James Dearden's list of Ruskin's manuscripts, 'John Ruskin the Collector', *Library*, XXI (1966), 140. The manuscript is now preserved at the Bibliothèque Royale Albert Ier, Brussels; MS. IV 1013.
[3][Denmark Hill, Feb. 1862] (ALS, Sharp Papers, Morgan).
[4]Entry for 9 Mar. (MS. 33, Bembridge).

To Emily, for her eighteenth birthday on 15 March, he gave another of his treasured French manuscripts, a superb Book of Hours of the fifteenth century, richly decorated with natural flowers and foliage—selected perhaps for Emily's interest in flower arrangements.[1] In Switzerland, he had been trying to draw sunsets, he tells Lady Waterford in April, but now during these weeks he has been 'trying—in vain—ah, so much in vain-er! to draw little Rosie La Touche', a probable reference to the portrait in the Frontispiece to this volume.[2] Early that month he had taken Mrs. La Touche and Rose to the British Museum so that they might hear a lecture by Sir Richard Owen. Chiefly, he writes in a letter, he wanted to show Rose to the professor. 'When I brought Owen to them ... I introduced Rose thus— "You must let me present Miss R.L. more especially to you, professor,—because she is distantly and curiously connected with the lower order of monkeys, and can climb trees"' (*WL.356*). On 22 April the La Touches left for Ireland. Ruskin thought that his father could not understand how difficult it had been to say goodbye: '... you thought that I ought after saying goodbye,—to be quite merry and able to amuse Mrs Simon at Tea', he told him later (9 Aug. 1862). What was Rose doing after her return to Harristown? 'If it is a fine morning', he speculates for Lady Waterford who had asked the question, 'she is probably either gathering anemones in the wood—or catching crawfish under the bridge of the Liffey.' He feared that during these weeks her principal occupation had been in spoiling *him*. 'Her mother says it is I who spoils *her*—but the real hurt is all the other way—and what I'm to do now she's gone to that horrible Ireland, there's no thinking.'[3] He could not know that this was to be the last time he would see Rose for more than three years. 'They took the child away from me—', he told Mrs. Cowper later, '... and since that day of April 1862, I have never had one happy hour,—all my work has been wrecked' (*LMT.89*).

[1] No. 58 on James Dearden's list of manuscripts, *Library*, XXI (1966), 148.
[2] [Apr. 1862], *Sublime and Instructive: Letters from John Ruskin to Louisa, Marchioness of Waterford*, p. 42. For the provenance of Ruskin's portrait of Rose, see *The Ruskin Newsletter*, No. 15 (Autumn 1976), 1–2.
[3] Denmark Hill, 24 Apr. [18]62, *Sublime and Instructive*, pp. 43–4.

But the La Touches apparently did not intend this break when they left London. Much talk must have passed about the possibility of Ruskin's visiting Harristown again, and on 7 May he received an offer from the La Touches of 'a little cottage dwelling-house, and garden, and field, just beside their own river, and outside their park wall', so he writes a friend. 'All the river being clear, and brown, and rocky; the windows within sight of blue hills; the park wall having no broken glass on the top; and the people . . . being all in their various ways good and gracious, I've written to say I'll come, when I please; which will, I suppose, be when I want rest and quiet, and get the sense of some kindness near me' (*36.408*). The house, he tells the Simons the next day, was 'just at the head of the river below theirs to let—Scotch firwood and meadow—and steep bank to river. . . . Or papa [John La Touche] says—if I'll take a bit of pretty park of theirs on which there's no house just now, he'll build me one. I'm afraid it's a little too—cold—and a little too—hot—there. . . . But it pleases me, all the same.'[1] On 15 May Ruskin left for France, taking with him as companions Edward Burne-Jones and his wife. The La Touches suddenly withdrew the invitation. To Miss Bell in the autumn Ruskin explains that Rose's parents 'saw how fond I was of her, thought at first that all might go on nicely if I were near them; and so they offered me a little cottage close to their park, where Rosie would have past every day on the way to her village school—(where she goes to tell lies to the children)—well this drove me quite wild with delight—. . . for when they went home & thought over it they wrote saying it could not be—that their Irish neighbours would never understand it—which indeed I thought true enough —but it was just a blow too much—' (*WL.381–2*). This explanation may have been incomplete. Mrs. La Touche may have been annoyed by Ruskin's insistence on returning to the Continent, her husband alarmed over the talk of Ruskin's religious views—while sitting for Rossetti, for example, Ruskin said that he had lost all faith in revealed religion[2]—or Mr. La Touche may have decided to put an end

[1] Denmark Hill, [8 May 1862] (Typescript, Viljoen Papers, Van A. Burd).

[2] As William Hardman notes in his monthly record for February 1862, *A Mid-Victorian Pepys: The Letters and Memoirs of Sir William Hardman*, ed. S. M. Ellis (London: Cecil Palmer, 1923), p. 95.

to his wife's encouragement of Ruskin. The sad moment in Paris when Ruskin heard from Ireland stayed in his memory, his receipt of 'the letter *refusing* me the house at H Town— and my going to the theatre that night with the Jones's'.[1] He told the Simons in June, 'The Irish plan is given up'.[2] To Lady Trevelyan in July he discloses one more fact: 'The Irish plan fell through in various unspeakable—somewhat mournful ways. I've had a fine quarrel with Rosie ever since for not helping me enough' (*36.414*). Meanwhile Ruskin asked his father not to open Mrs. La Touche's letters when they arrived at Denmark Hill for forwarding. 'There is always something about the family in her letters which she would not like to have read' (4 and 19 June 1862).

3. *Events from July 1862 through December 1863: Rose and the higher Biblical criticism; Ruskin's isolation at Mornex; the baptism of John La Touche; Rose's collapse after her first Communion*

Upon Rose fell the pressures of the quarrel between Ruskin and the La Touches for the next two months, tensions which could have contributed to the return of her illness in the autumn. 'I did'nt think she fought half hard enough for me about the house', Ruskin tells Miss Bell (*WL.382*). Letters became fewer. On 21 June he writes to his father that he had received letters from both Rose and her mother. He notes in his diary on 4 July his need to write a letter 'about R[ose]' (*D2.564*). On 21 July he informs his father that now he writes 'hardly a word to any body, not even to Rosie'. By August Mrs. La Touche 'made it up for us', Ruskin recalls (*WL.382*). He received a sympathetic letter from Rose on 6 August, as he writes to his father: 'Rosie is very sorry I am so ill;—(she says, "If I could say anything—do anything—write anything— that would cheer you—or comfort you—or make things softer to you—or you for them—would not I do it? but what can I do?").' The La Touches had been in Scotland, and the same letter tells of the family's plan to be in London by the end of August.[3] This news made Ruskin decide the following day to

[1] Ruskin in letter to Joan Agnew, Paris, 6 Oct. 1868 (ALS, L 33, Bembridge).
[2] Milan, 20 June [1862] (ALS, Sharp Papers, Morgan).
[3] Ruskin's letters to his father, Geneva, 6 and 9 Aug. 1862 (ALS, Yale).

delay his own return. Earlier he had assured his father he would be at Denmark Hill to celebrate his mother's birthday on 2 September but now he 'could not and would not' be in London at that time. 'I don't choose to have any more goodbyes', he declares (9 Aug.). The decision was as painful for himself as his parents. 'Great sorrow—caused by parting from the only people except you & my mother whom I loved in the world—& from whom the parting had in various complicated ways clearly become necessary—has had much to do with the last crush of the illness' (24 Aug.).

One reason for the La Touches' coming to London was to see the exhibition in the Crystal Palace now on Sydenham Hill, probably the Autumn Show of Fruit and Flowers. Earlier Ruskin had resolved 'never to enter' this show place, and he took satisfaction in telling his father that Rose too 'does'nt like coming to London even to see the exhibition'.[1] In late September Georgiana Burne-Jones, now home in London, writes to Ruskin that Mrs. La Touche 'called here the other day, to ask about you—it was so nice to see any friend of yours, and to be able to speak of you a little as we think. Pretty Rosey was not with her.'[2]

Some time in 1862, probably during this visit or the return of the family to London for the winter months, Rose overheard disturbing conversations on the higher Biblical criticism of which she understood 'more than anyone thought', so she recalls in her diary. The issues of these talks had been much in the air since the publication of *Essays and Reviews* (1860) in which Benjamin Jowett, for example, argued that the Scriptures should be read like any other book. The Bishop of Natal, John William Colenso, had raised in 1861 more questions about the authenticity of the gospels in his commentary on his translation of St. Paul's *Epistle to the Romans*, undermining Evangelical interpretations of matters like the Atonement and eternal damnation. Returning to London in May of 1862 to arrange the publication of a new work on the authorship of several books of the Old Testament, Colenso attracted the sympathy of Ruskin's more intellectual friends. Margaret Bell, an old friend of the Bishop's wife,

[1] Milan, 24 July, and Mornex, 25 Aug. 1862 (ALS, Yale).
[2] 62 Gt. Russell St., [London], 23 Sept. 1862 (ALS, Sharp Papers, Morgan).

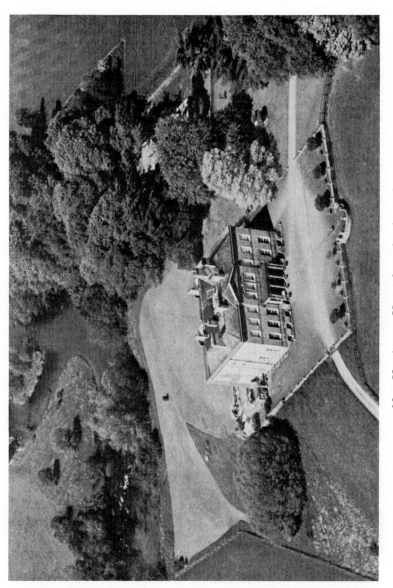

New Harristown House from the air, 1976

Facsimile of page one of letter from John Ruskin to Rose La Touche, 21 June [1861]

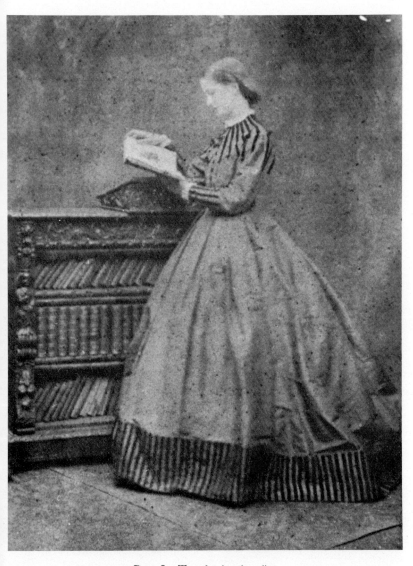

Rose La Touche (undated)

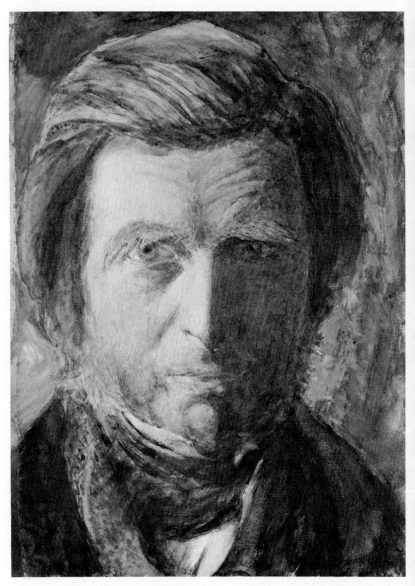

John Ruskin, about 1873
Self-portrait

invited the Colensos to leave their children at Winnington Hall. Ruskin threw his support with the Bishop, writing Miss Bell to tell the Bishop that he would 'stand by him to *any* extent' (*WL.384*). To another of his friends Ruskin confides at this time that during the last four years he himself had been 'working in the same directions alone, and was quite unable to tell any one what I was about' (*WL.387*). Rose found all of this talk very unsettling. 'If there was really a doubt that these Gospels had ever been written by the people they professed to be, how could one trust them? ... If the manuscripts were false, if they were not what they professed to be, what was the use of Faith?' she asks in her autobiography. Ruskin was guarded in his comments to Rose. He was not among those from whom she heard evil or light talk about faith in Christ, she writes. But the conversations tortured her, leading to hours of prayer that she might be shown 'what is right'. By the end of September the La Touches were back in Ireland with Rose suffering a relapse in her strange illness. A letter from Ireland, Ruskin writes to his father on 2 October, told him that 'Rosie has overworked her poor little brain more than I have mine, and her feet and hands are always as cold as ice and the doctors won't let her do *any*thing—so I get no letters to speak of' (*WL.379*).

The La Touches at Harristown, Ruskin now talked of returning to see his parents. He was not on ill terms with the La Touches, he tells his father several times, but he was 'much too fond of them' to see them (13 Oct.). He would come in November, but he would leave before Christmas, having 'an objection to seeing the la Touche's, who come at Xmas', perhaps return for his birthday in February, and again in June.[1] Letters continued to arrive from Mrs. La Touche and Rose. He heard from Rose that she had been ordered to rest, but could now '*read* letters: and that when she gets strong again, she means to learn Greek' (11 Oct.). Rose's letters were 'affectionate enough', he writes to Miss Bell, although 'quite short and dull' compared to her 'long nice ones'. According to her mother, Rose 'takes twice as long in the writing as she used to do—her feet and hands as cold as marble' (*WL.382*). Ruskin apparently kept his letters to Rose on homely themes

[1] Mornex, 28 Sept. and 6 Oct. 1862 (ALS, Yale).

about the village life in Mornex where he had rented a cottage. 'I wrote to Rosie . . ., of a scene between one great black dog of the village and a lamb, the other day', he tells his father in early November. Significantly the next day he gathered some roses, 'common roses, but so fresh—round, & strong in the leaf, it makes one feel young to look at them'.[1] By the end of that week he had begun the journey back to London.

At home he gave one lecture before the Working Men's College, chatted with Spurgeon as previously noted, but otherwise refused most invitations so that he might stay with his parents. On 12 December the Burne-Joneses called at Denmark Hill. 'O how very good it was to be there on Friday night', Georgiana writes to Ruskin afterwards. She wondered whether Rose would be coming to town soon. Alluding to the 'blue hills' portrait of Ruskin as a child by James Northcote in the dining room, Georgiana fancied she saw a likeness in Rose to 'that funny, dear little portrait of you in your white frock and blue shoe estate'. It was in the expression of eyes and mouth, she adds, 'both of them determined, don't let us say "obstinate"'.[2] He found his parents as wearing as he had expected. 'At home no one has any sympathy with me—', he had told Miss Bell before his arrival, 'and however much they love me, I can tell them nothing' (*WL.382*). He found that he could not write or 'do anything', he writes to her from Denmark Hill. 'The moment I got on this side the sea I got ill again' (*WL.388*). In mid-December, a few days before the reappearance of the La Touches, he returned to Mornex.

The wilfulness of his separation from his parents and the La Touches for Christmas never left him. 'Cruel!' he entered many years later in his diary opposite the entry for his departure (*D2.573*). He was sorry his parents were 'dull' after he left, he wrote to his father on 20 December, but it was 'quite clear that the only life possible to me is among these hills, now'. Alone at Mornex on Christmas Eve, he put on a brave front for his father. 'I am in my little wooden room, with the starlight coming in at my window. Orion rising over

[1] Mornex, letters of 4 and 5 Nov. 1862 (ALS, Yale).
[2] [London], 16 Dec. 1862. Only first page available; unsigned (Sharp Papers, Morgan).

the Mont du Reposoir: and very happy'—his words suggestive of the imagery of Rose's star-letter of a year ago. In truth his Christmas was desolate, he admitted later, the memory returning to him 'now in due punishment' (*D2.573*).

Nor did his wilfulness escape Mrs. La Touche. She decided at this time to show Rose bits of letters which Ruskin had not meant her to see. Rose then wrote to him, 'mightily vexed' about his 'heathenism', pleading: 'But for the sake of all Truth, and Love, you must not give the one true Good—containing all others, God—up', so Ruskin copies her letter for his father on 28 December. Although she also sent him 'a long little lock of hair' which her mother had cut to help 'steady' him, Ruskin was in no mood for repentance. 'I've become a Pagan, too', he had written to Norton a few days earlier; 'and am trying hard to get some substantial hope of seeing Diana in the pure glades' (*LN1.132*). To Rose's plea, so he tells his father, he would write to her that 'being a heathen is not so bad as all that' (*36.429*). Tensions increased. His diary contains no comment for her birthday on 3 January. He had only 'a little scrap from Rosie merely to say she misses me', Ruskin writes to his father on 21 January, and he speculated how 'entirely the conscience in childhood is a Taught thing'. Some people [like Rose] look for happiness in 'doing right', but 'nothing makes *me* happy but something substantial'. In February his dreams included scenes of partings with people, wanderings in search of them. 'What a strange waste of the soul all this seems!' he informs his father (17 Feb. 1863). He wrote to Norton in March that although Rose once had canonized him, she now 'mourns over my present state of mind, which she has managed to find out somehow'. Scolding him frightfully, she asks, 'How could one love you, if you were a Pagan?' (*LN1.138*). Mrs. La Touche could see that Ruskin's plan to buy some property high up in the Alps would do him no good. To George MacDonald she commented a few months later that 'stones & glaciers are cold friends'.[1]

Mrs. La Touche nevertheless could not bring herself to cut off the relationship. Besides her regular flow of letters to Ruskin, she attended in January the private viewing of an

[1] Harristown, 10 Oct. 1863 (ALS, Yale).

exhibition of pictures donated by artists for charity to which Ruskin had contributed some drawings of foliage.[1] The La Touches, he tells his father, 'liked the leaves' (*36.432*). Later they went out to Denmark Hill to see Ruskin's copy of a Luini fresco in Milan which he had completed the preceding summer. Rose wrote to Ruskin that they all liked the pictures which his parents were 'so kind' in showing.[2] Near the end of February Mrs. La Touche asked Ruskin for two tickets for friends to the lecture he planned to give in June at the Royal Institution on the geology of the Alps. It was too bad that she could not stay herself 'as I could'nt break down then', he told his father on 26 February, 'but they go back to Ireland in April'. The tickets were for George MacDonald, that fallen Scotch divine destined to serve as one of the mediators between Ruskin and the La Touches. Having lost his pulpit because of his unorthodox views on salvation, he had now settled in London to support himself through writing and lectures. Rose was attending MacDonald's lectures on Shakespeare in February, but the La Touches and Ruskin may have met him the previous winter when Mrs. La Touche wrote to MacDonald to send Ruskin a ticket for his lectures. 'He is a friend of mine, & I found him here on my return today – On hearing of your lectures he immediately expressed a wish to accompany us for the future. . . . I am sure you know his works & I think you would like to know him.'[3] MacDonald had qualities which would appeal to Ruskin, his ethereal if not mystic nature, his rejection of much Calvinist dogma, his admiration of that Broad Churchman F. D. Maurice whom Ruskin also liked. Mrs. La Touche enjoyed the intellectual atmosphere of the MacDonald home on Albert Street, Regent's Park, whose large studio accommodated some of his lectures, 'symposia' to which she later contrasted her tiresome five o'clock visits to neighbours at Harristown.[4] She came to find MacDonald 'more human' than Ruskin.[5] When Rose heard that her mother was

[1] *The Times*, 14 Jan. 1863, p. 9.
[2] Cited in Ruskin's letter to his father, Mornex, 20 [Mar. 1863] (ALS, Yale).
[3] 24 Norfolk St., Park Lane, undated (ALS, Yale).
[4] Harristown, 11 April [1863] (ALS, Yale).
[5] Mrs. La Touche in letter to M. F. Young, Mentone, 1 Feb. [1885], *The Letters of a Noble Woman*, p. 103.

arranging for the MacDonalds to hear Ruskin's geological lecture she wrote to Ruskin that she was sure that MacDonald wanted to know him, 'and if you want to know why I want you to see him,—I think he is good—has in him what you would—or would once, have thought good—is loving to other people, and is *sure* of things'.[1]

MacDonald's belief that the heavenly kingdom is not reserved exclusively for the elect may have inspired Mrs. La Touche's pamphlet *The Cry of Esau* which she had been writing during these months under MacDonald's encouragement. All copies of this anonymous pamphlet now disappeared, we can only surmise her answer to Esau's bitter plea for his father's blessing. That it did not follow Calvinist doctrine is shown in Mrs. La Touche's comment to MacDonald written in July,—that her parish Rector at Harristown (the Revd. Thomas Hare)—'an utter Calvinist, but a good-hearted, *very* young, simple-minded, stupid man, very fond of me, preached two sermons at me yesterday—the morning on Election—the afternoon on the character of Esau'. Mr. Hare, she said, regarded her as the biggest black sheep misleading the white ones into what he thought 'poisonous pastures'. John La Touche, probably fresh from his immersion at the Metropolitan Tabernacle, had no comment on his wife's latest literary efforts. He wrote the cheque for the costs of publication without comment, so Mrs. La Touche tells MacDonald.[2] She had designated a copy for Ruskin although she knew that 'he won't care, nor approve but still he is to have it'.[3]

The baptism of John La Touche would have come in the midst of some of Spurgeon's most compelling sermons. In 'The Sinner's End', delivered in late December 1862, Spurgeon disclosed that it is 'to the Holy Spirit we must look for all true regeneration and conversion'.[4] On 1 February 1863 his sermon 'Nominal Christians—Real Infidels', was recorded as especially successful in winning converts. His

[1]Cited in Ruskin's letter to his father, Annecy, 10 Apr. 1863 (ALS, Yale).

[2]Undated letter on mourning stationery in envelope postmarked Newbridge, 13 July 1863 (ALS, Yale).

[3]Undated letter on mourning stationery in envelope postmarked Newbridge, 1 July 1863 (ALS, Yale).

[4]*The Metropolitan Tabernacle Pulpit*, VIII. 720.

text was John 8:46, 'If I say the truth, why do ye not believe me?' Spurgeon implored his congregation to heed the call of Jesus. 'I bring you to that awful place where the two roads meet—the right, the left—to heaven, to hell—to righteousness, to sin—to God, to fiends! ... Put your hand to your brow now, and turn this matter over.'[1] His house already plagued by Ruskin's doubts, his wife's susceptibility to people like the MacDonalds, his daughter's strange illness—all these facts may have led La Touche to think that now was the moment he should join those converts whom Mrs. Spurgeon led to her husband standing in the waters of the baptismal tank in the Metropolitan Tabernacle. Spurgeon had no patience with the people in whom Ruskin was trying to interest Mrs. La Touche and Rose. The higher Biblical criticism, in Spurgeon's view, was no advance upon Paul and Peter; 'nor do we rank Messrs. Maurice, Kingsley, and others of the cloudy schools, with Luther and Calvin'. Pestilent heresies, he continued, 'advocated by cunning and crafty men', are working to undermine our churches.[2] Ruskin's fulminations to his father against the church may have spilled over into his letters to Mrs. La Touche. His perception of the 'fallacy & insolence' of the 'common creeds' of men was crushing. 'Long before Colenso was heard of, I had gone far deeper into the difficulties than he has', he wrote to John James on 8 April. A few weeks later he dreamed of being in a cathedral, squeezing past some bishops whom he angered when he upset some of their gilded books (26 April). To his father's thought of making a donation for the building of a church, Ruskin replied that nothing would give him 'so much pain, as to give one farthing to the church—as at present constituted' (8 May). John La Touche, by his baptism, demonstrated his clear choice of Spurgeon's road to the right.

The decision was a grief to Mrs. La Touche, so her biographer notes, and it must have deepened her restlessness after their departure for Harristown on 7 April. Although Rose was 'mad-glad' with the thought of returning home, so she writes to Ruskin,[3] her mother dreaded the routine of the

[1] *The Metropolitan Tabernacle Pulpit*, IX. 72.

[2] 'Preface' [to the sermons of 1861], *The Metropolitan Tabernacle Pulpit*, VII. v.

[3] Cited in Ruskin's letter to his father, Talloires, 13 Apr. 1863 (ALS, Yale).

dinner parties, the necessity to 'dress oneself up, & drive many miles in a stuffy carriage & go where nobody is amusing', she confides to MacDonald.[1] Already she was thinking of another pamphlet. . . . Ruskin, who had returned to London at the beginning of June, remained at the forefront of her thought as she watched his growing friendship with the MacDonalds. In mid-July Mrs. La Touche wrote to MacDonald of her gratitude 'for loving & helping & letting yourself be loved by that poor St C', and she urged him to continue talking with Ruskin 'and let him talk—about his pet Rosie if he pleases'. Only a tortured spirit could have written the remarkable confession of feeling for Ruskin included in this same letter. 'Nothing will ever get *me* right, save getting *him* right—for somehow if he were holding on to a straw & I to a plank—I must leave my plank to catch at *his* straw. Still I don't care what becomes of me as long as anyhow he can [be] brought to some sort of happiness & life.'[2]

These dissensions were too much for Rose, as her diary shows. She found herself 'tossed to & fro God knows fearfully', she wrote to MacDonald in later years of these and later differences, '—heart & desires—head & judgement, my interpretations of right—& my Parents, all pulling different ways, or all mixing to puzzle a brain that cannot bear perplexity'.[3] The zeal of that sense of duty which Ruskin had observed in her followed her from one dilemma to another— the meaning of the talks about the Bible she had overheard in London, the revelation that Ruskin was one of the doubters, her mother's solicitation of Ruskin's attentions, the issues of her father's final embrace of the Baptists. If the problems weren't at hand, she looked for them, so frenzied now was the pursuit of 'doing right' for this 'earnest' child, as she supposes herself in her autobiography. 'Remember that thou keep holy the Sabbath-day', she heard in the decalogue read in the parish church not on the seventh day, but on Sunday, the first day of the week. Here was another 'muddle' (as she calls it) over which she now 'puzzled', the record of which is in her

[1] Undated letter in envelope postmarked Newbridge, 16 May 1863 (ALS, Yale).
[2] Harristown, 13 July 1863 (ALS, Yale). Passage published with differences in G. MacDonald, *Reminiscences of a Specialist*, p. 107.
[3] Harristown, 15 May 1872 (ALS, Yale).

diary. Sabbatarianism was a common topic in the sermons of the day. The Revd. Walter F. Hook of Leeds, a favourite preacher with John James Ruskin, had explained that the keeping of the Lord's Day on the first day of the week was an ordinance of the Church, although the Scripture did not support it.[1] The question had troubled Ruskin in 1860 while travelling with the young American artist, W. J. Stillman, who became impatient with Ruskin's strict observance of Sunday. Against Stillman's demonstration of the lack of Scriptural authority for the Christian weekly rest on the first day of the week Ruskin could make no defence, saying: 'If they have deceived me in this, they have probably deceived me in all.'[2] Rose's diary reveals the prayer by which she resolved the problem of this 'nightmare'.

But other problems arose, this time in early autumn when her father (so she thought) began to urge her to take Communion. Her mother wanted her to follow the Anglican tradition of first undergoing Confirmation. Rose in her diary says that she agreed with her father's objections to the need for this rite. Spurgeon believed that faith, which Baptists professed as adults at the time of their baptism, was the only prerequisite for a place at the Lord's Table. Converted at the age of sixteen Spurgeon himself had taken Communion on the first Sunday after his baptism. In one of his more controversial sermons he ridiculed the Anglican belief in the conferral of a new nature to infants at baptism. This error, he insisted, was a reflection of the High Church movement, and he called it a stepping-stone 'to make it easy for men to go to Rome'.[3] Immersion as an adult would not require the further reaffirmatory vows of Confirmation. Ruskin in 1850 following the ecclesiastical controversy over the Revd. G. C. Gorham and his interpretation of baptismal regeneration, had written his own essay on baptism in which he had argued that the moment of baptism may be no more important in God's sight than others he was preparing for our further perfection

[1] Walter F. Hook, 'The Lord's Day', *The Literature of the Sabbath Question*, ed. Robert Cox (Edinburgh: McLahlan & Stuart, 1865), II. 368.

[2] W. J. Stillman, *The Autobiography of a Journalist* (London: Grant Richards, 1901), I. 267.

[3] His sermon of 5 June 1864, 'Baptismal Regeneration', *The Metropolitan Tabernacle Pulpit*, X. 322.

(*12.580*). Baptism, he wrote to a friend early in his acquaintance with Rose, is 'Holy if it is Life-Giving'—not otherwise (*36.308*). Rose, now exhausted by the pressures from her parents, tells in her autobiography the sad conclusion to her quandary. On Sunday 11 October a rainy day which her exasperated mother interpreted as 'a sign', Rose went to church for her first Communion with only her father and governess.

The La Touches had planned to leave that week for a brief visit to London and then the winter in Italy, but on Monday Rose collapsed. Attacks of hysteria, according to Dr. Skey, could follow a 'great mental emotion', causing a shock particularly in a patient suffering from previous exhaustion. Mrs. La Touche tells MacDonald that it was one of Rose's 'mysterious brain-attacks. . . . I am afraid she has *thought* herself into this illness, & I attribute it partly to the strong wish & excitement which resulted in her being admitted to her first Communion last Sunday. Altho' not confirmed nor willing to be confirmed, she was making herself unhappy at being the only one of us excluded, on our last Sunday at home, & her desire was granted. . . . At present she cannot bear a gleam of light or a whisper.'[1] Of Ruskin, who meanwhile had returned to Switzerland, Mrs. La Touche had written to MacDonald on 10 October that she was sad about him, that in his letters there was only 'a growing tone of misanthropy & unbelief'.[2] She kept Ruskin informed about the course of Rose's illness. On 1 November he writes to his father, 'I think she's dying'.

4. *Events from January 1864 through January 1867: Ruskin's interest in spiritualism; the restlessness of Mrs. La Touche; Ruskin's proposal of marriage to Rose in February 1866; the alarm of the La Touches*

The worst of her illness lasted about four weeks, so Rose records in her autobiography. By mid-November Mrs. La Touche wrote to George MacDonald that her daughter was improving after suffering from what the doctors called

[1] Undated letter in envelope postmarked Newbridge, 15 Oct. 1863 (ALS, Yale).
[2] Undated letter in envelope postmarked Newbridge, 10 Oct. 1863 (ALS, Yale).

'psychical phenomena'. She had 'a sort of clairvoyance, both of spiritual & earthly things. . . . For the first fortnight of her illness she was able to tell beforehand any little thing that would befall her thro' the day.' Later on she awoke with 'an infant's mind, . . . & an entire oblivion of all acquired knowledge, & of every person & thing not known to her eleven years ago'.[1] The pain was torturous, Rose recalls, even the act of thinking hurting her head. Meanwhile Ruskin's father suggested that Ruskin might help Rose if he would leave Switzerland to visit her at Harristown. 'No—it would do her no good to see me', he writes to John James. 'Her mother gave her my love as soon as she was able to hear messages, and she sent me hers, but said, "I wish he had sent me a 'God bless you.'"' She would be quite happy . . ., provided she thought I was "good"' (7 Nov. 1863). He saw that parental pressures could delay her recovery. 'I wish mama had her at Denmark Hill to take care of—instead of her clever mother in Ireland. I've a notion she would be better managed', he tells his father in another letter (31 Oct. 1863).

Nearly two more years were to pass before Ruskin and Rose saw each other again. During 1864, a long period of convalescence for Rose at home, she sent Ruskin only a short note or two, he recalled later (*LMT*.82). On his birthday, 8 February, Ruskin writes to MacDonald: 'I can't love anybody except my Mouse-pet in Ireland, who nibbles me to the very sick-death with weariness to see her.'[2] With the death of his father in March, Ruskin abandoned his plans to live abroad, knowing the necessity of staying at home with his mother, now eighty-three. He spent his time in lecturing, studying the antiquities at the British Museum, and making several visits to Winnington. His acquaintance with Spurgeon took on a surprising warmth. In January they had a lively argument about immortality, each using 'the most abusive language', so Ruskin writes to Miss Bell, but ending in 'entire affection for and trust in the other' (*WL*.464). Spurgeon alluded to the discussion in a sermon on 27 March, describing his opponent as one 'who was once a professed believer but is now full of

[1] Undated letter on mourning stationery postmarked Newbridge, 13 November 1863 (ALS, Yale).

[2] G. MacDonald, *Reminiscences of a Specialist*, p. 109.

scepticism'.[1] Spurgeon must have found the relationship a
test of his patience. 'You told me that I am not worthy to call
at your house, etc—which is very likely, but not very
encouraging', he tells Ruskin in a letter which may have been
written in that year or the next. He knew that he could do
nothing for Ruskin when the devil had boarded him, and
Spurgeon felt beneath him when Ruskin's good angel was in
the ascendant. 'I am not sent after such great folk as you are;
I have none of those gifts of argument which qualify men to
talk to you; but I pray for you.'[2]

Mrs. La Touche meanwhile continued to write to Ruskin,
taking an interest in his deepening association with Mr. and
Mrs. William Cowper and their recent pursuits in spiritual-
ism. Cowper, the favourite stepson of Lord Palmerston, was
then serving as a member of Parliament and First Commis-
sioner of Works. In recent years Ruskin had been astonished
to learn that Mrs. Cowper was the statuesque girl he had
admired from a distance in Rome in 1840 (*35.277, 503*). Now,
like George MacDonald, she was to become a 'tutelary power'
for Ruskin in his conflict with the La Touches. By the
summer of 1863 Mrs. Cowper was attending séances in which
the American, Daniel Dunglas Home, served as medium,
and by January 1864 she had persuaded Ruskin to take an
interest in Home's communications with the world of spirits.
The proposal was well timed since these were the days when
he was arguing with Spurgeon about immortality. Ruskin
had a long talk with Carlyle about the occult. 'He says
Spiritualism is real witchcraft', Ruskin wrote to Mrs. Cowper
in January (*36.464*). Nevertheless Ruskin attended some of
Home's séances with the Cowpers, although he remained
sceptical about the messages rapped to him. Mrs. La Touche
eagerly awaited news of these events. 'I am hoping for a letter
from you tomorrow telling me about the séance', she writes to
Ruskin following one of these sessions. To his reports that the
messages of the spirits were trifling, she asks, 'And yet, if all
this be true, and if Christianity be also true, are not all these
phenomena connected?'[3]

[1] *The Metropolitan Tabernacle Pulpit*, X. 189.
[2] Undated letter, [1865?], transcript in Viljoen papers in possession of Van A. Burd.
[3] Kilkee, 1864, *The Letters of a Noble Woman*, p. 42.

These months of Rose's convalescence brought no change in Ruskin's thinking. When MacDonald asked him in April to serve as godfather for one of his children, Ruskin replies that he is still 'a Pagan' and looks upon baptism 'merely as a very imperfect and unnecessary washing for that day' (*WL.486*). He expresses the same view in August when he declines to stand godfather to the daughter of the water colourist Alfred William Hunt. Ruskin describes himself as entirely severed 'from all the ordinarily accepted rituals of Xtian or any other "churches"', and says he would rather baptize the child 'to Apollo or the Egyptian Phre, than into what the modern Xtian calls his faith'.[1] In October, so Ruskin writes his mother, he received 'the first nice message from Rosie . . . for ever so long. I wrote to Mrs. L[a Touche] that I wanted her to make some purses and bags for my money for me, and she apologizes for this one's not being pretty by telling me it is of oriental stuff which Rosie says represents in its pattern, "a hearts-ease in the middle of a rose, and it must be sent to St. C."' (*WL. 518–19*). Rose must have known that wild pansies and roses were among Ruskin's favourite flowers, the first perhaps for its power to relieve the discomforts of love. Ruskin had gone to Winnington in December to deliver two lectures in nearby Manchester, the second of which he said later he had written 'to please one girl' (*18.47*). In her marked copy of *Sesame and Lilies* (now preserved at Yale University), which Ruskin had presented to her with the inscription 'Posie, with St C's love', Rose left without comment his strictures on women who study theology. 'Strange, in creatures born to be Love visible, that where they can know least, they will condemn first' (*18.128*). A few days before the lecture Ruskin had written with greater frankness to a friend: 'A great pet of my own has just been killed, or next thing to it, by those accursed religious hot-mushroom-sauces of her poor little head.'[2]

Why Mrs. La Touche left the rest of her family in Harristown during her visit to London during the early months of 1865 is not known, but she used her freedom for

[1] [Denmark Hill], letter postmarked 12 Aug. 1864, Virginia Surtees, 'Godfather to Venice', *TLS*, 28 Jan. 1965, p. 76.

[2] Letter to Dr. John Brown, Winnington, 6 Dec. [1864] (Typescript, Yale, and the National Library of Scotland, Edinburgh, Acc. 6289, box 3).

association with Ruskin and the MacDonalds. In January
the MacDonalds accompanied her to hear Ruskin's lecture
at the Working Men's Institute. 'What a jolly thing it will
be if you can get Mrs L to set to work really and write
things!' Ruskin exclaims to MacDonald in early February,
a proposal which soon led to her writing another pamphlet.[1]
'I wonder Mrs. L. never made you laugh at me a little about
Rosie. . . . You know—the child's just like a wild fawn—and
she likes me well enough—about as much as a nice squirrel
would.'[2] On her return to Harristown in early March Mrs.
La Touche seemed to find the adjustment especially hard.
The MacDonalds would hardly understand the 'many hours
of real happiness' they had given her, she writes to Mrs.
MacDonald. 'It is impossible that you, or even your husband
with his poet's sympathies, should understand it—for you
don't know the kind of life & surroundings that are mine
& have always been mine—nor a very bad & uncomfortable
fault there is in my character, which is, that I *cannot* make
myself fit into any place, . . . & so I don't *really* get on or feel
at home with my neighbours.' At Harristown she has found
herself in 'a whirlpool of small fusses', she adds. Her husband
has been buying new furniture, the house is being painted.
. . . 'And on the top of all this, who should turn up but
Emily's lover, who won't wait any longer to know his fate.'
Rose, she reports, is getting stronger, 'but she is perfectly
wild & how she is ever to be made a modern "young lady"
of, I can't imagine. She is out from dawn till dark, & it is
utterly useless to put on her any raiment that would not suit
a peasant, or to expect from her any observance of any of the
restraints of civilisation.' She encloses her copy of some verses
which Rose had written on the theme of Isaiah 58:10: 'And
if thou draw out thy soul to the hungry . . . then shall . . . thy
darkness be as the noon day.' Her poem tells of her vain
search for Jesus in the 'World of Hope & Pleasure', the city,
and in her 'silent room' with the Bible. Only in service to
others does she find her goal.

[1] Undated on mourning stationery in envelope postmarked London, 6 Feb. 1865
(ALS, Yale). For Mrs. La Touche's new pamphlet, see below p. 95.
[2] Undated on mourning stationery in envelope postmarked London, 13 Feb. 1865
(ALS, Yale). Passage cited with differences in G. MacDonald, *George MacDonald
and His Wife*, p. 333.

> I thought—tho' my heart was dreary
> I at least can do his Will,
> I can comfort the sad & weary
> And those that are tired & ill—
> For I said, 'tho' I find not Jesus
> 'He will see for His lambs I care.'
> So I went, & I worked for Jesus,
> And oh, He found me there![1]

Despite the preparations for Emily's marriage to Major Bernard M. Ward, Mrs. La Touche continued to be restless. 'I want to give out that I have "renounced the world" & think dinner parties wrong—but no one would believe me', she confided in MacDonald. Meanwhile she was starting her tract on dress, this time a topic which 'will shock nobody in the least'. Ruskin stayed on her mind. On the day when he was delivering a lecture on architecture in London, she asks MacDonald to tell her how Ruskin got through the lecture. 'He will tell me he broke down, whether he did or not.' Ruskin, she adds, 'is very grumpy still, & needs talking to'.[2] A few days before the wedding, she writes to the MacDonalds as 'My dear Pair' to tell of the sudden death of her brother, Lord Desart, whose life had been 'marred by an unhappy marriage & utterly fallen fortunes'.[3] In the late summer the La Touches took an extensive holiday in Scotland. Mrs. La Touche had thought of writing a story, 'but nothing comes—*real* things come between & put extinguishers on the fancies', she tells MacDonald.[4] Back at Harristown she wondered whether Rose would 'ever be a civilised being. She is out in the dew like Nebuchadnezzar at break of day—and all day long she is in and out, let the weather be what it may, and not one single thing that girls do does she do.'[5] By November she was yearning for another change. 'Oh dear, how I wish myself in London', she writes to Mrs. MacDonald. 'My husband is thinning his woods & won't move till the last axe-

[1] Mrs. La Touche's letter, Harristown, 14 Mar. [1865], which encloses the verses (ALS, Yale).

[2] Harristown, 15 May [1865] (ALS, Yale).

[3] Undated letter in envelope postmarked Newbridge, 21 June 1865 (ALS, Yale).

[4] Harristown, 25 Sept. [1865] (ALS, Yale).

[5] Ibid. Passage cited in D. Leon, *Ruskin the Great Victorian*, p. 361.

stroke has fallen for fear it should fall on the wrong tree.'[1]

The events that followed on the return of the family to London for the season were climactic, although Rose says nothing of them in her autobiography. With her eighteenth birthday in the offing, the La Touches intended to present Rose to society—possibly to the Queen, the highlight of her mother's 'coming out' in 1842. In his diary Ruskin notes that on Sunday, 10 December, he saw Rose for the first time in three years. Two days later he writes to Sir Richard Owen that he wants to bring her to the British Museum to see him again. She has 'grown into a terribly Irish-Irish girl, and she has been finding bones of old Irish people and old Irish beasts—somewhere in the Wicklow Hills', he declares.[2] His diary entry for 21 December records her visit to Denmark Hill and one of her comments which stayed in his mind. 'R[ose] comes to me. Walk in garden; "some people look better dressed"' (*D2.585*). They may have been talking about Mrs. La Touche's pamphlet on dress, soon to be printed in Dublin, in which she argues that if we are genuine, we shall admire what is really beautiful. 'With our minds thus trained, our bodies will be rightly dressed.'[3] Ruskin's walks with Rose along the little stream among the laurels in his garden at Denmark Hill were 'Paradisiacal', he recalled in *Praeterita*. 'Happiest times for all of us, that ever were to be' (*35.560–1*).

On Rose's birthday Ruskin took her for dinner along with her mother and Joan. For Henry Acland he later this year assesses the events leading to this occasion. Her parents had opposed the relationship, but Rose (he writes) 'held quietly to me, without saying much—but quite steadily—they did not know how steadily—and thinking they had it all their own way, brought her up to London last winter to bring her out. They could not wholly keep her from her old friend; and I took her down to dinner on her 18th birthday, last 3rd of January.'[4] Seven years later he recalled for Acland's daughter that on this occasion Rose 'was very happy, and talked to me

[1] Letter dated Monday in envelope postmarked Newbridge, 6 Nov. 1865 (ALS, Yale).
[2] D. Leon, *Ruskin the Great Victorian*, p. 362.
[3] *About Dress*. By Mrs. La Touche (Harristown) (Dublin: Thomas Webb, 47, Lower Sackville-St., 1866), p. 15.
[4] Denmark Hill, 10 Oct. 1866 (ALS in MS. Acland d. 72, Bodleian).

and nobody else, and I talked to her, and nobody else. (—and her mother put up her eyebrows to Joan every now and then—and looked at us out of the side of her eyes.)'[1] He commemorated Rose's birthday in a poem of five quatrains beginning 'Ah, sweet lady, child no more—'.[2] The day ended with 'a bright bit of sunset', he tells MacDonald a few weeks later.[3] Ruskin meanwhile had been encouraging the Cowpers to become acquainted with the La Touches, a relationship which became another means for him to be with Rose.

On the day of the birthday dinner, or soon afterwards, Ruskin proposed marriage to Rose. His letter to Henry Acland, cited above, offers the most details about the succeeding events. Probably a few days later Rose 'cross examined my cousin Joanna about me', he writes to Acland: '—found out how it was with me; and on Candlemas day [2 February]—getting me to herself here in the garden, She turned to me and asked if I would stay yet three years, and then ask her—for "She could not answer yet."' Ruskin tells Acland that he then asked Rose if she realized how old he would be in three years. 'Yes—she answered—fifty.' His letter continues: 'I could hardly find words [*sic*] any words at the time nor did I care to find them, but I wrote to her saying (I think) what was just and right to her, —both of my own utter obedience to her slightest wish, for ever; and of what she herself [*sic*] owed both to her parents & herself. However— she chose that it should stay so.'[4] In 1868 Ruskin told the story again for an old friend of the family. When Rose was sixteen and he was forty-five (1864), he writes, 'the mother got jealous of the daughter and pulled us sharply asunder and then I quarrelled with *her*, for being foolish and wicked and things got darker—till it came to eighteen and forty-seven— and then the daughter spoke to me and asked me to wait for "three years."'[5] The account which Ruskin gave Frank Harris in 1886 differs only in detail. That winter he had 'wonderful

[1] Letter to Sarah Angelina Acland, Brantwood, 5 Jan. 18[73] (Ms. Acland d. 170, Bodleian).

[2] MS.51/CII, Bembridge. Twelve copies of this poem have been printed for private circulation. *Ah, Sweet Lady* (Bembridge: The Yellowsands Press, 1968), 8 pp.

[3] Denmark Hill [letterhead], 12 Feb. 1866 (ALS, Yale).

[4] Denmark Hill, 10 Oct. 1866 (ALS in MS. Acland d. 72, Bodleian).

[5] Letter to Mrs. Douglas, Denmark Hill, 8 Feb. 1868, in Walter S. Scott, 'Ruskin and Rosie La Touche', *Quarterly Review*, 286 (1948), 211.

weeks' with Rose at Denmark Hill. 'It was then, he recalled, that I told her I loved her, and with her deep eyes on mine, she asked me to wait until she was of age—"Only three years more," she said. Of course I spoke to her mother, but she seemed displeased and very reluctant.'[1] On the day after this memorable moment in the garden with Rose, Ruskin asks Edward Burne-Jones, 'Did you see the gleam of sunshine yesterday afternoon? If you had only seen her in it, bareheaded, between *my* laurels and *my* primrose bank!' In the same letter he mentions some sittings for a portrait by Burne-Jones, hoping to come 'every other day—Proserpine permitting'. Already he associated Rose with the life-giving daughter of Demeter.[2]

As the La Touches came to understand Ruskin's offer of marriage to their daughter, gradually they made known their opposition. On 22 or 23 February they attended a dinner party at the Cowpers, Ruskin included among the guests. 'I think you will like Mr La Touche', Ruskin writes to Mrs. Cowper as he advises her on the make-up of the party. La Touche, he says, 'is very good—yet, (not by his fault) his coming will take away from the sense of "cosiness," because— more because he thinks so himself' (*LMT. 49, 50*). After the party he writes to Burne-Jones, 'Poor Proserpine had'nt a bone in her hair; but an ache in her head—all dinner time'. Ruskin had to leave before the company moved upstairs after the dinner. He had no sleep that night.[3] The La Touches, Ruskin had learned by 19 February, wanted Rose to be free to consider other suitors. 'I know very certainly she will not engage herself in any way without telling me about it first', Ruskin tells Mrs. Cowper. There was no confidence between Rose and her mother, he declares. Like Cordelia Rose is 'infinitely precious' to her father; '... there is great and true sympathy between them;—except about me' (*LMT.52–3*). To her father's dread of losing her, Ruskin comments to Mrs.

[1] Frank Harris, *My Life and Loves* (New York: Grove Press, [1963]), p. 401.

[2] Ruskin in letter to Edward Burne-Jones, Denmark Hill, 3 Feb. 1866 (ALS, Fitzwilliam Museum, Cambridge University). Passage partially cited in Georgiana Burne-Jones, *Memorials of Edward Burne-Jones* (New York: The MacMillan Company, 1904), I. 300; cited in full in *36.504*, but misdated.

[3] Undated letter postmarked Denmark Hill, 24 Feb. 1866 (ALS, Fitzwilliam Museum, Cambridge University).

Cowper, 'Why—how possibly could he *less* lose her than by giving her to me? He might live with us—or have us live with him—*always*.' Mrs. Cowper counselled patience to Ruskin, suggesting that the La Touches in time might change their minds—but the mother, Ruskin says, 'always told me— *never*—never' (*LMT.59–60*).

Still the parents gave their 'reluctant permission' for Ruskin and Rose to continue in the shadow of their old ways, he tells Mrs. Cowper (*LMT.52*). If things went wrong, Ruskin writes to Burne-Jones in early March, he and Joan have been laying plans 'for getting a poor little house in the country with a garden. . . . I don't know whether I won't even put it to Rosie, when the time comes, as the only possible plan for both of us – For she could'nt live here, Nor I with her sort of people. But I think she would be happy that way'.[1] Illness prevented Rose from attending a performance of the *Elijah* with Ruskin (*LMT.62*). Ruskin meanwhile had lunch with Mr. La Touche hoping to determine 'what were his real and final wishes as to my conduct to her', but the host 'only answered "my dear friend"—and went on to other matters', Ruskin informs Mrs. Cowper afterwards (*LMT.68*). By mid-March the family took another house at 4 Upper Grosvenor Street, and Rose had Joan to lunch and Ruskin to tea (*LMT.64*). 'They actually let her come with my cousin and me shopping—(at least to one shop—) without mama, yesterday,—and we got a little talk—', he writes to Mrs. Cowper on 20 March. 'And they're coming to dine with me—and I'm to have another chance for the Elijah.' Mrs. Cowper, he believes, had served as his good angel with the La Touches, and not without reason did he refer to her as his Madonna and Stella Maris (*LMT.65*). She had worked hard to understand Ruskin's love for Rose. It was not intellectual sympathy he needed from Rose, he tells Mrs. Cowper. 'I have enough of it from men. I do not care for it from women:—nor is it even love that I need. I have had much given me: But I want *leave* to love: and the sense that the creature whom I love is made happy by being loved: That is literally all I want. . . . I don't care that Rosie should love me: . . . I only want her to be happy in being loved' (*LMT.64*). He

[1] Denmark Hill, 4 Mar. [1867] (ALS, Burne-Jones Papers, X. 16, Fitzwilliam Museum, Cambridge University).

dreaded the loss of the three years of waiting for Rose's decision. 'If she *can* cast me into the dark at once, without too great pain for herself—I think she should', he counsels Mrs. Cowper to tell Rose. But neither succeeded in changing Rose's choice for delay. Several months later Ruskin records for Mrs. Cowper his last talk with Rose before the family left for Harristown about the first of April. 'You *know* I have no hope', he said to Rose. 'Why should you not?' she asked. He referred her to his letters in which he had lamented the disparity of their ages. 'For the letters were—in all the compass of them— just the repeating of one word—"Too late, Rosie, love"' (*LMT.105*).

The La Touches encouraged the growing friendship between Joan Agnew and their daughter by inviting her to Harristown. Only two years older than Rose, she must have impressed the La Touches with the same 'nice' qualities by which she had won Ruskin and his mother when she entered the household as a companion to Mrs. Ruskin in 1864. In a note for her birthday on 4 March, Ruskin writes to Joan that she has been 'very kind and good' during the past year, and compliments her for her amiable disposition (*36.502*). Joan was at Harristown in mid-April when Ruskin suddenly decided to include her in the party with whom he was soon to travel in Switzerland, Sir Walter and Lady Trevelyan and their young niece. She was overcome with joy at the prospect of these travels, she writes her aunt, all words leaving her 'that ought properly to express the gratitude I feel to both you and my cousin for ever thinking of arranging such a thing for me'. She includes an appreciative picture of Mr. La Touche laying the foundation stone for a new Presbyterian church at Naas. '... oh Aunt how you would delight in Mr La Touche he is the most earnest Christian in his work I ever saw, and it seems his aim to do good to every one and serve his heavenly master surely his reward will be great in the next world.'[1] Joan would have witnessed the kindness of the family as John McLaren, the gamekeeper of the estate, prepared to marry the maid for Rose and Mrs. La Touche. Rose gave them a Bible with an inscription from Psalm 119: 'Oh that my ways

[1] Harristown, 17 Apr. [1866] (ALS, L 55, Bembridge). Passage partially cited in S. Birkenhead, *Illustrious Friends*, p. 165.

were directed to keep thy statutes.' Mrs. La Touche presented Elizabeth with a wedding dress.[1] Back in London to leave with Ruskin's friends on 24 April, Joan must have been a welcome source of information about Rose who was now forbidden to write him.

During his absence Ruskin directed Charles Augustus Howell, that remarkable toady of the Pre-Raphaelites and now Ruskin's secretary, to forward as little mail as possible. 'Tie up the knocker—say I am sick—I'm dead. (Flattering and love letters, please—in any attainable quantity)' (*36.506*). But Ruskin heard only indirectly from Rose, usually through her letters to Joan or Mrs. Cowper. 'I get a syllable or two—worth a good many words—sometimes, out of the letter she is still allowed to write to my cousin', he writes to Mrs. Cowper in late May. *The Crown of Wild Olive*, a collection of his recent lectures, had just appeared. Ruskin vows to Mrs. Cowper that he intends now to write no more for three years, a promise which he kept practically through this waiting period for Rose (*LMT.71*). Mrs Cowper in June allowed him to see one of her letters from Rose which alluded to some prayer, Rose adding 'if St C would only pray that prayer, too' (*LMT.72*). Rose, he writes to Rawdon Brown on 11 June, knew that she could not please her parents as well as Ruskin. 'So she stays my child pet, and puts her finger up if ever I look grave. But they won't let her write to me any more now, and I suppose the end will be as it should be—that she will be a good girl and do as she is bid' (*36.509*). At Lucerne later that month, Ruskin notes in his diary that he 'Saw antelope like R[ose]' (*D2.592*). By mid-July he was back to the boredom of Denmark Hill. 'Mama provoking in her abuse of people (Colenso &c.) so that I had to come upstairs in evening', his diary reads (*D2.593*). The next day Joan left for a visit in Scotland.

Ruskin eagerly anticipated letters from Joan when she returned to Harristown for another visit in early August. Here to take her attention was 'Pep', Percy La Touche, who had returned home from Egypt perhaps even before Joan completed her earlier visit. His travels in Egypt had been the

[1] As Elizabeth McLaren writes to her sister, Harristown, [c. Apr. 1866]. The letter is preserved at Bembridge inside the Bible with Rose's inscription.

climax of the second section of the Grand Tour which his father had given him to complete his education. Percy, a sportsman at heart like his father in his youth, had never been much of a student. From his sister's schoolroom at Harristown, he was sent to English preparatory schools but he enjoyed most the salmon-fishing and deer-stalking which he learned on the summer visits of the family to the Highlands. Disapproving of public schools, Mr. La Touche reluctantly had entered Percy at Harrow in April 1860 where he lasted five terms.[1] Popular with his school fellows but not amenable to discipline, Percy made little effort, and Dr. Henry Butler, the Headmaster, advised the family to employ a private tutor. Intending his son to enter the family bank Mr. La Touche soon considered Percy's education adequate, and in January 1865, he sent him off for the Continent with a tutor and an itinerary prepared by Ruskin. When Percy returned for Emily's wedding in June, his mother notes that he had been inattentive to Ruskin's suggestions, finding Percy 'provokingly silent as to Art'. Now back from Egypt he had brought a monkey to plague the household.[2] 'Well he is not my sort of boy, but he is my boy', Mrs. La Touche writes to Mrs. MacDonald. 'I wonder if you are shocked & think me unnatural if I confess to you that he disappoints me—.... He is not a bit bad or wild & has never given us any trouble, but he isn't very good either—& he don't *think*—& he eats such a quantity! & is more doggy & horsy than I like—& more contemptuous of female opinion.'[3] He was not reluctant to disagree with his mother. Too much had been expected of him in his studies, he thought, and he could not understand his mother's aversion for hunting or her denigration of the county as Boetia. Pindar, he would remind her, was a Boetian. The same age as Joan Agnew, Percy apparently charmed her almost at once with the friendly manner and witty conversation for which he was known, while she reached him with her simplicity. By the time Joan left Harristown in mid-September, Percy apparently had proposed marriage.

The La Touches, so Ruskin gathered from letters either

[1] *The Harrow Calendar* (Harrow on the Hill: Crasley and Clarke, 1871).
[2] 'Memoir of Percy La Touche', pp. 11, 13–17 (MS., Mrs. Sheila Taylor).
[3] Harristown, Friday, [Summer 1866] (ALS, Yale).

from Joan or Mrs. La Touche, claimed that they had cut off his communication with Rose for his own good. 'You know they do me double harm by this—first because I felt it an insult to be judged for, by them—secondly because it makes me doubt their truth', he writes to Mrs. Cowper (*LMT.81*). Ruskin's notes in his diary about his letters from Harristown at this time are laconic. On 17 August he has a 'nice letter' from Harristown but a few days later he enters blank squares to indicate 'provoking letters, or none' from Joan. On 25 August he has 'nice long letter at last'. He notes on 30 August that his mother had received word from Rose telling of the birth of Emily's baby, Florence Rose, on the preceding day. Only Mrs. La Touche's letters to Mrs. MacDonald preserve any pictures of the family during the summer. 'Rosie is very well indeed & more active than ever—out at early dawn sometimes ... & in & out of every cottage, just as if she was everybody's dog', she writes some time before the baby's arrival. Writing later of 'Old Rose's' devotion to her dog Bruno, she says, 'So far it has not appeared that she will ever have any other husband—but who can tell? ... The Master [Mr. La Touche] has been very busy all the summer—much more so than was good for him—& he has been obliged to spend a great deal of time in that gloomy old Bank in Dublin.'[1] The indebtedness of the La Touche bank to the Bank of Ireland was increasing as the latter accommodated the private bank to £50,000 during the financial crisis of early 1866. To cover their indebtedness, the La Touches later that year agreed to transfer to the Bank of Ireland the large insurance policies which they held on the lives of Mrs. La Touche and her mother and to sell off some of their land holdings.[2] In early September Rose sent Ruskin a copy of *Charles Aucester*, a novel written by that child prodigy Elizabeth Sara Sheppard. A story of musicians and dancers who worship the arts, the heroines are young ladies of age seventeen or less who are courted by much older men. Clara Bonnette, only fourteen, says she does not wish to belong to her wooer, 'nor to any one, only to Music now, and besides, I should not have had his love. He wished to marry me that he

[1] Harristown, Monday, [Sept. 1866] (ALS, Yale).
[2] F. G. Hall, *History of the Bank of Ireland*, pp. 254–5.

might take care of me.' Another of the young ladies confronted with an ageing composer has a morbid presentiment, she says, of her own death. She thinks 'that people who form so fast cannot live long. I am only fifteen, and I feel as if I had lived longer than anybody I know.'[1] Ruskin, knowing well that Rose and he often exchanged messages with hidden meanings could not have overlooked the parallels in this musical romance.

Realizing that Joan was in no position to serve as his intermediary, Ruskin turned to Mrs. Cowper. 'For you must go to Harristown, please', he writes her during the summer months. . . . 'For you *alone* can find out for me whether Rose is acting only in childish love and pity, or whether there is indeed any feeling on her side, deep enough for me to trust to . . .; deep enough to justify me in persevering . . . against the absolute device of both her parents' (*LMT.77–8*). The Cowpers hesitated. In mid-September Ruskin assures Mrs. Cowper that he could not expect her to tell him 'a single word of what passes at Htown'. She should let Rosie talk to her since her parents did not have her confidence. Although Mrs. La Touche was once his dear friend, he writes, 'the power of the daughter over me justifiably now pains her with a not ignoble jealousy—for the mother is in many ways greater-gifted than Rosie—and feels that she ought to have been always principal power over me . . . but she can't understand that she can't be to me what Rosie can'. Complicating her feelings was 'the real womanly weakness and unavoidably womanly pain of dethroned—or abdicating beauty. But this makes her bitter & scornful, & separates her from Rosie' (*LMT.84–5*). He had no doubt of Rosie's feelings for him, but he could not tell if they arose from pity or love. If he could only be sure, his patience would never tire. '. . . let Mr. La Touche take me for a herdsman—*at Harristown*—', he cries to Mrs. Cowper, 'give me a shed to sleep in—and the husks that the swine did eat, for food—and see if I should tire! But, as it is—I am so sick already for the sight of her, that—if it were not that it would plague herself, I would go to Ireland now, and lie down at their gate' (*LMT.87*). This frenetic idea

[1] E. Berger, [Elizabeth Sara Sheppard], *Charles Aucester. A Memorial* (New York: Harper & Brothers, 1853), pp. 38, 131.

stayed with Ruskin, when later he sent Howell to Harristown disguised as a tramp or labourer in another desperate effort to communicate with the La Touches.[1] Mrs. La Touche meanwhile sent the Cowpers a note of welcome. 'St. C's sweet little cousin Joan is still with us but leaves on Monday. We shall all miss her sadly, but no one so much as my boy Percy. She has done him—a roughish youth of 20—all the good in the world.' The same note anticipates her attitudes on more difficult matters. 'Poor St. C. would give anything in the world that Rose was less to him. Only for that, he might be so happy with us.'[2]

The Cowpers did not go out to Harristown until early October, and then limited their visit to a day or two, so Ruskin writes to Henry Acland on 10 October.[3] The three letters which Mrs. Cowper wrote to Ruskin from Harristown are missing, but his replies show that the Cowpers did succeed in talking with Rose. Indeed, wrote Rose to Joan afterwards, she felt that they had 'taken the greater part of her away' with them (*LMT.95*). He learned that she felt duty bound not to write Ruskin, and that the La Touches were adamant that her marriage to him 'could *never* be', and they urged the Cowpers to 'help him to forget us' (*LMT.100, 97, 104*). But Rose's letter to Mrs. Cowper of 18 October makes it clear that she did care for Ruskin. Although she could not predict her decision at the end of the waiting period, 'I *could* tell him that I care for him very much now ... and that *whatever* the end is I shall always care for him.'[4] Mrs. Cowper's reports led Ruskin to write a long letter to Harristown on 17 October in which he apparently enclosed some of Rose's letters probably as proof of her affection. The reply was a 'Bad letter' from Mr. La Touche which kept Ruskin awake that night, he notes in his diary (*D2.601, 602*). 'The father's letter to me was insolent in the last degree.' Ruskin writes to Mrs. Cowper, '—and I have never been able to do the slightest good by any appeal, or reasoning, to, or with him'. Mrs. La Touche decided to do away with Rose's letters. 'She *destroyed* them all—slowly

[1] *Rossetti Papers, 1862 to 1870*, comp. W. M. Rossetti (London: Sands & Co., 1903), p. 297.
[2] Harristown, [Sept. 1866] (ALS, Morgan).
[3] Denmark Hill, 10 Oct. 1866 (ALS, MS. Acland d. 72, Bodleian).
[4] 18 Oct. 1866, cited in D. Leon, *Ruskin the Great Victorian*, p. 391.

murdered me, day by day', Ruskin declares (*LMT.102–3*). Meanwhile the silence from Rose continued. Whatever he said, he wrote to Mrs. Cowper somewhat later, the La Touches 'would not let me write to her—far less see her' (*LMT.107*).

In November Percy made two visits to Denmark Hill to inspect Ruskin's collection of minerals and to see Joan. 'There's been such a lark here!' Ruskin writes to Burne-Jones on 18 November. 'Fairy Rosie's brother coming out two days running—to see—minerals, and the like. – Only I noticed that Miss Joan knew much more about it than I did—but of course that's likely—as they write to her & not to me— ... & Rose wrote yesterday to Joan to insist on knowing what "that dearest-botheringest of brothers" had said—about the minerals. —for the botheringest of brothers would'nt tell *her*. *Joan* looks wonderfully sunny, since.'[1] The courtship was destined to end in less than a year. Already by the following March Joan was writing a 'decisive' letter to Harristown, so Ruskin notes in his diary (*D2.612*), and by summer she was talking of Percy's 'inconstancy' and 'faultful ways'.[2] Apparently she was not among the large party at Harristown on 12 July to mark Percy's coming of age. She may have seen that his tastes, celebrated on this occasion by four medallions representing Percy's passions for fox hunting, salmon fishing, shooting, and cricket,[3] were his weaknesses. When Percy abruptly broke off the engagement in September, Ruskin found it hard to believe 'it was wholly his own doing—but the mother's *through* his weakness'.[4] Fortunately for Joan, another suitor with interests much closer to hers was already appearing at Denmark Hill. In his *Memoir*, Arthur Severn recalls his first impression of Joan with 'a complexion like a rose'.[5]

[1][Denmark Hill, 18 Nov. 1866] (ALS, Burne-Jones Papers X. 18, Fitzwilliam Museum, Cambridge University).

[2]See Ruskin's letter to Joan Agnew, Windermere, 11 Aug. 1867 (ALS, Cowper-Temple Letters, Morgan); and entry for 24 Aug. (*D2.631*).

[3]Letter from Mrs. La Touche to George MacDonald, Harristown, [July 1867] (ALS, Yale).

[4]Ruskin's letter to George MacDonald, Denmark Hill, 7 Mar. 1868 (ALS, Yale), cited in D. Leon, *Ruskin the Great Victorian*, p. 395

[5]*The Professor, Arthur Severn's Memoir of John Ruskin*, ed. James S. Dearden (London: George Allen & Unwin, 1967), p. 26.

The enforced silence from Rose brought a bitter end to the year for Ruskin at Denmark Hill. In late November he had a 'long talk' with Mrs. Cowper (*D2.604*). He would never be living in Ireland, he writes a friend on 10 December. Rose 'must come to me like Ruth—for her people are unforgiveable to me. And it is all very dark to me.' From Rose's letter to Joan that morning he knew that she was studying geology and had been walking the moor with her dog and geological hammer.[1] As Christmas approached, he had a dream of Rose, and the next night a 'Dream of River, "Wolf" coming from under rock', he notes in his diary (*D2.605*). He was depressed on Christmas Day. 'The worst Xmas I ever past', his diary reads. His bitterness matched the mood in which he had written to George MacDonald earlier that same year. Our duty is 'to believe nothing but what we know to be fact, and to expect nothing but what we've been used to get', he asserted. 'Now— if it was possible for me to go to my Father in that personal way—(which it is not—) the very first thing I should say to him would be— "What have you been teasing me like this for? —Were there *no* toys in the cupboard, you could have shown me,—but the one I can't have?"'[2] The La Touches meanwhile were giving their attention to the desperate illness of Rose's uncle, William La Touche, for whom they were caring at Harristown.

Such was the web of tensions on New Year's Day, 1867, when Rose began the writing of her autobiography. Her father, so Percy's biographer observes, regarded any engagement between Ruskin and his daughter as impossible.[3] Mrs. La Touche may have been guilty of no indiscretion with Ruskin, as George MacDonald's son believes,[4] but her failure to break off the relationship gives substance to Ruskin's opinion that she was jealous of Ruskin's love for her daughter. Ruskin meanwhile sensed enough ambivalence in Rose to allow him to hope that eventually she would accept him. The tensions could lead only to further illness for both Rose and Ruskin. In March 1867, following a visit to London during

[1] As Ruskin reports in his letter to Thomas Richmond, Denmark Hill, 10 Dec. [1866] (ALS, Morgan).

[2] Denmark Hill, [about Feb. 1866] (ALS, Yale).

[3] 'Memoir of Percy La Touche', p. 22 (MS., Mrs. Sheila Taylor).

[4] G. MacDonald, *Reminiscences of a Specialist*, p. 106.

which the La Touches forbade any visits between their daughter and Ruskin, Rose became sick (*D2.613*); later in the year her illness worsened. During the summer she appeared to Ruskin in a dream as in a boat, looking pained when she saw him on the shore, and rowing away (*D2.629*). By September he was under doctor's care. One can understand Ruskin's retrospective view of his dilemma with Rose—and the events which were to follow—as 'the result of a foolish father's care, and a wicked mother's cruelty, and a true lover's love'.[1]

D. EPILOGUE

1. *The La Touches and Effie Millais; later meetings between Ruskin and Rose; her death in 1875*

FOLLOWING THE death of her uncle at Harristown in January, Rose records in her diary her versification of the 23rd Psalm with her observation that although the Psalmist declares he will not want, she realizes that she *does* have wants, that somehow her faith has not brought her gladness in life. Her remaining eight years never bring her this happiness. Only a highlighting of the main turns in the tragic course of her relationship with Ruskin is needed to complete this perspective on her diaries.

The flow of letters from Rose during the days of William La Touche's illness may have led Ruskin to hope that he would see her when she came to London in February. On 7 January he received a 'lovely letter', so he notes in his diary, and on the next day another significantly 'with flowers on the envelope'. Then follow a 'Beautiful letter' about her uncle's funeral and a few days later a 'Divine letter' (*D2.608*). As her diaries show, Rose had been writing poetry. Enclosing some bits of it for the MacDonalds, her mother comments that 'the thoughts are pretty & nice tho' the lines are worth nothing'. She tried to take little notice of it. 'Encouragement would make her go on to headache pitch, repression would make her boil & simmer inwardly.'[2] In a second note to one of the

[1] Ruskin in letter to Lady Mount Temple, Christ Church College, 22 Jan. [1874], *The Brantwood Diary of John Ruskin*, p. 498.

[2] Letter from Harristown, [21 Jan. 1867] (ALS, Yale).

MacDonald girls, Mrs. La Touche believes that Rose 'is too much alone, not having, like you a number of brothers & sisters, & friends near at hand— Her two best friends are people whom she cannot invite to sit with her indoors, because one of them, (called Bruno) is an enormous dog whose coat is generally dripping from the river—.' The other was her horse.[1] On 29 January Ruskin entered three crosses in his diary to mark his resolution that evening 'on new way of trying for what I want'. Rose had been sending Ruskin some of her poetic efforts, and two nights before her arrival in London on 5 February Joan played him 'R[ose]'s hymn for first time'. The next morning he received another 'Divine' letter from Rose. At half-past ten the following evening Ruskin writes in his diary: 'R[ose] perhaps within four miles of me' (*D2.609, 610*).

But his diary for 6 February carries only three crosses as a mark of his suffering and his later note: 'The awful day when I learnt what Lacerta was' (*D2.610*). Evidently Mrs. La Touche lost no time in writing to Ruskin that Rose was not to see him. Joan, because of her engagement to Percy, was not excluded and on 9 February she accompanied Mrs. La Touche and Rose to the Crystal Palace to see a company of Japanese jugglers. Again Ruskin enters three crosses in his diary with the notation, 'Deadly day'. His efforts at drawing a nautilus shell fail to distract him. 'Day of terrible suspense', he writes half way through the month (*D2.611*). The Cowpers dared not include Ruskin when they entertained the La Touches. '... I shall never pass through Curzon Street more —', so Ruskin wrote Mrs. Cowper a year later, 'I remember too well the night last year, when I should have waited at your door—with the night beggars—to see her pass, if I had not feared to hurt her' (*LMT.182*). In his diary for 18 February he writes that 'the hours increase in torment'. The next day he records his wait for Joan to come from Berkeley Square where she apparently had been with the La Touches. On Thursday of that week he went to watch the Japanese jugglers and thought of going again the next night on the 'chance' that he might see Rose. On Saturday he wrote a 'prayerful' letter to

[1] Undated letter to Lila Scott MacDonald, Harristown, in envelope postmarked 24 Jan. 1867 (ALS, Yale).

Mr. La Touche beseeching him 'for Christ's sake—that I might see her face once more', as he summarized it later for Mrs. Cowper. The reply was in such terms as 'A Banker uses to his clerks' (*D2.612*; *LMT.109*). Meanwhile the atmosphere at the La Touche lodgings was no less tense, as Rose's diaries reveal. Mrs. La Touche argues one evening that bitterness and jealousy mark the wake of disappointed love. But Rose inists that a lady of true love who has heard that her intended 'had done something that had lowered him forever in her eyes' and made marriage impossible, nevertheless would not feel bitter since such feelings would only prove that her love has been 'tainted with some predominating sin or passion'.[1]

Cut off from Rose, Ruskin discovers that he can speak to her (or her parents) through the public letters which early that month he had initiated with Thomas Dixon ostensibly on the subject of political economy. A few days after the departure of the La Touches to Harristown in late February, Ruskin explains to Dixon and his readers his attitude on the Bible, the key point on which his beliefs differed from those of John La Touche. Most of the British public, he argues, view the Bible first as literally true, a position which Ruskin describes as 'tenable by no ordinarily well-educated person'. Or they agree with most clergymen that at least the substance comes from Divine inspiration. But Ruskin seems to identify himself with the group who regard the Scriptures as merely the best of man's efforts towards the discovery of 'some relations with the spiritual world', no more authoritative than the religious speculations of other peoples like the Egyptians and Greeks (*17.348-9*). This and others of Ruskin's letters to Dixon show that he was not prepared to compromise his ideas. If his and Rose's faiths were to be reconciled, he writes to Mrs. Cowper in late March, 'it seems to me quite as reasonable to expect that an Irish girl of 19, ... should be brought finally into the faith of a man whom Carlyle & Froude call their friend, and whom many very noble persons call their teacher, as that he should be brought into hers. ... If she can join herself to my life and its purposes, and be happy, it is well—but I am not to be made a grotesque

[1] *Autobiography of Rose La Touche*, see below, p. 180.

chimneypiece ornament ... of the drawingroom at Harris-town.' Of Rose's loyalty to her father, he declares, 'She's Cordelia—twenty times worse—' (*LMT.114–15; 110*).

Through some chance on his birthday which Ruskin attributed to the grace of God he found Rose's prayerbook (*LMT.110*). Together with a book of texts in Greek and English which she had given him in connection with her study of Greek,[1] this prayer-book led Ruskin to resume his daily reading of the Bible. Not that he was coming to think of the Bible as the 'word of God', he cautions Joan that summer, but because of his love for Rose he believes that God was teaching him 'by her lips, through her book'.[2] Thus in February, during his days of anger with Mr. La Touche, he notes Paul's admonition, 'Recompense to no man evil for evil'.[3] In March when Rose fell ill and he attempted to write to her only to receive a 'mad letter from L[acerta]', Ruskin reads of the man with a pitcher of water who was to lead the disciples to the upper room.[4] In May, when Rose in a letter to Joan was allowed to name Ruskin, he reads the 61st Psalm, reassurance he would need in the difficulties ahead. It was in June that he enclosed at least one of Rose's letters between plates of gold to carry in his pocket (*D2.617, 619*). He spent nearly two months of the summer in the Lakes partly for his health, so he writes to Joan later of this holiday, 'partly that I could not bear to go far from that Irish sea'.[5] He filled his thoughts with Rose and looked for symbols of her: the wild roses at Keswick, a child whom he rowed on the lake in the evening.[6] She was in his dreams, sometimes in counterpart, one night as a child with keys which she wanted to sell to Ruskin until someone suddenly crushed them. On 3 August he notes in his diary that half of this waiting period of three years was completed.[7] A few days later he knelt on Mount

[1] As Ruskin relates in his letter to Kathleen Olander, Geneva, 5 Sept. 1888, in *The Gulf of Years: Love Letters from John Ruskin to Kathleen Olander*, ed. Rayner Unwin (London: George Allen & Unwin, 1953), p. 63.
[2] Keswick, 17 Aug. 1867 (ALS, L 33, Bembridge).
[3] Romans 12:17. See *LMT.110*.
[4] Luke 22:10–13. See *D2.613*.
[5] [Giessbach, 23 Aug. 1869] (ALS, L 34, Bembridge).
[6] Entries for 5 and 28 July, 1867 (*D2.622, 627*).
[7] Entries for 9, 3 Aug. 1867 (*D2.628, 627*).

Skiddaw and recalled the supplication of the Litany for pity 'upon all prisoners and captives', a prayer which had brought him a feeling of 'boundless liberty' as he saw below him 'leagues of moorland tossed one after another like sea waves'.[1] Rose's texts, which now appear almost daily in his dairy, seem to speak to his dilemma.

He looked for other light from analogues in literature. Writing to Norton in August in a passage which Norton omitted from his edition of Ruskin's letters, Ruskin compares his anger to that of the Master of Ravenswood in *The Bride of Lammermoor* against Lady Ashton whose efforts to thwart his love for her daughter included the intercepting of their letters and the circulation of rumours that Lucy might marry another suitor.[2] Such a rumour reached Ruskin, and in July Rose sent him a rose which he took as a pledge of her constancy (*36.531*). In early October he received a letter in which she apparently told him of a resolution to remain single (*D2.637*). He soon associated her with Atalanta, 'the maiden rose' of Swinburne's *Atalanta in Calydon* which he had read in recent months, 'Arcadian Atalanta, snowy-souled, / Fair as the snow and footed as the wind'.[3] Writing to a former pupil at Winnington, Ruskin declared that for these seven years he had been 'dying for love of Atalanta, who was eleven years old—(not quite), when I fell in love with her first. ... Well when Atalanta was eighteen she told me to wait three years— then she would answer me, but she had *not* answered me yet. And—since then ... she's gone mad, boar-hunting, I think. For just after your last letter came, behold, Atalanta wrote to me to say she would'nt marry at all!'[4]

During the early months of 1868 Ruskin and the La Touches each made desperate moves, both at cross-purposes. In December Rose had been staying in Dublin at the Shelbourne Hotel, presumably ill and under doctor's care (*WL.608, 611*), but she had promised to write to Ruskin on Christmas day and did not—a failure which he told Mrs.

[1]Ruskin in letter to Joan Agnew, [Keswick], 15 Aug. [1867] (ALS, L 33, Bembridge).
[2]Ambleside, 8 Aug. 1867 (ALS, Norton Papers, Houghton).
[3]*Atalanta in Calydon*, lines 44–6.
[4]Letter to Dora Livesey, Denmark Hill, 25 Oct. [1867] (ALS, Miss Olive Wilson).

Cowper 'has cursed the day for ever to me into the darkness' (*LMT.129*). Jealousy had prevailed against all good, he writes to a family friend, the parents had used their full strength, and had 'conquered' Rose.[1] By chance in early March a lecture committee in Dublin invited him to speak there during May. Against the improbabilities he conceived the lecture as a means of conciliation with the La Touches and perhaps a meeting with Rose. The La Touches, realizing meanwhile that they could not end Ruskin's entreaties or Rose's occasional letter of encouragement to him, now sought convincing evidence to use with their daughter against Ruskin's potential as a husband, proof that could come only from his first wife now married to the painter, John Everett Millais. Mrs. La Touche's letter to Effie Millais, apparently written in May, has been lost, as well as the reply from Mrs. Millais, known to have been dated 18 May. The latter letter carried something of the belief of Mrs. Millais that a second marriage for Ruskin would throw doubt on the decree of nullity which had been granted to her on the grounds of Ruskin's impotence, and her threat to publicize the decree if Ruskin and Rose were to announce the banns of marriage.[2] In her letter of acknowledgement to Mrs. Millais, Mrs. La Touche included the gratitude of her daughter for this information 'that has saved her, and us all, from so much misery'.[3]

Until the arrival of this letter, Ruskin was not wrong to hope that he would see Rose when he came to Ireland. At the end of April she had written to him to 'Say what you will to me' (*LMT.149*), and the next day he had entered 'Peace' in his diary. 'She is mine, and nothing can come between us any more', he writes to Mrs. Cowper on 4 May (*LMT.150*). Joan was to accompany Ruskin to Dublin, and they left early to spend several days first at Winnington Hall where Ruskin planned to complete the writing of his lecture. The delightful

[1] Letter to Mrs. Douglas, Denmark Hill, 8 Feb. 1868, in Walter S. Scott, 'Ruskin and Rosie La Touche', *Quarterly Review*, 286 (1948), 211.

[2] As Mrs. La Touche writes to Mrs. Millais in her letter from Harristown, 8 Oct. 1870, in Mary Lutyens, 'The Millais–La Touche Correspondence', *Cornhill*, 176 (1967/8), 9.

[3] [Harristown, 21 May 1868], in M. Lutyens, 'The Millais–La Touche Correspondence', p. 7.

setting of this school in the Cheshire hills made Joan think of the park at Harristown (*WL.616*). Rose's letters elated Ruskin, especially the last one before they left for Dublin in which she told him, so he writes to his mother, that 'she means to try to see me—and it is all as right and nice between us, now, as can be' (*WL.622*).

If the La Touches were in that audience of some two thousand, they would have found much to admire in Ruskin's lecture, 'The Mystery of Life and Its Arts', including his graceful recollection of Mrs. La Touche's brother—'a man of superb personal beauty and of noble gifts of mind' (*18.169*). The lecture series had a restriction against religious topics, but the La Touches would have understood Ruskin's opening insistence that he must speak about the devotion of the arts to the expression of divine truth. They would have appreciated other characteristic themes: the relation of art to life; the importance of noble motive in the artist; the reach of the artist for a loveliness which lies beyond his grasp; the nobility of feeding, clothing, and housing the less fortunate—the humanitarianism dear to John La Touche. But the La Touches also might have felt personally implicated in the melancholy of the proem to the lecture in which Ruskin describes the disappointments of his middle years as he finds himself startled by 'the fading of the sunshine ... into the sudden agony' of knowing the fragility of life, a passage rightly described as Ruskin's elegy to his forsaken hopes and shattered faith.[1] The La Touches could have had a private understanding of his comments on that purest love which 'too often does but inflame the cloud of life with endless fire of pain' (*18.174*). They could not have missed the barb of the peroration in which Ruskin describes the corruption of religion as the greatest of the mysteries of life, particularly when it wastes the vital powers of earnest young women in 'grievous and vain meditation' over the Bible, warping their consciences with 'fruitless agony concerning questions which the laws of common serviceable life would have either solved for them in an instant, or kept out of their way' (*18.186*).

[1] *18.146*; John Rosenberg, *The Darkening Glass* (New York: Columbia University Press, 1961), p. 171.

Ruskin was not at all prepared for the note he received from Rose the morning of his lecture. Under the impression that she 'has free leave to write now, what she will', as he had told his mother shortly before he left for Dublin (*WL.618*), he was astonished to read: 'I am forbidden by my father and mother to write to you, or receive a letter' (*LMT.155*). Elsewhere in the note she adds a line intended, it seems, to mollify the effect of the message: 'I *may* tell you that this has been a happy May to me—happy enough to throw a light over all the rest of the year, however cloudy that may be' (*WL.642*). Her enclosure of two rose-leaves, ordinarily a sign of reassurance, did not lighten the heaviness of heart with which Ruskin was obliged to deliver his lecture in the afternoon. No less mystifying was a floral tribute which a messenger presented to him at the end of the lecture, a large cluster of the Erba della Madonna in bloom with purplish flowers which Ruskin had observed on the capitals of St. Mark's porch and which (he tells Mrs. Cowper) 'was always considered as *my* plant, at Harristown'. In the centre were two bouquets, 'one a rose half open, with lilies of the valley, and a sweet scented geranium leaf' (*LMT.156*). The flowers must have come from Rose, and he soon took them as 'a sign of her being right, in the heavenliest way' (*WL.607*). A year later he was to classify these flowers as the fairest of a group whose spots suggest that they have been touched by poison, beautiful but capable of an 'evil serpentry' (*19.377*).

It was during Ruskin's fortnight in Ireland that Mrs. La Touche heard from Effie Millais. Her letter only added to the family problems. During the winter John La Touche had left Harristown every day before dawn to travel to Dublin to stave off the collapse of the family bank. His principles, according to his wife, were above those of the other partners. 'And so we are not nearly so rich as we were', she had written to Mrs. MacDonald, 'seeing he has sold or is selling all the land he has except in Kildare & paying other people's debts, for the benefit of the public'.[1] Then on 1 June their daughter Emily—'my sweet, fair, gentle Emily', as Mrs. La Touche

[1] [Dublin, Feb. 1868] (ALS, Yale).

describes her—died at sea returning with her second child from Mauritius.[1] Confronted with the legal issues which Effie presented in her letter, the La Touches turned to a solicitor for counsel only to learn that his views agreed with those of Mrs. Millais that Ruskin was not free to remarry. If he had children by a second marriage, the divorce could be annulled, the former marriage held good, and his children considered illegitimate.[2] Ruskin, who had been staying with friends in Dublin and vicinity, meanwhile felt sufficiently encouraged by the secret language of Rose's flowers to think of finding a house nearby, on 19 May driving into County Wicklow to look at a possibility. A few days later he writes to Mrs. Cowper that he has debated 'whether or not to take the train to Sallins and walk round H.town—on the chance of meeting her [Rose] on a walk. But I felt that if I succeeded, I might only give her pain, and that the coming away again might be too terrible for me. So I have been wistfully staying, within twenty miles of her, climbing spurs of the Wicklow Hills, and looking across the plain—to where she was' (*LMT.162, 163*).

Even before Ruskin's return to Denmark Hill on 2 June, the La Touches had informed the Cowpers of the revelations from Effie Millais. Perhaps Mrs. Cowper would not even read his note, so Ruskin begins his letter to her, knowing by this time 'that all is over'. He realized 'that this thing, whatever it is, has been openly against me from the year 1854 till now' (*LMT.165*). The cry was against him; Rose had fallen under Effie's influence, and Rose had written Ruskin in words that were 'fearful', so he tells Mrs. Cowper in successive letters (*LMT.169, 170, 167*). George MacDonald now demanded the truth of Ruskin. 'Was it true that you were incapable?' Ruskin denied it unconditionally. Then why did he not defend himself at the divorce? He had never loved Effie before he married her, so MacDonald's son records his father's memory of Ruskin's reply, but he had hoped that he might come to love her. Without this love, which never developed, Ruskin would not complete the sexual relationship which he held as

[1] Harristown, 29 June 1868 (ALS, Yale). Passage published in D. Leon, *Ruskin the Great Victorian*, p. 412.

[2] D. Leon, *Ruskin the Great Victorian*, pp. 402–3.

sacred.[1] Ruskin would not pretend to Mrs. Cowper that he was sinless. Alluding to that sexual vice which Rousseau described as so attractive to timid young men of lively imaginations and to which he had confessed in his youth, Ruskin asks, 'Have I not often told you that I was another Rousseau?' But that sin of his early life was 'indeed past as the night'. He could trust that knowing the worst of him, Rose would not forget his best. 'Tell her—will you not—', Ruskin implores Mrs. Cowper, '... to trust—not me—but her own heart. And there yet may be light' (*LMT.167*). Meanwhile his old friend, the Revd. William T. Kingsley, counselled Ruskin to have no fear of the outcome of these matters; '... you have only to continue your clean straightforward unselfish course to prove to all who care to know that you are not like your enemies' pictures'.[2]

When Charles Eliot Norton saw Ruskin at home in mid-August and later in Abbeville and Paris during Ruskin's sojourn abroad for his health, he must have heard more of his troubles with the La Touches. Ruskin had often thought of writing his autobiography, he writes to Norton in September in another of those passages which Norton excised from his edition of the letters, but he hesitated because the greatest part of his life had been 'one succession of Love-sorrow, which I could only describe by giving myself up to it hour by hour and pain by pain—by writing another Nouvelle Heloise— which ... would not be the *best* work I could leave behind me'.[3] His thoughts were on Rose to whom he could not write. On one occasion he had a 'most strangely happy dream' about her (*D2.655*). He noted for Joan that Norton, walking with him in the Parisian boulevards, bought for his daughter 'a little doll—... in a green gown—only strapped over shoulders, which are white, with flaxen hair—and the face almost—only the eyes a little darker,—the very image' [of Rose].[4] Norton took note of the change in Ruskin, 'mentally more restless and unsettled', no longer possessed even of moderate happiness (*LN1.177*)—an observation borne out by the

[1] G. MacDonald, *Reminiscences of a Specialist*, pp. 100–1.
[2] S. Kilvington, 5 July 1868 (Typescript, Bowerswell Papers, Morgan).
[3] Abbeville, 11 Sept. 1868 (ALS, Norton Papers, Houghton).
[4] Paris, 6 Oct. 1868 (ALS, L 33, Bembridge).

entries in Ruskin's diary during the rest of the year. Ruskin
told Kate Greenaway later that a nightmare he suffered in
Abbeville on 12 October in which the wall-papers turned into
faces was the first real sign of the insane delusions leading to
his collapse.[1] Near the end of the year Rose was suffering
attacks of violent pain. The doctor had forbidden letters from
even the kindly Mrs. Cowper, so Mrs. La Touche writes as
she sends the Cowpers a copy of the legal opinion she has
obtained about Ruskin's divorce. She asks if they think it
'pardonable that he should have offered marriage', and she
begs them to understand the necessity to cut off his appeals as
well as 'those of his friends, against the right judgment of her
natural protectors'.[2] Again Ruskin associates Mrs. La Touche
with the serpent. She is like a Lamia, he tells Mrs. Cowper,
'only with a strange Irish ghastliness of grotesque mistake
mixed with the wickedness'. In Jael's destruction of Sisera he
finds a counterpart for her perfidy (*LMT.182*).

By 2 February 1869, Rose had already passed her twenty-
first birthday and the third anniversary of Ruskin's proposal
to her. The three years which she had told him to wait before
asking her again had provided no opportunity for them to
meet and now no hope that she could even receive any
renewal of his offer. Ruskin had awakened on her birthday in
January from a heavy dream of wandering about the streets
of Dublin in the dark. In his diary for 2 February he notes 'all
wrong.... sick and weary' (*D2.663, 664*). For more than a year
he had ceased numbering the days before Rose would come
of age. He busied himself now with several lectures from
which he drew the three essays in *The Queen of the Air*, a
study of the mythography of Athena which again he used as
a channel of private talk to Rose. Of the book which chance
had set upon him, he tells Mrs. Cowper in April, 'There's a
word or two here and there—which only ρ will understand'
(*LMT.197*). Rose marked these passages with unsympathetic
comments in the margin of her copy. Ruskin, writing of the
serpent with which Athena was associated, had moved to the
serpentine corruption of Christianity. 'And truly, it seems to

[1] Note in Joan Severn's hand on first flyleaf of Ruskin's diary for 1868 (MS. 15,
Bembridge).
[2] Dublin, 11 Dec. 1868, in D. Leon, *Ruskin the Great Victorian*, p. 415.

me, as I gather in my mind the evidences of insane religion, degraded art, merciless war, sullen toil, detestable pleasure, and vain or vile hope ... —it means to me, I say, as if the race itself were still half-serpent, not extricated yet from its clay; a lacertine breed of bitterness' (*19.365*). Rose did not miss the sting, writing in the margin: '? Poor green lizards! they are not bitter: Why not say serpentine?' Opposite Ruskin's assertion that Christianity has never excelled heathenism (*19.418*), Rose writes 'oh—'. To Ruskin's farewell to the reader at the end: 'And so I wish you all, good speed, and the favour of Hercules and the Muses; and to those who shall best deserve them, the crown of Parsley first, and then of the Laurel' (*19.420*), Rose adds: '& afterwards a better Crown that fadeth not away'. On the flyleaf of this book Rose cites what may have been a remark of Ruskin's, 'If she could but understand it! & if it was not quite so heathenish!'[1]

Ruskin left for Italy in late April on a commission from the Arundel Society to make some drawings of the tombs of Verona. He had suffered so much pain, he tells Mrs. Cowper, that he had no sorrow left for anything, that in Verona he would 'live under those tents of the dead' (*LMT.192*). On an excursion to Venice in May he visited the Accadèmia and for the first time gave his attention to the series of paintings which Carpaccio had painted on the life of St. Ursula, the Christian princess who gave her hand to a heathen prince on the pledge of his baptism and a three year delay so that she could make a pilgrimage to the Holy Land. This Carpaccio, Ruskin wrote to Burne-Jones excitedly, 'is a new world to me' (*4.356n.*). Even on first impression he was particularly charmed by *St. Ursula's Dream* in which an angel appears to the sleeping princess to tell her that she should win the hearts of the heathen.

At home by the end of August Ruskin worked on his lectures for the professorship to which he had been appointed at Oxford, but Rose stayed in his thoughts and sometimes in his dreams. He copied out for Mrs. Cowper some old French songs with allusions to love and roses and spoke of his plans for a botanical book to be titled *Proserpine*, pointing out that the first two letters stand for 'pet' and 'Rose' (*LMT.235*). In

[1] Rose's annotated copy of *The Queen of the Air* is preserved at Bembridge.

October Rose sent him via the Cowpers a botanical book containing what he called 'a bit of my own weed' (probably the Erba della Madonna) 'and a single rose-leaf (*green* leaf only)' laid together into a page that discussed a heart-shaped plant (*LMT.236*). What could this mean, he asked Mrs. Cowper. A few weeks earlier he had had a troublesome dream of himself 'going down a spiral stair in a tower, broken and difficult, till a cobweb came across my face, and I thought, "I can't have come *up* this way"'. In November he dreamed of a serpent with a woman's breasts which entered his room under a door; and another which fastened itself on his neck like a leech (*D2.680, 685*). Rose meanwhile was well enough in October to travel to France with a friend without her parents, Ruskin learned through the Cowpers.[1] At some point that year Rose and her mother each wrote a retrospective poem about her life. 'Let me record what life has taught me / In the lapse of its five and forty years', Mrs. La Touche begins her poem, 'A Life's Lesson'. She has learned 'that life is a hopeless tangle' to which she cannot find the clue; that the commonest natures are the best because they ask 'no questions from Star or Sun'; that 'the Devil disguised as Angel of Light / Has much to do with the soaring flight / Of the restless heart and the seething head'; that Genius is only fever and morbid dream; that the blessings of God may be understood best through love of the beauties of nature.[2] 'I would look back upon my life tonight, / Whose years have scarcely numbered twenty-two', Rose begins her poem, 'A Retrospect'. She too has learned that life is sad, and she yearns to leave the 'clouded past' within God's hands. Like her mother she loves Nature but can find no anodyne in it for the soul's weariness. Her eyes are dim, as she looks back; 'I have not done that which I knew was right, / I have not wholly loved and followed Him'.[3]

His chance encounter with Rose on 7 January 1870—the first time he had seen her in four years—opened for Ruskin another cycle of hope and bitterness. About twelve o'clock he entered the Royal Academy, he writes the next day to Mrs.

[1] Rose in letter to Joan Agnew, Denmark Hill, 25 Oct. 1869 (ALS, L 4, Bembridge).
[2] *The Letters of a Noble Woman*, pp. 239–44.
[3] Rose La Touche, *Clouds and Light* (London: James Nisbet & Co., 1870), pp. 135–9.

Cowper-Temple (as the Cowpers were now known), and the first person he saw was Rose. 'She tried to go away as soon as she saw me, so that I had no time to think—I caught her, — but she broke away so that I could not say more than ten words—uselessly.' Ruskin approached her again to offer 'her letter of engagement' which he carried between the gold plates. 'She said "No." I said again—No? enquiringly. She repeated the word. I put the letter back into my breast and left the rooms' (*LMT.247*). In his diary he recorded the incident with only a cross on a page which is otherwise blank. Perhaps because of a talk with Joan, Rose wrote Ruskin a letter which failed to satisfy his feeling that she had treated him cruelly (*LMT.259*). By mid-February he had heard from her again asking 'if all was at peace' between them. His fury explodes in his reply as he tells her the inscription he meant to write in her copy of the lectures he was giving at Oxford. 'To the woman, / Who bade me trust in God, and her, / And taught me / The cruelty of Religion / And the vanity of Trust.' But he closes the letter with the admission that he could not help loving her still.[1] Rose apparently wrote two replies, the first of which she sent via Mrs. Cowper-Temple who decided not to give it to Ruskin. 'Your inscription would have been most unjust', she asserts. 'Who has so great a right to say God bless you, as the one who most desires it for you.'[2] On 24 February he heard from her directly: 'I will trust you. I do love you. I have loved you, though the shadows that have come between us could not but make me fear you and turn from you. . . . I believe God meant us to love each other, yet life—and it seems God's will has divided us.' Thinking of her return to Harristown, she reminds Ruskin that her parents forbid her writing to him, and that she cannot do so in secret. 'And now—may I say God bless you?' she asks in closing. 'God, who is Love—lead—guide, & bless us both.'[3] Although he could not see Rose or write to her, he tells Mrs. Cowper-Temple, 'She has come back to me' (*LMT.268*). The great

[1] As Ruskin writes Mrs. Cowper-Temple, Denmark Hill, 20 Mar. 1870 (*LMT.272–73*).

[2] D. Leon, *Ruskin the Great Victorian*, p. 480.

[3] Cited in Ruskin's letter to Mrs. Cowper-Temple, Denmark Hill, 20 Mar. 1870 (*LMT.273 74*).

darkness has ended, he informs George MacDonald, '&
nothing more can take her from me—in heart—though—if
fate will have it so I may never see her'.[1]

Norton heard the news with dismay, finding it hard to
understand how Ruskin could 'be patient with her who has,
as it seems to me, needlessly renewed your suffering & broken
the current of your days with a new trial. I could accept
Lucretius's hardest line—Religio qui potuit. There is nothing
so cruel as the heart that thinks itself one with God.'[2]

The succeeding weeks of silence dulled Ruskin's new
confidence in Rose. Shortly before he left for the summer's
travel on the Continent he received indirectly a copy of Rose's
recently published collection of stories and poems entitled
Clouds and Light. Although the title page carried the
admonition to Job that God 'wearieth the thick clouds ... and
caused the light of his cloud to shine', Ruskin read the book
with impatience. If she wrote the book for him, why had she
dedicated it to an Edith—unknown to him? The book showed
only 'the forming of her mind permanently in the fatal dream
and narrow furrow of thought' (*LMT.277*). Poor thing, he
writes to Mrs. Cowper-Temple, 'how she is wasting her sweet
soul' (*LMT.275*). Still he cautions Norton not to be angry
with Rose. 'My life was entirely at an end in a certain sense—
before— And she has made it now—far better than it
was.'[3] But in Vevey he noted in his diary that he was 'bitterly
sad' (*D2.695*). On his return Ruskin acquired a manuscript of
the *Roman de la Rose*, a purchase whose timeliness he could
attribute to Providence. Receiving a photograph of Rose via
Mrs. Cowper-Temple, he risked a letter to Rose, asking his
mother to address the envelope (*D2.701*). He also exchanged
some letters with Mrs. La Touche's sister-in-law, Lady
Desart. 'Why is Rosie sad—believing what she believes?' he
asked. '... Will you help me now—or Never?'[4] Meanwhile,
apparently on the urging of the Cowper-Temples, he was

[1]Undated letter in envelope postmarked London, 11 Mar. 1870 (ALS, Yale).
Passage cited with differences in D. Leon, *Ruskin the Great Victorian*, p. 481.

[2]Florence, 31 Mar. 1870 (ALS, Norton Papers, Houghton). The allusion to
Lucretius is from *De Rerum Natura*, I.101, trans.: 'Such evil deeds could religion
prompt.'

[3]Geneva, 4 May [1870] (AL[initials], Norton Papers, Houghton).

[4]Denmark Hill, 15 Sept. 1870 (ALS, Cowper-Temple Papers, Morgan).

trying to clarify his marital status. In a statement dated 20 September 1870, he concludes: 'I am in Law unmarried & in my conduct to my wife—I boldly say & believe—guiltless— though foolish.'[1] Through some means the Cowper-Temples showed this statement to Rose.[2]

These events alarmed the La Touches, and again they turned to Mrs. Millais. What they needed now, Mrs. La Touche writes to Effie on 8 October, was 'a contradiction of the statements Mr. Ruskin is now making to Mr. Cowper-Temple, who with his wife, has great influence over my daughter—and is using that influence eagerly, to justify Mr. Ruskin in all things, and persuade my unhappy child that she is bound to reward his love and constancy, by at least hearing his defence and allowing him to renew his addresses'. Ruskin, she adds, now denies the impotence stated in the decree as the justification for the divorce. The exchange of correspondence, all made available by Lutyens, includes Effie's well-known reply of 10 October in which she declares that Ruskin's mind 'is most inhuman; all that sympathy he expects and gets from the female mind it is impossible for him to return excepting upon artistic subjects which have nothing to do with domestic life'. Mrs. La Touche, promptly showing the letter to Rose, reports appreciatively to Effie on 14 October that her child is now 'quite saved' and has promised her father to have no more to say to Ruskin.[3] The manuscript of the Preface which Ruskin was preparing at the end of the year for a new edition of *Sesame and Lilies* reveals his bitterness as word reached him about these new communications between the La Touches and Mrs. Millais. Since writing the *Lilies* in 1864, he has come to see 'more of the evil that is in women than of good'. Following his praise of woman as exemplified by Mrs. Cowper-Temple, Ruskin turns to those degraded and vindictive women [*like Effie?*] from whom he has learned 'the gloomiest secrets of Greek and Syrian tragedy'. Some women [*like Rose?*] are cruel through 'want of power of imagination

[1] From copy in unknown hand of Ruskin's statement (Cowper-Temple Papers, Morgan).

[2] As Mrs. La Touche indicates in her letter to Mrs. Millais, Harristown, 14 Oct. [1870] in M. Lutyens, 'The Millais–La Touche Correspondence', p. 15.

[3] M. Lutyens, pp. 9, 10, 13, 15.

(a far rarer and weaker faculty in women than in men;) . . .'.
Such women suppose that 'all will be brought to a good end'
because of 'the doctrines of shallow religion'. He continues:
'I have seen them [*like Effie?*] betray their dearest duties to
lust in frantic passion; . . . I have seen mothers [*like Mrs. La
Touche?*] do their guard their children as Athaliah did hers;
and children [*like Rose?*] obey their parents as the daughter
of Herodias.'[1] Discretion led Ruskin to omit or reduce the
venom of the most of these passages in the published version
(*18.47–8*).

Although Ruskin gave the opening months of 1871 to his
lectures at Oxford and the first of the letters in *Fors Clavigera*,
inwardly he chafed in his exile from Harristown, and
redoubled his efforts to prove that legally he could remarry.
Through his solicitor and W. W. Richardson, his cousin,
Ruskin sought a legal opinion from Dr. Thomas H. Tristram
at the Temple whether anyone could now impeach the decree
of divorce. In Tristram's opinion, as Richardson summarizes
it, neither Ruskin nor Mrs. Millais could impeach the decree.
'For all practical purposes', Richardson concludes, 'you are
free to marry again.'[2] Ruskin lost no time in posting this
information to William Cowper-Temple, adding in his letter
of 23 July that by the same post he was writing to Rose to tell
her that she should now 'rationally determine if it will be
advisable to marry or not'. His was a 'very civil letter', he tells
William a few days later, but Rose's reply, he says, beat
everything 'for folly, insolence, and selfishness' he had yet
known produced 'by that accursed sect of religion she has
been brought up in' (*LMT.298, 310*). Even Joan, who had
remained friendly with the La Touches, was shocked that
Rose was 'capable of such conduct' and thought that she had
spoken in terms 'which never can be forgiven', she writes to
Mrs. Cowper-Temple.[3] Ruskin had Joan send back Rose's
letter with a note that as soon as they had left Matlock (where
he had been confined with a serious intestinal upset brought

[1] MS. of 'Preface' to *Sesame and Lilies*, 1871 edn. (Typescript, Viljoen papers, Van
A. Burd).
[2] Richardson's letter written from London, 21 July 1871 (ALS, Cowper-Temple
Papers, Morgan). A handwritten copy of Dr. Tristram's opinion, 19 July 1871, is in
the same collection.
[3] Matlock, 27 July [1871] (ALS, Cowper-Temple Papers, Morgan).

about, he believed, by the anxiety of this crisis), he would return all the letters from Rose and Mrs. La Touche. He was satisfied in being quit of Rose, he told William; 'and the young lady shall never read written, nor hear spoken word of mine more' (*LMT.310*).

Although neither Leon nor Birkenhead had access to all the sources now available, both writers have provided able accounts of the last act of this tragedy which included two periods when Ruskin and Rose were together. The first in the summer of 1872 was another cycle of hope and despair set in motion in April when Rose turned to the MacDonalds for help. 'I wonder if you remember me at all—Rose La Touche', she begins her letter to George MacDonald. . . . 'It seems to me you could help me, & I think too you would help me if you could & I want help, & that is why I write to you.' With no responsibilities she suffered from the disparity between the poor and herself. Her parents could not understand. 'Be happy yourself—Separate yrself from the world—& preach to those you can. This is my Father's religion, & he is *very* good—but it is a religion that I cannot feel is the whole of Christianity.' She feels isolated from her mother. She cannot look forward to marriage 'unless indeed one [*Ruskin*] alters utterly & completely & miraculously during life!'[1] The MacDonalds, apparently thinking this letter showed some change of mind, ask whether she has been ruled by her parents or her own mind. 'I knew that you wd say—Perhaps I am acting wrongly to some "external relation" but I have been put in positions where I have not known right from wrong.'[2] The life at Harristown, she says in another letter, was not a life that she could tolerate. 'If it could have been so that I might have kept the *friend* who has brought such pain & suffering & torture & division among so many hearts—if there had never been anything but friendship between us— how much might have been spared.'[3] Visiting the Cowper-Temples and MacDonalds, Rose seemed to be agreeing to a

[1] Undated letter from Harristown in envelope with postmark showing its arrival in London, 20 Apr. 1872 (ALS, Yale). Passage partially cited with differences in G. MacDonald, *Reminiscences of a Specialist*, pp. 111–12.

[2] Harristown, 15 May [1872] (ALS, Yale).

[3] Letter to Mrs. George MacDonald, Harristown, 14, 15, and 16 May 1871 (ALS, Yale). Passage published with differences in G. MacDonald, *Reminiscences*, p. 113.

meeting with Ruskin when for the first time she saw some letters which Ruskin had written two years earlier to another aunt of hers in Tunbridge Wells in which he had confessed again the sexual sin of his boyhood. The revelation left her crushed. 'He thinks because he has loved me strongly, . . . & has been given many good gifts by God, that this overweighs transgression against God's laws, sin against *knowledge* of God's will & admiration of purity—.'[1] Still she consented to see him, and the MacDonalds wrote to Ruskin, who was then in Venice studying Carpaccio, to suggest that he return. After some hesitation he agreed. 'I am not a saint', he writes to MacDonald. 'Rose is—but a cruel one. . . . What good there is in me she has power to learn if she will.'[2]

Although Rose was troubled by Ruskin's attitude and was under pressure from her parents to come home, she did wait for Ruskin's return on 26 July. Two days later he met her at the MacDonalds, a reunion which lasted three days and was resumed on 13 August when the Cowper-Temples invited him to spend the day at Broadlands with Rose. 'I have had three days of heaven, which I have very thankfully bought with all the rest of my life', Ruskin writes to MacDonald after the first visit.[3] At Broadlands, he wrote to Mrs. Cowper-Temple afterwards, 'I vowed loyalty to her, to the death, and she let me kiss her' (*LMT.332*). Nothing could come now that he could not bear, he declared in another note of gratitude to Mrs. Cowper-Temple. 'No death, nor life shall separate me from the love of God any more' (*LMT.329*). On her way back to Ireland, Rose left the train at Crewe to see some relations of the Cowper-Temples, a Mr. and Mrs. Ralph Leycester of Toft Hall who lived near Knutsford in Cheshire where she had been on a visit in early July. From here she wrote Ruskin at least two letters urging him to come, an invitation which raised his hopes even higher. 'I am called down suddenly into Cheshire . . .', he tells 'Angie' Acland (a daughter of Henry Acland). 'I think you would not be pleased with me if I did

[1] Rose La Touche in letter to George MacDonald, Tunbridge Wells, 18 June [1872] (ALS, Yale). Passage published with minor differences in D. Leon, *Ruskin the Great Victorian*, p. 489.

[2] Venice, 8 July 1872, in G. MacDonald, *Reminiscences*, p. 119.

[3] Herne Hill, 11 Aug. 1872, in G. MacDonald, *Reminiscences*, p. 120.

not tell you that I like going down into Cheshire. But I've no
complete right to speak—yet ... about anything that makes
me happier than I was —.'[1] At Toft on Sunday 18 August he
spent the morning at church with Rose, but the day did not
end as he had hoped. 'I cannot be to him what he wishes, or
return the vehement love which he gave me, which petrified
and terrified me', Rose wrote to Mrs. MacDonald soon
afterwards.[2] Ruskin had assured Mrs. Cowper-Temple that
he would not press Rose for marriage, but he had done so. She
would not marry him, he told a friend later, 'because "I don't
love God better than I do *her*"'.[3] On his return to London that
night Ruskin wrote MacDonald, '*She* sent for me to
Cheshire— ... but was fearfully cruel'.[4] A year later, on the
anniversary of this collapse of his hopes, he filled the page
with telling passages from the *Roman de la Rose*:

> Love, it is a wrathful peace,
> A free acquittance, without release,
>
>
>
> A pain also it is joyous
> And cruelty, right piteous ... (*D2.754*).

From her bedroom at Harristown two days later Rose wrote
to Mrs. MacDonald that she felt 'very tired & head-painy
& rather like an old worn out instrument that wants new
strings'.[5]

Further letters between Rose and Ruskin did not change
the attitudes of either lover. On Sunday 8 September Ruskin
who was then living at Coniston, preparatory to moving into
Brantwood, received at the church door his most recent letter
to Rose which she had returned unopened, and wrote in his
diary that night the words of Jesus on the cross, 'It is finished'
(*LMT.335*; *D2.732*). His only recovery lay through work, he
realized, but 'the worst of the aconite the fledgling gives me is
that it blinds me to any other world', he tells MacDonald.[6]

[1] Herne Hill, Saturday, [17 Aug. 1872] (ALS, MS. Acland d. 170, Bodleian).
[2] G. MacDonald, *Reminiscences*, p. 121.
[3] To Alfred William Hunt, Brantwood, 4 Sept. 1872, in V. Surtees, 'Godfather to Venice', *TLS*, 28 Jan. 1965, p. 76.
[4] Undated letter in envelope postmarked London, 19 Aug. 1872 (ALS, Yale).
[5] Harristown, 21 Aug. [1872] (ALS, Yale).
[6] Brantwood, 10 Sept. 1872 (ALS, Yale).

His friends pitied him. Ruskin 'good and affectionate', Carlyle observes of him in late November, but he has 'fallen into thick quiet quiet despair again on the personal question'.[1] Early in 1873, after a visit of his wife to Brantwood, Burne-Jones writes, 'I don't like to think of you alone there . . . & I can't bear to think of your companionless and joyless days'.[2] Rose, who spent some part of the spring months under care in a physician's house,[3] appeared occasionally in Ruskin's dreams. In June, his diary reads, he dreamed 'that she was still hard and cruel in heart, but that she came to me—and gave herself to me—as sweetly in body as Cressid to Troilus'.[4] In another of the missing passages from Ruskin's letters to Norton, he tells him in July that 'the deadly longing for the companionship of beautiful womanhood only increases on me'.[5] The Cowper-Temples invited Ruskin to Broadlands in early August while Rose was visiting them, but Ruskin declined, saying that her cruelty had been such that he could not be rightly faithful to her (*LMT.348*). From Harristown in October Rose writes to the MacDonalds that she lives under constant pain '& I feel very much like a caterpillar going to turn into a chrysalis'.[6] Carlyle in the autumn writes to Norton about Ruskin's current lectures at Oxford and includes his observation that Ruskin 'is treading the Wine press alone'.[7] Ruskin informs Norton the following year (*36.92*) that in his self-portraits he tries to suggest 'the terrible subtleties' of his being. A comparison of the self-portraits in Plates VI and XIII shows the destructive effect of his passion for Rose. In the first drawing of 1861 we see the 'very sulky' expression which Ruskin at the time described for his father (*17.cxiv*), as well as the defiance of the heretic. In the later drawing, probably of 1873, he leaves the left side of his face in shadows, his eyes set in the despair of loneliness and defeat. On the last day of the

[1] In letter to John Forster, Chelsea, 20 Dec. 1872, in *New Letters of Thomas Carlyle*, ed. Alexander Carlyle (London: John Lane, 1904), II. 293.

[2] [London], 14 Jan. 1873 (ALS, Sharp Papers, Morgan).

[3] Ruskin in letter to Mrs. Barnard, Brantwood, 12 Mar. 1873, in John H. Whitehouse, *The Solitary Warrior* (London: George Allen & Unwin, 1929), p. 139.

[4] Entry for 15 June 1873, *The Brantwood Diary of John Ruskin*, p. 353.

[5] Brantwood, 15 July [1873] (AL[initials], Norton Papers, Houghton).

[6] Harristown, 9 Oct. [1873] (ALS, Yale).

[7] Chelsea, 3 Nov. 1873 (ALS, Norton Papers, Houghton).

year Ruskin tells Mrs. Cowper-Temple that he feels 'more beaten than I thought I should be, at the beginning of the new Year. . . . I had no notion how horribly girls would be persecuted who believed in me.'[1] Brantwood, he writes Dr. John Brown the following February, ought to be called Ravenswood as once again he thought of Rose as a counterpart to *The Bride of Lammermoor*. 'She broke away from both Father & Mother, in the autumn of 1872—and gave me a week of perfect life,—but would'nt marry me—wants to be a Saint.'[2]

Again it was Rose who encouraged Ruskin in September 1874 to renew their companionship. Her parents, knowing that she and Ruskin were now exchanging letters, realized that the year's medical care in London had failed to help their daughter and that Ruskin's letters seemed to do her good. Feelings of penitence had led Rose to renew the correspondence. Early in September, on the train nearing Crewe, she recalls for Joan her break with Ruskin here two years ago. 'Joannie do you think I shall ever see him again?' And she wonders whether her parents might not now 'give *real* permission to my having just a bit of a letter from him now & again'.[3] The Severns forwarded her letter to Ruskin with their judgement that 'if you both love each other enough to marry, *you ought to*'.[4] Ruskin, who was making his way home from a summer's study in Italy, was wary. He knew that Rose was fearfully ill, he writes to Joan a few weeks later, and in his first letters to her he tells Rose that he 'must be sure that she is fit to join my life without destroying its usefulness before I take her'.[5] From Lucca on 21 September, where he received what may have been his first letter from Rose with its seal, 'Je reviendrai', he writes to Norton of this change in his fortunes and comments on the irony of the seal: 'Alas—the false—false words—when once we have been—truly—Left.'[6] The pru-

[1] *The Brantwood Diary of John Ruskin*, p. 497.

[2] Brantwood, [Feb. 1874] (ALS, Acc. 6289, box 3, National Library of Scotland). I am indebted to Mr. Tom Johnstone of Roslin, Midlothian, for bringing this letter to my attention.

[3] 4 Sept. [1874] (ALS, L 63, Bembridge). Passage cited with minor differences in S. Birkenhead, *Illustrious Friends*, p. 240.

[4] S. Birkenhead, *Illustrious Friends*, p. 241.

[5] Ibid., p. 244.

[6] Lucca, 21 Sept. [1874] (AL[unsigned], Norton Papers, Houghton).

dent Norton earlier in the year had been relieved to think that Ruskin's break with Rose was final. He had been glad to hear that 'the Lady of perplexity and pain is banished', he had written to Ruskin. . . . 'May there never be need to mention her [Rose's] sweet sad name again! She has done you such harm and wrong that I who love you find it hard to forgive her.'[1] This news of the revival of their relationship brought Norton only pain, he writes to Ruskin in late October, and he laments Ruskin's need for a wise counsellor. 'Joan . . . can at best be only a cushion; the C. Temples are weak reeds . . . and, worst of all the woman to whom your heart has been given is a torment to herself & to you through her insane conceits & fluctuations.'[2] The La Touches meanwhile agreed that on his return Ruskin could see Rose, although (as Joan wrote to him), they continued to oppose any 'definite plan'—probably for marriage.[3]

On his way home via Chamouni and Paris Ruskin was encouraged by numerous letters from Rose and a book of texts which she had sent him the previous March. On 4 October, for example, he knew that she was reading for her daily verse, 'If we confess our sins he is faithful to forgive' (*D3.814*). Back in London on 22 October he visited Rose the same day in her London hotel, and then divided the weeks of the Michaelmas term between his lectures in Oxford and numerous trips back to London to see Rose until her departure for Harristown in December. He asked Joan in late October to write to Mrs. La Touche that he and the doctors were in accord as to what should be done for her health, and that she suffered by a sense of disobedience to her father. 'But I can't put myself out of Rosie's memory, any more than *he* can—out of her conscience. She wants us both—*peace* at least, with us both. He might as well refuse his "sanction" to my pulling her out of a burning house, because he thought I was only fit myself for the fire—. . . . Can't he then leave the issue in the hands of *His Master?*'[4] On 12 November, according to his diary, he received his first letter from Mrs. La Touche

[1] Shady Hill, 4 May 1874 (AL[initials], Norton Papers, Houghton).
[2] Shady Hill, 30 Oct. 1874 (AL[initials], Norton Papers, Houghton).
[3] Letter of 5 Oct. 1874 (S. Birkenhead, *Illustrious Friends*, p. 242).
[4] Corpus Christi College, 31 Oct. [1874] (ALS, L 39, Bembridge).

'after eight years of anger'. His diaries show that he would lunch with Rose, take her to church, to tea, to play chess with her, talk with her doctors. After dining with her on 14 November, Rose sang 'a word or two of hymn' with him. The next day, Sunday, he 'read lessons and psalms for the day to her'. 'Dinner by lamplight' with Rose he notes on a Sunday in late November before taking the slow train back to Oxford (*D3.823, 824, 825*). He inscribed her copy of his recently published lectures, *Val d'Arno*: 'To Briar-Rose / Fleur de Lys / 31 October 1874'.[1] Rose was well enough to meet him at the Crystal Palace on 12 December. On the preceding weekend he had the 'evening with Rosie, settling many things on the hearthrug' (*D3.831, 829*).

That week he had written to Joan of his thankfulness that Rose was now staying near her. 'If you can but get her father to leave her there for the present— Can't you stop his coming over—.'[2] Both Rose and Ruskin realized the depth of her illness when she left for Harristown. 'I fear there is no hope of any help now, for poor Sweet-briar;—I have had much talk with her, & perceive her entire being to be undermined', he writes to Joan on 15 December, the day of Rose's leaving. 'The insane *cunning* is the thing that thwarts me beyond my power; her naturally keen and delicately truthful nature being turned exactly wrong side out—like a cyclamen leaf— Only that curls its right side out, the moment it's long enough,—but my poor briar-rose will only drop the blighted leaves, one by one.'[3] From her home Rose writes to Mrs. MacDonald, 'You see I am at home now— ... but I am sorry to say I am less well than ever'.[4] To Norton on 28 December Ruskin conveys the desperation at Harristown. He had just received a letter 'in pencil from poor Rose—praying me to deliver her from her father—(who has driven her mad and is shutting her up with a Doctor in Dublin.)—I am of course helpless.'[5]

[1] Rose's copy of *Val d'Arno, The Works of John Ruskin* (Sunnyside, Orpington, Kent: George Allen, 1874), VIII, is preserved at Bembridge.
[2] Corpus Christi College, [about 8 Dec. 1874] (ALS, L 35, Bembridge).
[3] Herne Hill, 15 Dec. 1874 (Typescript, Cook and Wedderburn transcripts, MS. Eng. lett. c. 51, Bodleian).
[4] Harristown, 17 Dec. [1874] (ALS, Yale).
[5] Brantwood, 28 Dec. 1874 (AL[initials], Norton Papers, Houghton).

With Rose now beyond the probability of reading, Ruskin informed his readers of *Fors* in January 1875 that 'the woman I hoped would have been my wife is dying' (*28.246*). For the last time, apparently in mid-January, she returned to London for medical care. Ruskin was at Brantwood for most of the month, a period almost unbroken in dark days of ominous weather which added to the weight of his leadened spirits. After a brief stay in Oxford, he went down to London 'very broken in will and thought', he notes in his diary for 3 February. Some time between this date and probably 14 February he saw Rose for the last time. She was out of her mind, and only Ruskin was able to quiet her. To Joan he wrote a year later that 'the last solemn promise she made me make to her, lying in my arms, after that fit of torment, was that I would never let her stand between me and God'.[1] So 'dreamy and wrong and despondent' did these experiences leave him that on 9 February he went to his doctor for help. His last meeting with Rose may have been the preceding day when he wrote out in his diary Rose's text: 'For though he was crucified through weakness, yet he liveth by the Power of God' (*D3.837*). From Oxford on 25 February he wrote to MacDonald: 'Poor Rose is entirely broken—like her lover.'[2] In April he wrote to a friend that Rose 'is now placed by her people under some restraint with a physician in Dublin'.[3]

The recent discovery of the page missing from Ruskin's diary covering 24–8 May richly supplements what has been known of his activities in the days around Rose's death on Tuesday 25 May.[4] He had divided the spring months between his responsibilities at Oxford and trips to the Severns in London where he could get reports about Rose. On 23 May he visited the springs of the Wandel River in Carshalton which some years before he had taken steps to cleanse and

[1] Venice, morning, 4 January 1877 (ALS, Sharp Papers, Morgan; see also Ruskin's letter to Francesca Alexander, 16 Mar. 1888, *John Ruskin's Letters to Francesca*, ed. L. G. Swett (Boston: Lothrop, Leo & Shepard, 1931), p. 118.

[2] D. Leon, *Ruskin the Great Victorian*, p. 500.

[3] J. H. Whitehouse, *The Solitary Warrior*, pp. 79–80, where the letter to a Mrs. Barnard is misdated 1865. Whitehouse has dated the MS. 11 Apr. 1875, presumably taking the date from the envelope which is now missing (ALS, B V, Bembridge).

[4] James S. Dearden recently found the page enclosed in a letter from Ruskin to Joan Severn; the page has been restored to the manuscript of Ruskin's diary for 1875, MS. 20, Bembridge.

preserve in memory of his mother. Feeling wretched, as he writes in his diary the next day, he noticed a 'nettly island of mud in middle of Wandel—like myself—yet sheltering many creatures—wild ducks and the like'. In the same entry he records his return to Oxford: 'Up, with feeling of cold, ambiguous.' Although Ruskin did not learn of Rose's death until Friday, 28 May, a telegram notified Mrs. La Touche's cousin in London on 25 May that she had died at seven o'clock that morning before her parents could be with her.[1] Ruskin that same morning, according to his diary for the next day, had a 'nice boys' breakfast at Oxford', then left for a stay of three days at nearby Aylesbury, the location of the press then responsible for the printing of his work. That Tuesday he talked with his printer, Henry Jowett, and 'had walk in buttercup fields under hedges of perfect May blossom—very marvellous'. In the defilement of the country-side he found a parallel to his black mood. 'Smoke from rail fouling all on one side, worse than blackest manufactory for half an hour. . . . Ground all more or less black every where.' He felt, he notes, 'as if all life was leaving me—just as the understanding of all life came to me'. In the evening he observed a 'sullen sunset' but took a 'walk on old English road 41 miles from London—all hawthorn and nightingales'.

On Thursday a 'black northwest wind' made the day at Aylesbury miserable, 'cold and foul—black as thunder at 12 o'clock'. Ruskin spent some time at the printing press, and before dinner strolled in the park where he had also walked the day before, and in the evening 'towards hills by the opposite road'. On Friday when Rose's body was placed in the La Touche mausoleum after services performed at St. Patrick's Church,[2] Ruskin finally heard of Rose's death. 'I heard of Rosie's death on Friday', he wrote to Norton later in an unpublished letter.[3] At ten o'clock in the morning of that day he writes to Joan that he still has been unable to compose a suitable telegram to the La Touches, nor does he know what to say in it 'except—that it is best so. . . . Of course

[1] Letter from Mrs. Bishop to Miss Nina Cole, 26 May [1875] (ALS, Yale).
[2] Burials Register of St. Patrick's Church, Carnalway, p. 2. The burial service was conducted by the Rev. George Young Crowley, the incumbent of St. Patrick's.
[3] Corpus Christi college, 10 Nov. 1875 (AL[initials], Norton Papers, Houghton).

I have long been prepared for this—but it makes one giddy in the head at first. . . . Think of other things, as a duty to *me*, who have only you now to depend on. And don't write about it to me; but . . . tell me all you can hear, when I see you, only don't forget what you *do* hear.'[1] To Susan Beever he writes, 'I've just heard that my poor little Rose is gone where the hawthorn blossoms go'.[2] In his diary he notes that the weather was quite as miserable as yesterday's, and that he was 'much like' the weather. He closes the entry with a cross. Not until a month later did he enter anything in the space for 25 May, then writing simply: 'June 25th. 7. morning', and drew what appears to be a hawthorn leaf on either side of the entry.

Living on what he called later the outside of himself, he responded to his duties at Oxford, returning that evening to prepare for a weekend of ceremonies with Royalty in connection with his gifts to the Ruskin Drawing School—all of which he had to face with civil cheerfulness as he told Carlyle (*37.168*). He spent Saturday in his rooms at Corpus, not going out until the court dinner. The night was 'bitter in coming back through Peckwater', he writes in his diary (*D3.846*). Thinking of his student days at Christ Church and his rooms at Peckwater, he adds, 'If, from my windows, I could have seen, forty years ago, myself pass in the future, and my thoughts!' Throughout the ceremonies, he writes Joan on Monday, he was 'all the while wondering when that child's "wake" was—which please find out for me—for I want to know. It would be strange thing if today. Probably yesterday —'.[3] MacDonald on Sunday had written to Ruskin the consolation that 'the Psyche is aloft, and her wings are broad and white', and he added the assurance of Ludwig Richter that 'it is only in God that two souls can meet. I am sure it is true.'[4] Ruskin had forgotten the stunning effect of grief. 'I find this thing more terrible than I knew', he writes to Joan a few day later; 'the way it seems to possess and shadow me all

[1][Aylesbury], 28 May 1875 (ALS, L 40, Bembridge). Passage partially cited with differences in S. Birkenhead, *Illustrious Friends*, p. 248.

[2]Aylesbury, 28 May 1875 (ALS, JR 39, The Huntington, San Marino, California).

[3]Corpus Christi College, 31 May 1875 (ALS, L 40, Bembridge).

[4]Great Tangley Manor near Guildford, 30 May 1875, printed addendum to pp. 122–3 of G. MacDonald, *Reminiscences of a Specialist*.

through and through,—just as the happy letters were warmth & life to me.'[1]

2. *The spiritualization of Rose*

As Rose had wished, Ruskin did not allow her to stand in the way of his reconciliation with a spiritual view of life. To the readers of *Fors* in April 1877 he gives two reasons for the more Christian tone of his writings during the last two years. One was his study of Giotto at Assisi in the summer of 1874, where he learned the 'fallacy' of his thinking during the last sixteen years, that religious artists were inferior to irreligious. In Giotto he discovered that 'the Religion in him, instead of weakening, had solemnized and developed every faculty of his heart and hand' (*29.91*). The other reason, which Ruskin lists as first, he explains only obscurely. Since *Fors* began, he writes, '"such strange things have befallen me" personally, which have taught me much, but of which I need not at present speak' (*29.86*). These teachings emanated from his experiences after the death of Rose, first from his further interests in spiritualism at Broadlands and then the renewal of his study of Carpaccio's *St. Ursula.*

By early October, the Cowper-Temples had given him a room for his own use at Broadlands, his 'new home', as he describes it to Norton (*LN2.121*), from which he travelled to Oxford for some of his lectures. His diary during these months is a record of his brooding over Rose. At an Abingdon inn where he often retreated from Oxford he left the door open one evening in November, and noticed that the currents blew the melting wax of his candle into the configuration of *R* (*D3.870*). A few days after his arrival at Broadlands in December, Mrs. Cowper-Temple assembled some spiritualists for a series of séances in one of which she herself was able to throw one of the mediums into a trance. In the first of the sessions Ruskin learned from a medium 'the most overwhelming evidence of the other state of the world' he had ever heard, a revelation that left him 'like a flint stone suddenly changed into a firefly', so he writes in his diary the next morning, 14 December. That afternoon, he tells Norton, he had heard

[1] Friday evening, [June? 1875] (ALS, L 40, Bembridge).

more wonderful things from this lady, 'a person who has herself had the Stigmata, and lives as completely in the other world as ever St. Francis did, from her youth up' (*LN2.124*). Four days later he was 'wonderstruck' by the disclosures of the other medium, the 'bewitched doctress' whom Mrs. Cowper-Temple had induced to tell Ruskin much about his past. From further talk on Sunday, so he notes in his diary, he gained 'knowledge of—I know not yet what, or how much'. Awakening early the next morning he lamented the darkness, the 'eye of day taken out of it,—Blind, Blind, Blind, for ever'. After an evening's reading and more talk, he believed that the truth had been shown him which he had sought so long (*D3.876–7*).

It was on the following day, 21 December, that he received a sign from Rose, so he believed a year later.[1] The first of the mediums in the afternoon gave him further 'teachings' from a trance in which she apparently reminded Ruskin that he had read *Marmion* to the La Touche children when he visited Harristown in 1861 (*D3.877*). Probably in the same conversation she told him that she had seen a spirit beside him the previous evening when he was talking of women. What was she like, he asked. '"Young—very tall and graceful and fair— she was stooping down over you, almost speaking into your ear—as if trying to stop you."' The medium claimed that she had seen the ghost earlier and had learned from her that she had not been married. '"I was able to ask that, but she cannot speak much, yet—she has not been long in the spirit world— I think—probably not a year."' Believing the spirit to be Rose, Ruskin replied to the medium, '"No—not a year. She died in May."'[2] That evening, according to his diary, the medium told Ruskin 'what to trust and hope, in all deed and thought' (*D3.877*). Either the most horrible lies had been told him, he writes Norton a month later, 'or the ghost of R. was seen often' beside the medium or himself (*LN2.127*).

[1] Ruskin in a letter to Joan Severn, Venice, 24 Dec. 1876 (ALS, Sharp Papers, Morgan).

[2] Conversation recorded in Ruskin's letter to Mrs. A. Tylor, 31 Dec. 1875, Guild of St. George Collection, Reading University. Passage cited in Robert Hewison, *John Ruskin: The Argument of the Eye* (Princeton, N.J.: Princeton University Press, 1976), pp. 162–3.

But in the coming months Ruskin believed that Rose had signalled her presence to him. He took it to be no common sign, he writes to Norton from Broadlands on 1 February, 'that just after the shade of Rose had been asserted to have been seen beside Mrs. T. and beside me, here, I should recover the most precious of the letters she ever wrote me' (*LN2.129*). On the same day he writes to Angelina Acland that at Broadlands he was 'hearing all manner of things about ghosts and angels, and am beginning really to feel as if some day I might see both'. Back at Oxford later that month he informs Angelina that he was feeling quite well, 'chiefly because my dear little ghost seems to be looking at everything I want in all my books for me, as if she were really here, and Librarian. It's almost come to the point of my telling her to fetch me the books.'[1] It was not Fors now that guided his hand as he opened his Bible, but angelic ministration, he notes in his diary on 16 February. Listening to the cathedral clock strike seven in the morning he opened his Greek manuscript of the Gospels to Jesus's reply to the blind man seeking his sight: 'Thy faith hath saved thee.'[2]

From such events could come only the desire for a second sign from Rose. On leave from the University, Ruskin departed for the Continent in late August mainly for an extended period of drawing and study in Venice where he arrived on 8 September. From his rooms in the Grand Hotel overlooking the Grand Canal, he could watch the sunrise behind the island of San Giorgio Maggiore and the colours of the sunset on the dome of the church of Santa Maria della Salute and the ships' masts in the Giudecca. Within a few days he had persuaded the authorities at the Accadèmia to take down *St. Ursula's Dream* from its high place on the wall so that he could make a copy of it in water-colour. 'Fancy having St. Ursula right down on the floor in a good light and leave to lock myself in with her', he writes to Joan. ... 'There she lies, so real, that when the room's quite quiet, I get afraid of waking her!' (*24.xxxvii*). Progress was slow. 'Desperately discouraged ... at St. Ursula yesterday, and wild with what

[1] Ruskin's letters to A. Acland from Broadlands, 1 Feb. 1876; and Corpus Christi College, 20 Feb. [1876] (MS. Acland d. 170, Bodleian).
[2] Luke 18:42.

I can't get done', he notes in his diary for 4 October. As late as Christmas he was still struggling with finishing touches. On 14 December he watched the entries in his diary for a year ago when 'the series of teachings' had begun at Broadlands. Particularly on the solstice was his mind on the revelations of that day, and he began to pray for another message from Rose. 'I have been asking for some sign from Rose', Ruskin writes to Joan, '—it was a year on the shortest day since the last.'[1]

Until now the circumstances of the second sign have been known largely through Ruskin's often cryptic notes in his diary. 'Story thereupon to be told Joanie', his diary reads on 2 January 1877, but until recently these letters, still unpublished, have been unavailable. Titled his 'Christmas Story' this series of carefully written letters, which Ruskin began writing on 27 December 1876, describes and interprets the events between the morning of Saturday 24 December, and midnight of the 26th. 'I light candles, and sit down quietly to tell you', he writes to Joan in his first letter, 'not shutting out the twilight of the window, and its vision of the Salute dome.' He divides the events into two periods, the first of them ending at 3.30 on Christmas afternoon. Lady Castletown, an Irish acquaintance of Ruskin who was visiting Venice with one of her daughters and staying at the Hotel Danieli,[2] unknowingly initiated the first period on Saturday when she brought to Ruskin's door a plant of dianthus, the window-flower which Carpaccio had painted in the right of the double arched windows in St. Ursula's sleeping chamber. Knowing of Ruskin's work with this painting, significantly she attached to her gift the note, 'from St. Ursula out of her bedroom window, with love'. The morning post on the preceding day had brought him from a friend at Kew a dried sprig of

[1]Venice, 24 Dec. 1876 (ALS, Sharp Papers, Morgan). Subsequent citations from Ruskin's letters to Joan in his Christmas Story, all in the Sharp Papers, will be identified in the text by date.
[2]Lady Castletown (c. 1810–99), wife of John Wilson Fitzpatrick, 1st Baron Castletown, then Lord Lieutenant of Queen's County, Ireland, as recorded in *The Complete Peerage*, ed. Vicary Gibbs (London: St. Catherine Press, 1913), III.101–2; and her daughter Cecilia, wife of the Hon. Lewis-Strange Wingfield, as shown in Edmund Logde, *The Peerage and Baronetage of the British Empire* (London: Hurst and Blackett, 1882), p. 114.

vervain, the spiked plant in the left of St. Ursula's windows, and a letter from Joan enclosing another from Mrs. La Touche to her. Well aware of the mythology of these plants which Carpaccio had chosen—dianthus, the flower of Zeus, and vervain sacred to the ancients as a symbol of domestic purity—Ruskin found the deepest meaning in this combination of incidents. The following hours, he writes to Joan on the evening of 4 January, 'went on gradually increasing in distinctness, and consisting of a succession of helpful and sacred suggestions, presented so as to connect themselves with the best feelings and purpose of my life'. That night he 'slept without stirring, like a child, till Christmas morning', so he tells Joan on 27 December.

From the beginning, he writes in his letter of the evening of 4 January 1877, he had felt himself under supernatural guidance 'and that the Virtue required by it, throughout was only happy, effortless obedience'. On Christmas morning he received other gifts from friends, including some shells of the kind he was drawing, he tells Joan on 27 December 1876, when Mr. La Touche's refusal to let him see Rose in London had reached him (probably February 1867). 'This was St. Ursula's order to forgive the Master. No other sign of *him* ... could have been sent.' Planning a call on his friend Rawdon Brown, he thought first he would take the shortest route to the Rialto, but 'then it struck me— "No—I should like to go past St. Mark's" I went into the square, in a kind of dream,—then it struck me— "Little Bear [*St. Ursula*] and Rose want me to return thanks in St. Marks."' So he went on to the Cathedral, prayed by the side altar, 'and came out at the Arabian porch, and went hard for Mr. Browns, down the Merceria'.

At two o'clock he had promised to meet his best gondolier Piero at the Fondamenta Nuove to go with him to visit his family. In Piero's 'small wooden stained house' he found the family, including Piero's married daughter and her baby. 'And of all the Madonnas I've ever seen, . . . this young mother beat!!—the very purest type of *simple* Venetian beauty at 18', so Ruskin writes to Joan on 27 December. With Piero's help he made his way through the narrowest alleys to the chapel of San Giorgio degli Schiavoni. 'Oh—I said to myself, little

Bear means me to finish *here* then—where the telegram came to me from Rosie [*in 1872*] to bring me home.' Dismissing Piero he entered the oratory alone. 'I wondered whether little Bear had anything special to say there—on Christmas day.' Looking at the Carpaccios, he gave special heed to the spiked leaves which Porphyrio, the bird of chastity, is nibbling in the foreground of *The Baptism of the Sultan*. 'I looked to see what the plant was It was the vervain in *flower*. "That's enough, little Bear, for today," I said— "I can't take any more." So I knelt under the St. Jerome and returned thanks.' Kissing the feet of the crucifix at the door Ruskin left at three-thirty, feeling that now his 'Christmas day was done, and lesson ended'.

The second phase of these events, as he writes to Joan in his letter of 4 January, began only a few minutes later, a period during which 'there was not a single suggestion made but to what was wrong, or stupid; Every thing which occurred to my mind was a trap, or a discouragement'. Going to the Riva for a gondolier he saw first 'a horrid monster with inflamed eyes, as red as coals—crying Barca, Barca— I turned away in great disgust and had walked ten steps or so, away—when I bethought me of the stories of people shrinking from disease', so he had told Joan on 27 December. 'I turned back and looked the man in the face but did'nt like it.' Certain that the earlier 'lovely lesson' was complete and that St. Ursula knew he was ready 'to take any painful or ugly lesson she chooses, as well', Ruskin found another gondolier, took the front oar himself, and pushed off for the Convent of the Armenians. So dense was the fog that at first they mistook the madhouse on San Clemente for the island of San Lazzaro. After a visit with a Padre at the Convent, Ruskin returned to his hotel late for his Christmas dinner which had been scheduled for five o'clock. That evening he devoted to calls by gondola, including a visit to Lady Castletown at the Danieli at nine. Realizing he was early for this last appointment, he asked his gondolier to take him to San Giorgio only to find that half way across the lagoon they became lost in fog.

Throughout this second period of wrong moves, so Ruskin interprets for Joan on 4 January, 'The virtue required was throughout Defiance and Resistance, —distrust and refusal,

instead of trust and acceptance'. To the mind of an old Venetian 'nothing could have appeared more probable, not to say certain', in the first sequence of events, '. . . than that the Madonna had actually appeared to him in the form of Piero's daughter'; and in the second sequence that Lucifer had appeared in the person of the red-eyed boatman. The most curious condition of the whole, so Ruskin believes, was 'that the supernatural power should be just as closely masked in the one case, as it was frankly in the other. It was necessary to the Evil Spirit's power, that I should not perceive its presence. And accordingly—in a way altogether astonishing to myself in looking back, I never for an instant felt the nature of the trial till it was over;— . . . but I, all the while, felt only the departure of the helpful Spirit—and that I was left, unkindly, it seemed, to my own prudence and effort, contending with adverse *chance.*' The great use of the lessons, he concludes, 'will be in their exhibition of the three spiritual powers, good, evil, and human, in entirely distinct action, the Will and reason of the Humanity called up to obey in the one case, to resist in the other; and acting, itself, by powers indeed as much given to it by God as that of the two angels with which it walked, or strove; but developed, nevertheless, and only to be developed for such contest, by long years of former effort, meditation, and grief'.

The seventeen years of Ruskin's association with Rose, particularly the last years of grief, had prepared him for this contest with the powers of light and darkness sent to him, he believed, through the mediation of Rose. In his mind Rose had achieved a kind of apotheosis, a tutelary force with the same revelatory power as the myth of St. Ursula. All great myths, Ruskin tells his readers of *Fors* in March 1877, manifest their meaning only slowly to the imperfect intelligence of human beings. He further explains that 'whatever spiritual powers are in true personality appointed to go to and fro in the earth, to trouble the waters of healing, or bear the salutations of peace, can only be revealed, in their reality, by the gradual confirmation in the matured soul of what at first were only its instinctive desires, and figurative perceptions' (*29.54*). He then goes on to trace the phases of his own development, describing most of the period he had known

Rose as the years when he believed in the Religion of Humanity. Now he is neither Roman Catholic nor Evangelical Protestant, but a Christian Catholic (*29.92*). Through grief he had come to share the love of God and hope for the spirit which Rose describes in her diary, the faith which he had ridiculed in her and allowed to keep them apart. Before her martyrdom Ursula's suitor had assured her of his belief in immortality, so much had he 'already tasted of the sweetness of Paradise' in his love for her (*28.743*). Through Rose, Ruskin had forgiven the La Touches and was to formulate plans for new kinds of usefulness in his writing. In the future, he tells the readers of *Fors* in December 1876, he hoped to show more clearly what he had been able to say only 'vaguely and imperfectly' during recent years, that in the useful service of God may we find 'the presence of the Holy Ghost of Life and Health—the Comforter' (*28.766–67*). Carpaccio, according to Ruskin, wanted to show in his Apotheosis of the martyr that she was now one of those who are not given in marriage but are as angels. Ruskin could not be sure of the poor bridegroom in the picture, he adds, unless it was he who holds St. Ursula's standard (*24.167*).

Though reserved, Collingwood's judgement about Ruskin's relationship with Rose may still be the best. In his conversations with Viljoen he told her that Ruskin had 'left much to be desired as a husband ... had no idea how to look after a wife', so her notes read.[1] But Collingwood believed that Ruskin was deeply in love with Rose. '"Is not the fact that he wanted to marry her in itself indication that he was not abnormal?" I asked. "If the stories told at the annulment were true, would he be marrying again?" "Certainly I think not", agreed Mr. Collingwood.' He had known Ruskin intimately for years, he reminded Viljoen, and was sure that Ruskin '"did not go about with women & never led a 'loose' life. But that does not prove he was impotent. R[uskin]'s character & ideals were such that such things would be undesired by him."' Ruskin was much older than Rose, Collingwood pointed out. 'She herself was introspective, neurotic. She was

[1] 'Mr. Collingwood on Ruskin' (MS., Van A. Burd).

deeply fond of him but could not make up her mind to marry him,' so Viljoen summarizes Collingwood's opinion. He did not regard the story as 'hard to understand'.

Viljoen in her notes about this conversation leaves her own comment. 'But I think there's more to the story than this.'

THE DIARIES OF ROSE LA TOUCHE

I. Journal of Travels in France and Italy
Diary for 7 March–1 April 1861

In this diary Rose La Touche records her notes about the tour on the Continent which she and her sister Emily take with their parents. The family has spent the winter in London, Rose seeing much of Ruskin. Before the La Touches leave, Ruskin and Rose apparently agree to exchange 'Diary letters'. On 7 March the La Touches go from London to Dover. Making a rough crossing by steamer the next morning, they arrive at Calais from which they travel by railway to Paris. During a stay of five days in Paris they visit the Louvre and Notre-Dame. They leave by rail on 13 March to travel south to Toulon where they begin a posting tour along the Riviera. At Nice on 18 March, Rose writes to Ruskin in response to the long 'Diary letter' which she has received from him. She bases her letter, nine pages in length, on the events which she has recorded in her diary up to this point. Her diary continues with the tour through Menton to Genoa, and here the fragment ends. For other analysis of this tour and this section of Rose's diary, see the Introduction, *pp. 47–9, for the full text of Rose's letter to Ruskin from Nice, 18 March* [1861], *see 35.529–32.*

Other sources show that the La Touches go on to Florence where Rose, about 11 April, is taken ill with a fever. They return by Turin where Rose and her mother meet Garibaldi. Ruskin resumes his visits to see Rose after the La Touches come back to London in late April. During the second week in May the La Touches go to their home in Ireland for the summer. The other letters which Rose writes to Ruskin during the Continental tour have been lost.

Ruskin is generally despondent during these months. While Rose is abroad, he gives two lectures in London. In mid-March he spends about ten days in Cheshire visiting Margaret Bell's school for girls at Winnington Hall. It is here that he receives Rose's letter written from Nice. He is depressed when the La Touches return to Ireland.

The first page of Viljoen's typescript of this portion of Rose's diary carries in the upper right-hand corner this bracketed notation in her handwriting: My copy from her Diary. *After the title she also adds the bracketed note:* Rose age 12. *Viljoen*

errs on Rose's age since she would have been thirteen at this time. The typescript is three pages in length, single-spaced, on paper measuring 8½ × 11 inches.

March 7, 1861. [Thursday. Dover]. We started on our Journey to the Continent on the afternoon of March the 7th. Going away is always rather sad excepting when its going home – I think one feels very Brown, Jones, and Robinsony going off on tour just to see things.[1] The aspect of the country from London to Dover is not very enlivening. Flat, flinty plains and banks of chalk reminding one of Archigosaurus and Professor Owen.[2] The hops were not above ground and the stacks of hops which dotted the barren fields looked somewhat desolate. We got to Dover about seven, had dinner, and went to bed.

March 8th. [Friday. Paris.] ——The steamer was a little larger than a fishing boat, but went well. ——As we got near an enormous flock of small dark birds flew along the sea. We were puzzled about them, but I suppose they were French ducks. It was so funny when we stopped at the pier to see the Douaniers or Custom House people in long blue cloaks— *So* French. Then there was such a jabbering one almost expected to see long tails appearing from under those blue cloaks and curling themselves round our luggage so well would they have corresponded with some of those grinning at 'Les Anglais' from those curious hats. ——A French table d'hôte[3] with hungry Frenchmen and Garçons flitting like so many gnats on a warm day here and everywhere was a new phase of existence to my Irish eyes. ——(In Amiens) the cabmen screaming and roaring at each other keeping us in fits of laughter.

March 9–10. [Saturday–Sunday. Paris.] ——The Louvre I thought most be-e-eautiful. Mr Ruskin told us to look at the

[1] *The Foreign Tour of Messrs. Brown, Jones, and Robinson* (London, 1854), drawings by Richard Doyle satirizing the snobbism of the middle-class English abroad.

[2] For Professor Richard Owen of the British Museum and 'Archigosaurus', Rose's pet-name for Ruskin, see Introduction, pp. 46–7.

[3] In her letter to Ruskin of 18 Mar. Rose says that they breakfasted at the Table d'Hôte in Calais and then took the railway to Paris (35.530). They probably ate in the Refreshment-room of the Terminus on the *quai*.

Titians.[1] Well it's no use trying to describe what they were and what I thought of them. I won't attempt it. ——I liked the statues just as well as the pictures. I can't say much more than that Venus Victrie is so perfectly lovely though her arms are broken off.[2] The Parisians are very civil but let Mrs. Browning say what she will and let it be an insular way—I will not have it's such a foolish one—the French *are* light— cruel yes—very tigers when roused—but as a panther is lighter than a bull-dog so are the French lighter than the English—[3] So much for Paris.

March 14. [Thursday.] (Toulon). ——an enormous 'hop-grass' which kept me in a fidget while I was drawing because the aforesaid gentleman hopped so high and so far one couldn't see why he shouldn't be on one's back one minute and up one's legs the next.[4]

March 15th. [Friday. Fréjus.] ——the same grey-haired olives, such quantities of olive trees—they weren't content with the valleys but were trooping up the hills like a noble army

[1] Ruskin had told them to look particularly at Titian's 'An Allegory in Honour of Alfonso d'Avalos' and 'The Virgin with the Rabbit', as Rose indicates in her letter of 18 Mar.

[2] Presumably the armless Venus of Milo, although Rose seems to confuse the name of this statue with the Winged Victory of Samothrace (also armless) or the Venus Genitrix. In her letter to Ruskin of 18 Mar. she refers to the statue as Venus *Victrix*. She asks Ruskin whether it is wrong to like this statue as well as Titian's paintings. 'If it is, am I a hardened little tinner?'

[3] In her letter of 18 Mar. to Ruskin Rose repeats this allusion to the opening lines of the Sixth Book of E. B. Browning's *Aurora Leigh* in which the poet defends the French against the common English belief that they are light in character.

> Is a bullet light,
> That dashes from the gun-mouth, while the eye
> Winks and the heart beats one, to flatten itself
> To a wafer on the white speck on a wall
> A hundred paces off? Even so direct,
> So sternly undivertible of aim,
> Is this French people.

Ruskin, in a footnote to Rose's letter, says that her comment grew out of a debate over Mrs. Browning's attitude towards the French (35.530n.).

The La Touches left Paris by train on Wednesday, 13 Mar.

[4] Sitting with Mrs. La Touche and Emily on a rock, Rose was trying to sketch Toulon Harbour for Ruskin, so she writes to him on 18 Mar. The insect to which she refers is presumably the grasshopper.

besieging the garrison of calm grey rocks which rose far above them.

Fréjus is a dirty sort of town with rather a curious sort of hotel. To be sure it is a small town and one can't expect anything very wonderful from a village inn,[1] but I must say we did get a bad supper—at least a supper we didn't like—for I daresay the country inhabitants would have thought it excellent. Still, one's hungry travelling and it's disappointing not to get something to eat. But the rooms were good, the beds not bad, and we have no right to complain.

March 16th. [*Saturday. Nice.*] ——The glens were one mass of foliage, every little leaf throwing back a flash of sunlight. Our driver (a most agreeable Italian) told us there were bears and wolves in the hills. We didn't see any.[2]

Nice, March 17th. [*Sunday.*] ——Papa and I didn't go. There was a hot sun and a strong wind which blew clouds of dust into our faces and I thought an expedition in an open carriage having to shut one's eyes nearly all the way for fear of being blinded with dust, anything but agreeable. Papa agreed with me that one could see more of the beauties of Nature in a sheltered walk than driving with shut eyes to any beautiful scenery.

——The inhabitants gave us of all mixtures intended for human eating the most horrible. They called it Bouillabaisse, it's fish done up somehow so as to make it odious eaten with slices of bread soaked in oil.[3] Ugh!

[1] Either the Hôtel du Midi or the Hôtel de la Poste, the first of which John Murray rated as preferable, but 'only tolerable', the other 'not good' (*A Handbook for Travellers in France* [London, 1861]), p. 495. In her letter of 18 Mar. Rose elaborates: 'I was pretty tired that night & we had to sleep at Fréjus such a disagreeable place.' Ruskin had a similar reaction after spending the night there in 1840. 'The people at Fréjus half savage and smelling of garlic; talking at the pitch of their voices and very stupid—the waiter especially' (*D1.94*).

[2] 'The next day we had six horses to our carriage for it was a hilly road', Rose writes Ruskin on 18 Mar. In the Pass of the Esterelle the La Touches walked about two hours of the way over the hills. 'You know what sort of a view there was at the top. . . . *You* the author of M–Ps cd describe it Irish roses can't.' They arrived at Nice that evening in time to visit the ruins of the Roman ampitheatre on the hill in Cimiez where they enjoyed 'of all sunsets the most glorious'.

[3] A Provençal dish made of pieces of fish served on bread over which is poured a stock made from the heads and tails of the fish, olive oil, wine, and many seasonings.

Nice is too cockneyfied – the town itself is a regular little Paris.

Menton [–Genoa.] March 26th–April 1st. [Tuesday–Monday.] The scenery is (I'm so tired of 'beautiful', etc.) anything you like.

I couldn't look about me a bit when the sun got high for it made my head ache horribly so I sat in the open carriage under an umbrella hearing people say 'Beautiful' charming, etc. at every turn. But towards evening I looked out, and it *was* glorious.

——My head got better friends with the sun and we enjoyed it (the trip to Genoa) very much. Who but the golden-mouthed author of Modern Painters could describe the scenery?[1]

One gets almost tired of seeing churches, particularly when one sees two or three in a day. Well, I like Westminster Abbey best. I have never had that feeling in looking at any church abroad (except perhaps Pisa Cathedral) that comes from one gaze through the gray arches filled with the dim red light in our own Cathedral. Perhaps it is because the Continental churches I have seen have had very little stained glass and a great deal of gilding and bright wonderfully beautiful frescoes. Some of them are glorious and after all why should we like drab gloomy temples to serve our Father in. I suppose Solomon's was very gorgeous, but then it was *all* gold and silver, etc.[2] and the Continental churches seem to try and combine dark pillars and arches with bright gildings and paintings and fail therefore in all attempt at grandeur.

Oh it was all 'grandly beautiful' and 'strangely sweet'.[3] Who could describe the turns of the road, the long views of the valleys, the red-soiled hills, shadowy purple mountains and calm white-headed Alps with clouds scarce whiter turning round and bending over them. Then the stop in the middle of the day at some queer narrow-streeted village looking

[1] Mrs. Cowper's pet-name for Ruskin was St. Chrysostom, an allusion to St. John, the Golden-mouthed. One of Rose's epithets for Ruskin was 'St. C.' She alludes here to Ruskin's descriptions of nature in his *Modern Painters*.

[2] 2 Chron. 3:4–10.

[3] If these are quotations, I have been unable to identify the sources.

lovely at a little distance, but like *all* Italian [towns] I've ever seen (except Turin) dirty and disappointing when you get into it. Then the curious hotel you get out at with the ceiling sometimes painted in the most gorgeous fresco and the curious luncheon of Mediterranean fish (not always good) excellent omelette (which I never eat) and ever and always that same dish—(maccaroni)—which we've all got excessively fond of.

II. Rose La Touche's Autobiography
Diary for 1 January–24 February 1867

Although Rose gives no reasons for writing her autobiography at this time, she seems to have been in an introspective mood as she approaches her nineteeth birthday on 3 January, groping for some explanation of the tensions under which she lives. She begins her diary for this period at Harristown where her family has delayed its usual excursion to London because of the grave illness of her uncle, William La Touche. About eleven months have passed since Ruskin's proposal of marriage to her on 2 February 1866 when she asked him to wait three years for her answer. She has not seen him since late March of that year and her worried parents have cut off almost all communication between them. During the summer of 1866 Joan Agnew becomes engaged to Rose's brother, Percy. Ruskin and Rose rely on Joan as an intermediary as well as the William Cowpers whom Ruskin persuades to visit Harristown in the autumn. While Rose is writing on her autobiography for three days beginning on New Year's Day, Ruskin is at home with his aged mother and Joan, embittered over his treatment by the La Touches, frustrated in his love for Rose. On her birthday he notes in his own diary that he yet must wait 771 days before Rose will come of age and be free to make her own decisions.

Rose, on the first day of her writing, recalls her development as a 'conscientious child', the deep sense of Justice embedded in her character, her struggles with her governesses to do what she considered right. On the eve of her birthday she continues what she calls 'the history of my Child-life', telling of the influence of her father's Calvinism on her, the fasting, praying, and the close study of the Bible which he encouraged. She attributes her interest in the poverty of the Irish peasants on her father's estates to the humanitarian themes in her earliest reading of Ruskin. She tells of her bewilderment with the intellectual conversations she overheard in London about the higher criticism of the Bible. She writes the longest section of her autobiography on her birthday, stressing 'the trouble of body, soul, and spirit' which leads to her spiritual crisis of 1863 and the parts which Ruskin and her parents played in these events. By 8 January Rose is obliged to

*give her full attention to her uncle's illness and death. She tells of
the starving peasants on the doorsteps of Harristown House. The
diary ends on 24 February after Rose has written of the arrival
of the La Touches in London on 5 February and the dissensions
reflecting her persistent feelings for Ruskin.*

*The small notebook from which Viljoen transcribed this diary
is described on p. 11 of the* Introduction. *Her typescript is thirty
pages in length, double-spaced, on paper measuring 8½ × 11
inches.*

[*January 1. Tuesday.*] *New Year's Day – 1867* [*Harristown.*] I
am going to look over my life. It is just nineteen years and I
think I can remember as far back as to when I was two,
indeed, I think I can remember before that in a kind of way.
I can remember distinctly feeling naughty when I was about
2 or 3 years old, or rather perhaps I should say, being wicked –
I used to get angry, and pinch my brother and sister[1] and
would rather destroy a thing if I did not want it than give it
to them. But then we were left almost entirely to nurses at
that time and I don't think they assisted to make us better.

My first governess[2] came when I was about three, or rather
she was Emily's governess but she looked after me, made me
fond of her and taught me not to be naughty. I don't
remember anything much else. Then, when I was about four
years old Bun* came, and she began teaching me not only not
to be naughty (for I believe I was pretty good all that time)
but *why* one ought not to be naughty.[3] Except some pictures
of Cain and Abel in our nursery book and some glimmerings
from Miss Barton[4] she was the first to make me understand

*Miss [Bunnett], nicknamed Bun, our second governess.

[1] Emily Maria and Robert Percy O'Connor La Touche, for whom see the Index.
[2] Unidentified.
[3] Viljoen transcribes Rose's footnote of identification for 'Bun' as 'Miss Barres', but
I have amended it to Miss Bunnett, for whom see the Introduction, p. 38. Miss
Bunnett probably died at Harristown in 1861. In a letter dated 1 November of that
year Ruskin tells his father that the governess is not expected to live (*36.386*).
[4] Lucy Barton (1808?–98). The author of two books designed to make the Bible
familiar to the young: *Bible Letters for Children* (1831), which retold stories from the
Old Testament including that of Cain and Abel, and *The Gospel History of Our Lord
and Saviour Jesus Christ* (1837). Using the epistolary forms in both books, Barton
tells the stories as literal history.

anything about religion—(I suppose I must use that word). I thought it very beautiful and it all seemed very true. I think I took it in remarkably literally. I used to take the Testament and read it as a book, because I suppose its beauty struck me so, and I thought of Christ as a friend one could really love—or [as a][1] father loved. I had yet to learn that love was to guide one's life and conquer all one's sins. I was never quick (that I can remember) but I was studious, and the thought that a thing was Right always seemed to me to make it well worth doing, and the having done right used to reward me, I believe, more than anything, after all my difficulties. So I suppose I was a 'conscientious child'.

Fighting against Wrong things was more difficult. It seemed to me I never felt them until I had done them and an impertinent answer, etc.[,] would slip out almost before a thought that it was wrong. I used to be punished strictly, and then my Remorse was great. Also I used to think that the Punishment was hard, considering how thoughtless the fault was, and this used to gall my sense of justice and, mingled with extreme sorrow for the fault, used to make me very miserable. I think if people had known how I felt things, I should not have been punished so hard, but I'm sure I was very provoking, and my remorse was generally not so much for vexing the person as for having done what was not Right, which always seemed to me so far worse. It was such a disappointment to me, and then to have to bear the punishment as well was overwhelming. I have never cried as I did then, and I'm sure I am happier now. I had a very strong sense of Justice, but if I was punished for a fault I had not been guilty of, I would bear it quietly and comfortably enough—though I am afraid it sometimes hardened me and made me think I had a right to be naughty.

Bun had a great way of punishing us when she *thought* we were not trying over our lessons, or not attending, etc.[,] and I being really stupid used to suffer—but when I was good, and as long as I knew myself I was trying I did not mind. One day I remember well. I was learning French, and I could not remember the three French accents. Bun had taken a great

[1] Viljoen's transcript reads: 'or (us?)' and she suggests the emendation of 'as' for 'us'.

deal of trouble to teach me and could not believe that I did not know them. (Note – Why on earth should a child pretend not to know a thing when it does know it?) I racked my brain to no effect. At last she sent me out of the room, and bade me stay in our bedroom until I knew the three accents and could tell her the missing one, for she 'knew I was not trying'. I walked off and sat me down in a chair in my room, very tired and feeling I should have to sit there the whole morning. I turned over all my scattered French ideas and the two known accents but 'came no nearer what I sought'. Then I knelt down and prayed that I might find it (for I always took 'ask and ye shall receive'[1] literally), then I sat down again and suddenly a bright idea flashed into my mind of going over the alphabet and stopping to think over each letter and then perhaps it might come into my head. So I began 'A'. I thought and thought of everything with a French sound beginning with 'A' till suddenly 'aigu'[2] flashed into my mind. I jumped up thankfully and ran back to the room – it was all right. I don't know what Bun thought but I know what I thought— (and I think the same now).

People should have been very careful, I think, about saying things were right if they knew what an impression it made upon me. Long before that I remember Mama or a nurse saying that one ought to sit or lie straight and for nights I used to torture myself in bed trying to lie on my back with my legs quite straight – it seems absurd. But as I said before it was not so easy for me to combat wrong as to do what I thought right. I think Impertinence (saying what I thought) and a certain amount of wilfulness, and I should like to add, Remorse, were my principal faults when I was a small child. I don't know if I ever tried to fight against the latter or thought it a fault – it always seems to me, even to this day, a hopeless one to console. If you've done wrong and are sorry, who can console you? They can't say you *haven't* done wrong. Indeed, it was often my case when I was in this state for people to come and lecture me and show me my fault, which was certainly not a 'word in season'.

But Remorse is not the same thing as Sorrow and I would

[1] John 16:24.
[2] The adjective for the acute accent.

often be at the greatest degree of Remorse for a thing I had done or said, when I would not go up to the person and say I was sorry, which I am sure made me very disagreeable, and naturally earned me that character of being 'hard'.

I think I was fond of learning even without the additional motive of doing what was right, but it was curious how strangely difficult some things were to me—farthing table, grammar, rudiments of music, mental arithmetic, etc., while at the same time even in my punishment at play hours I would sit thinking (I don't think it was dreaming but really *thinking* quietly over things I wanted to understand) and writing poetry. I never remember thinking it good or a bit better than I do now. I do think from childhood upwards I have had a very strong Sense of Justice, which has made me judge fairly, by nature, all my 'gifts' or achievements, and though it has made me appear conceited, yet I do believe it is the chief thing that has preserved me from being so. It has certainly made me very indifferent to the opinion of other people—which is not general with a conceited nature, but when joined with a little self-will is not agreeable. Also my sense of justice led me to judge my governesses. I shall not say that was wrong because I know I could not help it, but where it led me to rebel it was certainly hurtful. (I must add that my 'Sense of Justice' was more exercised towards myself and towards other people's *characters*, than brought into the little daily incidents of Life—for I would be quite content to take matters of arrangements of games into my own hands, and even attempt to enforce my Brother and Sister to abide by my decision, when Justice might have shown that they being older, had more right to arrange than I had.)

[*January 2. Wednesday.*] Tomorrow is my nineteeth birthday. It seems strange to think this when I am in the middle of writing the history of my Child-life—and yet I am so much the same still—so entirely the same I might say. And yet I suppose different every year, being taught things, learning things against my will, loving new things, seeing the imperfections in the old ones (ah, that is sad), finding new Wrongnesses, without; to learn *within* to fight against [—] and above all new Beauty, new Goodness and new Love—I

suppose being framed and taught and fashioned into a
'polished corner of the temple', being made, God grant, more
after His pleasure till the 'King's Daughter' is 'all glorious
within'. So truly year by year may we pray 'let the Beauty of
the Lord our God be upon us'.[1]

I am going to take for my birthday text this year, to help me
through the year to come 'He that is faithful in that which is
least is faithful also in much'.[2] For my old child's ambition of
doing right helps me still, in the things that have grown more
difficult than the farthing table or my old attempts at
Harmony.

It seemed as if my ideas of doing Right carried me into
muddles. I have said that I loved 'Religion', and as I grew
older I listened and took in all my father's doctrines.[3] I
suppose I was 'earnest'. It seemed to me as if one saw what
was *most* right, one could but do it. He taught me that there
was but the one thing needful, one subject worthy of thought,
one aim worth living for, one rule for conduct, namely, God's
Holy Word. So I read and sought and let all things else drop
by, with the one aim of being perfect. (I did not do it
conceitedly – it is my aim still though I look back now and see
the mistakes in those efforts of childhood that have cost (and
gained) so much.) I saw and believed how the eternal things
passed and surpassed in value all in this mortal life. I meant
to be earnest and *live* as if they did. I did not think anything
mattered so long as one could look forward to that day in the
heavenly city when the Master should say, 'Well done, good
and faithful servant; enter thou into the joy of thy Lord'[4] and
nothing with God's help should be too hard. So I read of
fasting and prayer, and I fasted and prayed. Papa said that
the Bible was the great, important study, and in my playtime
tired with the other studies I sat and read it—(not ostenta-
tiously, no, my innocent delight in it was gone. I used to hide
it under the table whenever my brother or sister came in), and
I went down to his room and I talked to him of these things.

[1] Ps. 144:12 in the Book of Common Prayer; Ps. 45:14; Ps. 90:17.
[2] Luke 16:10.
[3] That is, John La Touche's convictions as a Baptist, for which see the Introduction,
pp. 31ff.
[4] Matt. 25:21.

He used to say that the things that concerned God were the only real and important things, and games and pleasures seemed to get utterly small and tasteless to me, and mingling with everything that I before had liked came the sense that it was wrong. Well, this I thought was only the [rejection][1] of oneself, the taking up of the Cross, and must be born faithfully. I tried to be good in the schoolroom, and to do my lessons, but the old things had got distasteful to me and the struggling with the two natures (for I was a child still) and the constant thought, I am sure made me irritable and unchildlike too. So I got ill and things used to make my head ache constantly, and it was a weary period, all that of childhood. I was not often happy.

Well, I shall stop now tonight, and shall begin again where new teaching awaited me, and worse conflicts. And this is the night before my nineteenth Birthday, and I look back on so many past, and forward to some yet to come, for yesterday is passed, 'as a watch in the night'[2] but the Night is not ended yet – only one can look forward to the day when

> 'Even like Thee at last
> So shall we be
> Saints warriors now on earth
> Children with Thee'.[3]

I think it was Mr. Ruskin's teaching[4] when I was about twelve years old that made me first take to looking after the poor—at least that made me see it as a thing Right, and a part of Christ's love, and I got easily very fond of them and liked doing it. So I used to take them tracts in a basket (that papa gave me) and used to read the Bible to them, and go to see them when they were ill (and well too) and I suppose enough of childishness mixed with my visits to make them pleasant as well as 'profitable'. I always liked the poor. Still I cannot say

[1] Viljoen left a blank here in her transcript. The emendation is my own.
[2] Ps. 90:4.
[3] Unidentified.
[4] Rose would have been twelve years old when *Unto This Last* (1860) appeared. For Ruskin's advice in this book about helping the poor, see *18.106–7*. In his earlier *Lectures on Architecture and Painting* (1854), he declares 'that to give alms is nothing unless you give thought also; and that therefore it is written, not "blessed is he that *feedeth* the poor," but "blessed is he that *considereth* the poor"' (*12.67*). See also Introduction, p. 61.

I always liked the visits – there was too much of the doing it *because it was right* to make it easily happy. I was constantly worried and tortured by the feeling that I had not done as well as I might. Oh[,] no one that could see into my heart could ever have called me a conceited Child, but most unhappily discontented with myself (though I know there were plenty of things in my own decided judgments of good and bad qualities particularly that made me appear so). At least my visits to the poor cured me of cowardice. I remember going down one darkened walk late at night (for me) to take a pudding to a sick woman, trembling as I went, but believing it to be perfectly right and that my weaknesses whenever they came in the way of Right should be conquered. And I had always Faith enough to believe that God would protect me which kept me through many (seemingly child-like) difficulties though it did not keep my childish heart from beating, nor I believe now from my efforts doing me physical harm.

Love casts out fear.[1] Now I know that it is not 'Do this though you are afraid' but 'Love me and the things I love will come easy to you and you will do them without fear'. Oh now it is so different going to the Poor! But Mr. Ruskin did not only teach me that which was good – or rather was[?] it him? I do not believe he ever taught me evil, but I used to hear conversations in London (that was about two years later)[2] of which I understood more than anyone thought, doubts about Truth said earnestly, unbelief of Christ's faith spoken of lightly (this was not by him) and indeed more pains taken by them how all might be false, than how the whole thing I lived by might be true. Perhaps I may be hard, but the things that were said lightly, I took earnestly. Light unbelief had a much more terrible effect upon me than earnest doubt. One seemed so terribly wicked, the other so terribly sad.

So I used to sit up nights and pray, more for the sadness, which I could not bear to see, than for the wickedness which made me tremble to think of. It was a most terrible time for I got utterly puzzled and the terrible feeling of wickedness haunted me like a nightmare. I could not say my prayers, for

[1] 1 John 4:18.
[2] 'Two years later' would place these conversations in 1862. For their probable content and significance, see Introduction, pp. 80–1.

the doubts and arguments I had listened to quietly in the daytime would come thronging into my head till they were but crys of despair or, worse than all, blank hopelessness of doubt. I think my doubts used to multiply in the evening particularly—and it was so terrible to go to bed at night with prayers unsaid and the feeling that what kept me from them might be awfully wicked. Many a time I have started up in the night to pray and have fallen asleep from perfect despair and utter weariness of mind and body. In the morning things began again and even lessons were a relief (though nothing was well done in those days) but when I came to read the Bible (a habit formed from my Father's teaching, as regular as breakfast) all the night doubts arrived. If there was really a doubt that these Gospels had ever been written by the people they professed to be, how could one trust them? If Christ had not risen and if it was all a lie and his disciples had come 'by night and stolen him away'[1] where was all my hope in Life, where was all that was beautiful and lovely, all that had kept me through my difficulties, all that had helped me to do right. 'If Christ be not raised then is our faith vain'.[2] Yet there was no proof? If the manuscripts were false, if they were not what they professed to be, what was the use of Faith – one could not believe a false thing—could not, however comfortable. If Christ was not Christ—oh then I would die. If Christ *was* Christ—oh what a fearful thought—there *was* a sin not to be forgiven, and was not that the sin against the Holy Ghost? —or not—? and nothing could answer that – it all seemed utter despair.

—But there was God, I could call upon Him and laying aside Christ altogether and all that puzzled and tortured [me], I called early and late for help on Him—and He heard me out of the horrible pit.[3] My one prayer was 'Hearken unto me le[s]t if Thou make as though Thou hearest not, I become like unto them that go down into the pit'[4]—(and I was) [—] 'Show me what was right'. Then I determined that whatever was true and whatever not I would give all a fair trial. I would pray continually to God and I would obey all the Commands in the Bible and I could and I would do all those things that

[1]Matt. 28:13. [2]1 Corr. 15:17. [3]Ps. 40:2.
[4]Ps. 28:1, paraphrased.

had promises attached to them—particularly promises of guidance. Haply that might be true 'He that doeth my will shall know of the doctrine whether it be of God, or whether I speak of myself[']¹ (and surely that was the first step in bringing me up out of the horrible pit, that decision, for He might have let me grow careless in my doubts and even gain from it liberty to do that which was displeasing to Him). Also all that promise in Isaiah seemed to me most beautiful, 'If thou draw out thy soul to the hungry and satisfy the afflicted soul—then shall thy Light rise in obscurity and thy darkness shall be as the noon-day. And the Lord shall guide thee continually'² – [T]hen I would do that, then I would know if it was true.

My Birthday, January 3d, [Thursday,] 1867. Yes! it was true – as I write this I think of the text Joan illuminated for me hanging up in my room now for I only got it today 'God *is* your Guide' and I suppose I may say now 'He brought me up also out of the horrible pit, out of the mire and clay, and hath set me a new song in my mouth, even a thanksgiving unto our God'.³

And by degrees things did get better⁴ – I do not know how, exactly, but I got happier, and the black despair did not come over me at the creeds in church, and certainly my trust in God remained firm, for it seemed that He did hear my prayers and I felt that he would teach me what was right. I think that [helped]⁵ me up very much and kept me from being ill. Still, all these doubts and so much thinking told upon me – things that used to please me lost their interest – it was so impossible to seem merry and gay with such thoughts (we only learn that in after years) and that won for

¹John 7:17, paraphrased.
²Isa. 58:10–11.
³Ps. 48:14, paraphrased; Ps. 40:2.
⁴For Rose's improvement, see Introduction, p. 90.
⁵Viljoen's transcript reads: 'I think that kept me up very much', but she suggests the emendation to 'helped' from 'kept'.

me the title of being '99'[1] and of 'looking down upon other people', though it was not that, but I could bear any misunderstanding quietly better than say what it was. One must remember that the Calv[i]nistic doctrine my Father taught me made everything worse for me. When the doubts were better, then the terrible thought would come 'Could I be one of God's people and have these doubts?' Or then when I had prayed to be forgiven and made His Child through Christ and the doubts would come again, the terrible thought 'There *is* a sin unto Death'.[2] Then my prayers for those who were in doubt too (stronger than my prayer for myself) were impeded, for was there not that verse 'I [d]o not say that he shall pray for it'.[3] And it seemed as if I could *only* see the uncomforting and difficult texts at times, and then all my father said unwittingly made it worse.

In the middle of this I got a new governess and a new maid. I think anyone would imagine I was not likely to be *pleasant* to a governess, however good and obedient I might try to be. She and I did not understand each other (how could I well expect to be understood – I did not understand myself) and the strange heavy aching in my head that used to put a stop to all my enjoyment, or study, must have made me a dreary pupil. I often wonder she was not more impatient with me. When I felt well and was really brightened up, I felt that I could understand things better then *she* could, and that was uncomfortable. She was very kind to me at times and would always spare me if I confessed to a headache, which I didn't often because it was almost always there. At night sometimes (always my worst time for trouble of any sort) my head used to seem *alive* with pain when I put it on the pillow. – The mornings were better, but there was generally a conflict over my prayers in the morning – it would have been much better when I felt the doubts coming and myself feeling muddled to have made them short and run into the schoolroom, but my Father's doctrine made that seem dreadful and I would wait and wait till I could believe and feel the words I tried to say,

[1] 'I say unto you, that likewise joy shall be in heaven over one sinner that repenteth, more than over ninety and nine just persons, which need no repentence' (Luke 15:7).
[2] 1 John 5:16.
[3] Ibid.

then go into the schoolroom late, not being able to hear the rebuke for being so thoroughly wearied out. Then I could not eat always, for that verse 'This kind cometh not forth but by prayer and fasting'[1] kept presenting itself to my extraordinary mind and I determined not to leave anything untried.

Indeed I think anyone that could have seen into me at times would have wondered that I was even as cheerful as I was. There was *some* Child-nature as well as animal nature in me still and a great delight in what was beautiful, and a fine day and a ride or walk with some one would find me as happy and forgetful at times as ever Child was meant to be. If it had not been so, I certainly must have died. It did not do for me to be alone, for then I was sure to think (and thinking was already beginning to be akin to pain), yet strangely enough that was what I liked—partly because my governess walked very slowly. My little maid was a great help to me. She used to bundle me in, in time in the morning, if she could, and beg me not to sit up, sympathizing with my headaches, which she always laid to overworking, and helping me by her sympathy, for as they were not confessed, nobody else sympathized— only laughed at me.

The letters Mr. Ruskin wrote at that time only helped me and did me no harm—whatever others may say. Well, I got better anyhow of my doubts and troubles though health, spirits, and temper had suffered. Sometimes in my solitary rides my little pony used to irritate me and I used to get angry and strike her, and then I used to be terribly sorry and used to cry, even out in the field—for she was almost my one pet thing—and I could not bear to have been unjust. All the pleasure of my ride would be gone— (My cat was another great pet – I don't think I was ever angry with her—or *him*) – But when the [. . . ?] doubts went gradually away and I could read the Testament with a little the same feeling as in my smaller Childhood, I was not left happy – others came, strange and different, but as real.

Well, I must stop now, for I must go to tea with Emily's child[2] and its nurses. How much more of a Child I am now.

[1] Matt. 17:21, paraphrased.
[2] Florence Rose Ward who had been born to Emily and Major Bernard Ward (1831–1918) on 29 Aug. 1866 (*D2.598*).

Little Baby, I hope you will never have any troubles like your Aunt Rose. God will keep you in his garden and teach you sooner what she was so long and stubborn in learning.

I had got a most extraordinary idea about the Sabbath that if the Commandment to the Jews applied to us (as I was told it did) why then we ought to keep our Sabbath rigorously on the seventh day. What right had we to change it because Christ rose from the dead on the first day of the week? This puzzled me terribly. Everything I read and heard on the subject only puzzled me more. Some said the Jewish law was binding. – Then we should not change the day. Others said the Law had altogether passed away and we kept the day for Christ's sake (that I could understand better). But then why did we read the Law in church with the other commandments and not keep it? This doubt pained me as much as any. I never could avoid a qualm when sitting down to do my lessons on Saturday, for fear it would not be right. It was no argument to me that others did it. It was quite right to them because they did not think of it—but was it right for me when I felt it might be wrong? I searched out every text in the Bible I could. 'He that regardeth the day to the Lord regardeth it and he that regardeth not the day to the Lord he regardeth it not'[1] —but that did not help me much, only taught me not to judge others. Doing my lessons was not so bad, for that I *had* to do, but to do anything for my own amusement was much more difficult and it seemed much safer not. I used to go through tortures when asked to ride on that day, and do what I would, *could* not be pleasant out riding—yet when asked to go I only gave as answer that 'I did not want to', 'would rather not', and then Mama was applied to and I was thought selfish and called so. At last I wrote to Mama and told her all my difficulties, and she wrote to Mr. Sherrard,[2] who wrote a long letter in answer, which she gave me with one of her own. They did not do me the least good (though I

[1] Rom. 14:6, paraphrased. For this dispute over the Sabbath, see the Introduction, pp. 87–8.
[2] Probably the Revd. William Nassau Sherrard, Rural Dean, Incumbent of Kilcullen, as listed in *Crockford's Clerical Directory* (London, 1868), p. 773. He was educated at Trinity College, receiving his M.A. in 1832 (*Catalogue of Graduates . . . in the University of Dublin* (Dublin, 1869), I. 515).

could not say so) – the fact was I had thought it all over as deeply and more deeply than they had, and read these same arguments over and over again and never found them convincing.

Nor do I now. – I think it is not the least use trying to combine 'Jewish Law' with 'Christian Liberty'. Say we keep one day holy (the first) for Christ, for our own souls or because it pleases God, and I do it joyfully, but I say the Law is binding on us, that the old Jewish Sabbath commandment is in force still and I may at once blame you for changing the day.

No one can tell how earnestly the words of the Collect spoke my heart's desire[:] 'Grant us Lord we beseech Thee a right judgement in all things', but I had to wait a long time before I could 'rejoice in His holy comfort'.[1] I remember one day particularly, it was Saturday afternoon and Mama had invited me for a long ramble with her to look for nests. I had no doubt about going—but I knew I should be unhappy all the time, so I knelt down and asked God to show me what was right and if He was not angry (my imperfect Love would not cast out Fear)[2] with me to be with me and let me be happy. And it was a very happy walk—and since that [time] my night-mare difficulty gradually dwindled away.

But others came, only it would be too long and it would seem too strange to put them down here. I suppose they, and the lessons they taught, marked the crisis of my mental life. For they did not leave me the same.* After each I was slowly learning the lesson of Liberty—and each lesson was a step towards the perfect Truth that 'God does not want us to be unhappy'. I do not know what first made me wish it (I think it was my Father) but at this time I wished to take the Lord's Supper first. I agreed with my Father's objections to Confirmation,[3] but now that the horrible doubting time seemed passed, and the mists of puzzles were getting clearer, there was no reason why I should not take the Holy

*1863 written in upper margin. [*Note by H. G. Viljoen.*]

[1] Whitsunday, 'The Collect', Book of Common Prayer.
[2] Allusion to 1 John 4:18.
[3] For John La Touche's views on Confirmation, see the Introduction, pp. 88–9.

Communion. My Child's love for God (I will not say religion) this time remained stronger, and my Faith which had always been strong was now clea[r]er[1] – besides it seemed as if God had helped me out of my difficulties and my faith in prayer had increased. I had still some puzzles about some books in the Bible, but I felt that the promises had come true and that gave me new hope to believe that all might be made clear. At least I would have His ordinance. But another difficulty set in. Mama was dead against it—I cannot tell why—I only know that if she had seen into me I am *sure* she would not have put another difficulty in my faith. She wished me to be confirmed. Indeed she forbade[?] it altogether unless I would promise to be confirmed at the first convenient season. I could not see the needfulness of the vow at any time—could not possibly have taken it then, for I could not have answered lightly and reading over each vow, I could not ever feel that I agreed at all. It was a terrible time to bring my mind to bear on any new scruple. I had meant to see Mr. Hare[2] alone before Sacrament Sunday and get a little help in some of my old difficulties but this new one completely vanquished me. I could not take the vow.

I don't think I could now, and certainly I could not then.

Mama made me read all kinds of books—Papa also—but as before, I had thought it over and over again long before and knew all their arguments, so that it could not affect me. Should I be altered from my purpose by Mama's opposition, thereby putting off the Sacrament for an indefinite period, for her, perhaps, or should I follow Papa's wishes and remain firm in my purpose[?] And I wanted help so, and no one could give it! There was nothing but prayer again. So it ended in my going with Papa to see Mr. Hare alone (on Saturday). There I told him some of my difficulties, and it *did* help me. He walked home with me alone and left me at the door resolved that I should receive and he should give the

[1] Viljoen's transcript reads 'cleaner'.
[2] The Revd. Thomas Hare, rector of Carnalway from 1859 to 1872 as shown in the data beneath his portrait in the entrance to Carnalway Church near Harristown House. He is probably identical with the Thomas Hare, B.A., 1853, listed in *A Catalogue of Graduates of Trinity College* (Dublin: Hodges, Smith, and Foster, 1869), I. 254. M. F. Young gives 1903 as the year of his death (*Letters of a Noble Woman*, p. 65n.).

memorial of Christ's death on the morrow and if the weary
and the heavy-laden and the sorrowful and the penitent were
invited,[1] I needed it. Coming home [I] found Mama very
angry—I shall say no more—only I slunk[?] up stairs tired
out (having had to wait for Mr. Hare I had had hardly
anything to eat all day) but firm—*not* angry. I was angry
sometimes but not then, only so tired that I could only rest. So
in the morning I went. Mama had said she would not go if I
went and it rained hard which she said was 'a sign'. Papa
went with me and my governess – she had been very kind to
me all this time and we were nearer together than ever. –

So strangely the Psalms for the 11th morning of the month
came from my heart. They will always have an unutterable
meaning for me.

> Be merciful unto me, oh Lord,
> be merciful unto me, for Man
> goeth about to devour me.
> He is daily fighting and troubling me.
>
> Mine enemies are daily in hand
> to swallow me up—for they be many
> that fight against me, O Thou
> most highest.
>
> Nevertheless though I am
> sometimes afraid, yet put I
> my trust in Thee.[2]

And hearing them I seemed to grow quiet and restful, like a
little Child—for under 'the shadow of His wings' I had found
'my refuge'.[3]

'Thou hast delivered my soul from death—my eyes from
tears—and my feet from falling—that I may walk before God,
in the land of the living'—[4]

Only it was not really walking in the Land of the Living—
But I must go down now to my Mother.

[1] Allusion to Matt. 11:18.

[2] Ps. 56:1–4, paraphrased from the Book of Common Prayer. Pss. 57 and 58 are also
listed for the morning prayers of the eleventh day of the month.

[3] Ps. 57:1.

[4] Ps. 116:8–9.

1863

But I suppose all the trouble of body, soul, and spirit had been too much for me, for on Monday morning I had a terrible headache and before evening was very ill. It was a strange illness—I can't tell about it gradually but look back upon it— I know I suffered terribly. (I was in bed about four weeks.) *Everything* hurt me. People coming in and talking however kindly, used to give me tortures of pain – I seemed to *think through my head*, and every thought hurt me. I was only comfortable when I was not thinking— (really). To talk I had to think and think in words and it was dreadful to me. Light hurt me. Food hurt me (not my head). Sometimes I was hungry but had such terrible pain after eating. Everything hurt me. I can only say again—I seemed to hurt myself. I got very weak and thin and the Doctors were frightened. (They seemed to think so much more about my body than about my head. Now I was never the least frightened, for [I] never minded being weak, only the pain.) They made me eat, but I could not, for it hurt me so. I did what they told me but suffered dreadfully and seemed to get worse.

I should not have minded dying but I could not bear pain and wanted rest terribly – very, very earnestly I used to pray (when I could) that God would help me and I did not pray for myself only and show me what I ought to do. It was a continual warfare in my restless mind as to whether I ought always to obey and do what the doctors told me and be made so much worse (as it felt). So I asked Him to take me into His hands, and let me only do what was right. And He used to show me exactly what to take and do—at least I believe so— I want to write faithfully – all my tastes changed, things that I disliked before I liked then and took easily. I knew that I ought to lie quiet and not think and I did it – I knew that people, even people that I loved, talking to me made me worse, and I said so. But it was very hard to make them understand and that tortured me. What was more I saw clearly what was the matter with me—but that the Doctors would not believe. They said I could not know, and went on their own way. This made me very unhappy and worse for I was quite certain I was right, and having to take their things knowing they were bad was a hard fight. If they had only

known how they hurt me sometimes and how the pain pulled me down worse than the weakness! The Doctors would allow that some of my ideas were sensible (particularly the food I ordered myself) but it galled me particularly to be half-believed, and be obliged as it were to work half against myself. Once though he did come round and say I was right.

But the strange thing was (and I think this was the greatest trial of my faith I ever had) that when they asked me how I knew, and why I could be sure one thing hurt me and another, I felt obliged to tell them—compelled—I ought to say – no one could have hated it more than I did—yet I know not quite why—but I had to confess sometimes, though it felt like dying, that I believed God taught me. It was very hard to say. It was very, very strange altogether. I don't think I could describe it to anyone else—but I did know what was good for me and what was bad and whenever I disobeyed I suffered for it. It was an answer to my prayer, but it made me miserable. Though they constantly followed my advice, they did not always, and yet I could never help thinking it was my own fault when they did not—and had to bear that in addition to the bodily pain. But there were some times when I was happy—Happy as I have never been since and could hardly [have] been again. It seemed such perfect rest – I used to lie through the long nights awake, but at rest in soul and body and mind. And thoughts used to pass before me, not as if it was I thinking, but as if the thoughts came down to me, such happy restful thoughts as if I was very near to Someone I loved and who was talking to me. Every morning I had the LXIII Psalm read to me. It said just what I felt –

> Oh God Thou art My God, early
> will I seek Thee: my soul
> thirsteth for Thee, my flesh
> longeth for Thee, in a dry [and]
> thirsty land where no water is.[1]

> * * * * * * * *

> When I remember Thee me upon my bed
> and meditate on Thee in the night-watches –

[1] Ps. 63:1, paraphrased.

> Because thou hast been my help—
> *therefore in the shadow of Thy wings will I rejoice.*[1]

Every morning Mama read to me. I liked best the first chapter of Revelation, and she read that often. I seemed to see it all – I felt it so—St. John tired and praying 'in the spirit on the Lord's Day'[2] and the Heavens opening and Him whom he had longed to see being made plain to him in all His dazzling glory.

> And when I saw Him
> I fell at His feet as dead –
>
> And He laid His right hand
> upon me saying unto me
> 'Fear not'[3]

I cannot tell what those words said to me—
 Then I confided to my mother all my troubles, and she showed me (the very telling them let me see) how wrong I had been, how He would so much rather I had been happy and not tired myself and made myself unChildlike for His sake. And I saw it all, and everything looked different. Now I knew the meaning of that verse (and loved it so) [—]

> In Heaven *their* angels do always behold the
> face of my Father which is in Heaven.[4]

I had tired myself out when He had not meant me to, and after all now I had only to learn His lesson and rest.
 But it was not learned easily. Still I was confused, by the knowing (in general) what I should do and take and by the doctors disagreeing. I had to yield, but yielded uncomfortably and suffered both ways. And then I always thought *I* had done wrong and got utterly confused in what was Right and Wrong, and what I knew I ought to do, and what I ought to do because they told me. It would have been much better to have rested in simple faith in God's taking care of me, and not have expected a law to show me everything, and make me miserable when I could not obey it. But perhaps He wanted

[1] Ps. 63:7–8, paraphrased. [2] Rev. 1:10. [3] Rev. 1:17.
[4] Matt. 18:10.

to show me this and how His really working all things
together for good in His great love for us is better than His
showing us strictly what is Right and letting us blunder after
it. It would have been great rest if I had thought so then. I
used to seem to know and feel things as commands or
promises from God as truly as if I heard His Voice. And one
was 'You must rest'[1] (I wonder if I shall ever tell the others).
And this is what I have tried to do all this time – I have
learned that God our Father wants us to be happy – That He
loves to give us what we ask, that He thinks nothing too good
for us, that we cannot trust Him too much or believe anything
too great for His love.

I have learned enough to make me as happy as it is possible
for our infinite nature to be if I could believe it always, and
when not believing it trust body, soul, and spirit, all wants
and desires, and energies to my Father's infinite Love.

'Perfect love casteth out fear.'
'That My joy may remain in you and that your Joy may
be full –'[2]

[*January 6. Sunday.*]

Epiphany 1867

Heaviness may endure
for a night
but joy cometh
in the morning.[3]

Psalm for the day

'To deliver their soul from Death'
Psalm for the Ep[i]pha[n]y[4]

Blessed i[s] the man that hath
Set his hope in the Lord' –
Psalm XL (for the day)[5]

[1] Allusion to the Commandment, '. . . and on the seventh day thou shalt rest' (Exod.
23:12).
[2] I John 4:18 and John 15:11, paraphrased.
[3] Ps. 30:5, paraphrased.
[4] Ps. 33:19. The Book of Common Prayer lists this psalm as appropriate for the
sixth day of the month.
[5] Ps. 40:5. 'The Psalter' lists this psalm as appropriate for the eighth day of the
month.

[*January*[1]] *8th* [*Tuesday*.] *1867*. My uncle[2] is very, very bad. They have given up all hope—now utterly—and the Doctor is come again this afternoon. I cannot help it, I hope still. I picked up a little Primrose I found out of doors to bring it in with me and keep as a sign that I do hope and believe he will get well and live, through God's Mercy—but I lost the primrose while trying to deliver a hedgehog from our terri[e]r Vich and so I have only got the leaf* –

Jan[*uary*] *9th*. [*Wednesday*.] My uncle is no better. This is a very dreary morning and raining hard –

Yesterday afternoon Mama and I went up to the School-children's Feast at Mr. Hare's. They looked very happy. And the fireworks were very beautiful. I could not help being happy as I looked at [him]—with a little boy hanging on to each hand – ![3]

<div align="center">

'Our God shall come'
Psalm L (for the day)[4]

</div>

January 10th. [*Thursday*.] *1867*. He is dead –

He died very quietly and painlessly this morning at half-past five –

Well, he *is* 'blessed' for his 'hope was in the Lord' – I shall keep my primrose-leaf – if my hope was disappointed, it was

*The leaf is still mounted on the page of the diary. [*Note by H. G. Viljoen*.]

[1]The transcript reads 'Feb.'—a slip either on the part of Rose in her diary or Viljoen in making the copy.

[2]William La Touche (b. 1815), the younger and sole surviving brother of John La Touche. 'We have had a heavy loss in our dear "Uncle Willie" as he was called by most of us', Mrs. La Touche writes the George MacDonalds on [21 Jan.] 1867. 'He was a very rare nature. . . . There was much more heart than intellect, and somehow he had next to no education. The three things he understood were Field Sports, Banking, & how to love & help every creature that came near him' (ALS, Yale). His landholdings were small compared to his brother's. In County Cork he owned 679 acres, in Dublin 123 acres, according to V. H. Hussey de Burgh, comp., *The Landowners of Ireland* (Dublin, [1878], p. 261). *Thom's Irish Almanac and Official Directory* regularly lists William La Touche as one of the partners of the La Touche bank in Dublin. The *Directory* for 1865 gives his address at 34 Stephen Green, Dublin, and Harristown.

[3]8 Jan. was the Feast Day for St. Lucian the Martyr; also, Prince Albert's birthday. For my emendation in this line, the transcript reads 'them', an obvious slip.

[4]Ps. 50:3. The Book of Common Prayer lists this psalm as appropriate for the tenth day of the month.

only because it was short-sighted. This was a bright, sunshiny day. I walked alone by the mill, everything was beautiful, but looked lifeless. Papa and I walked together and we talked of

> That sweet and blessed Country
> The home of God's elect[1]

and how joyful it would be when Christ our Lord should come. We were happier today than yesterday. It is very sweet to know that he is out of pain and that we must meet again –

January 11th. [*Friday.*] I had a delicious walk yesterday—delicious at least *outside*. I went down by the river, which was sparkling with sunshine and saw the light shooting through the tall grey bceh trees and brightening up the little beds of dark green moss below. Then I went up to the walk between my favourite pines. They are nearly all cut down now but one or two remained with their tall evergreen crosses against the blue sky. And the wind whistled through them and rustled in the brown leaves on the little beeches behind as though it would have spoken. It looked half like Dreamland. Today is very bright too but frosty. I have been out with Papa. This time we talked about troubles. I and glad he[2] does not hear. At least if he does he will not fear them.

January 12th. [*Saturday.*] We seem to have had three Sundays without church and I am glad tomorrow is a real one. It will be better after Monday. It is so cold out, and one does not know what to do inside. I cannot help getting weary if I do nothing, and feeling half myself only – yet though every thought about him is a happy one, one cannot keep out the dreary feeling. There's snow today and the birds seem very happy. It must seem to them like a great white table-cloth with nothing spread on it. There's no news in the paper. No snowdrops have come up yet. The conservatory though is very nice and warm. I go there to feed the little goldfish. I think Bruno[3] likes this weather, but he's dull when I'm dull.

[1] Lines 33–4, paraphrased, of the hymn, 'For thee, O dear, dear country', No. 142 of *Hymns Ancient and Modern* (London, 1861). The tune was 'Jerusalem the Golden'.

[2] Her dead uncle, William La Touche.

[3] Rose's dog, Bruno, is pictured in *WL, Plate X*. In 1865 Ruskin alluded to himself as second to Bruno in Rose's affections (ibid., p. 555).

Jan[uary] 13th. [*Sunday.*] I went to church alone today. We had a sermon on that verse 'If we believe that Jesus died and rose again even so them also which sleep in Jesus will God bring with Him'.[1]

I knew they were all thinking of him. Mr. Hare felt it very much. I thought '*they sleep* in Jesus, and we live in Jesus, both with Him—both meeting again in the Day when He shall appear and we shall see Him as He is[']. That verse came in the Psalm 'God is the Lord whereby we *escape death*' – it was strange that it should have come that day but truly 'He has abolished Death'.[2]

And it makes all the difference, that certain hope of everlasting Life. Tomorrow I go to his funeral.

Jan[uary] 14. [*Monday.*] *1867.* His funeral—but I shall describe it tomorrow, for I am tired and have promised to go to bed quickly.

Jan[uary] 15th. [*Tuesday.*] Well, I must tell about his funeral. I got up and dressed by starlight and came down and met Papa. They were not ready so we waited together in the Library till they called us, I kneeling over the fire. When they did, the hall was full of men. They had all white scarfs on and looked so strange. I followed Papa and they made room for us at the door. They went on in front of us then, six of them carrying the black coffin, on their shoulders and the next keeping close round to change with them. We went very slowly on through the snow. Behind Papa and me came the maids, and our people, then [M.] Royse[3] and some of his own friends. It was very silent. We could hear nothing but the tramp of their feet through the snow and a voice now and then as they quietly changed bearers. On we went and the day grew and the sky got brighter. Then we got to the church and Mr. Hare met us with those words

[1] 1 Thess. 4:14.

[2] Ps. 68:20, appointed in 'The Psalter' to be read on the thirteenth day of the month. The second quotation is a paraphrase of 2 Tim. 1:10.

[3] The transcript reads 'W. Royse', but Rose probably refers to John MacDonnell Royse, Brannoxtown, Newbridge, a Magistrate of County Kildare. See *Thom's Irish Almanac and Official Directory ... for the Year 1867* (Dublin, 1867), p. 1163; and *Kelly's Handbook to the Titled, Landed and Official Classes* (London, 1882), II. 721.

'I am the Resurrection and the Life' [.]¹

So natural they sounded and so beautiful, for they had been in my heart all the way. Then they brought it into the church and heard those Psalms and the long, glorious lesson that brings one into eternity. But it seemed like a dream, only it all seemed to teach more of Life than of Death. They took it up again then, and carried it to the Vault. The[n] came the prayers, those beautiful prayers—and the cold and the snow and the tiredness vanished and Christ and eternal Life and that blessed, blessed hope, seemed near. Yet we were standing in the snow under the yew-trees and there was the grey dark vault opposite—and it – We could not see into the vault though the door was open for there was nothing but darkness, only across the doorway hung down a living sprig of green ivy—our symbol of Trust. Then we saw it raised and we heard the blessing pronounced on it

'Blessed are the dead'²

and our hearts answered yea – then we saw it go down into the darkness and then prayers were said over and the blessing said—and we stood silent on the cold ground and all was over. Some one touched me on the shoulder and asked me to drive. I was numb with cold and could only say 'yes'. So we drove home, Papa and I in Major B's³ brougham. It was kind of him. It seemed like a dream getting home to warm bright fire and Mama—but whenever I think of it I shall feel happier—I can't tell quite why.⁴

¹John 11:25.
²Rev. 14:13.
³Probably Major Robert Henry Borrowes of nearby Gilltown, Brannoxtown, a Magistrate of County Kildare who also served with John La Touche on both the Board of Guardians for Naas Union (one of the local Poor Law Unions) and the Board of Superintendence for the County Gaol. See *Thom's Irish Almanac and Official Directory . . . for the Year 1867*, pp. 1162, 1164.
⁴In her letter to the George MacDonalds of [21 Jan.] 1867 Mrs. La Touche describes the funeral procession for William La Touche. 'He was carried to his grave from this house, by the poor people who knew him, followed on foot by my husband & Rose & all the tenants & neighbours & labourers & servants—under the golden sunrise of a cold snowy morning last week' (ALS, Yale). La Touche's interment was in the family mausoleum built of white granite by his grandfather in the wood just behind Carnalway Church. The mausoleum still stands today, but sealed by the La Touche family since 1947.

Thursday. Jan[uary 17. Thursday.][1] The last two days have had very little in them—so there has not been much to write. We have a desperate frost (30 degrees last night) and the ground is covered with snow a foot deep. This afternoon Major Borrowes took me for a drive in his sledge. It would have been nice only rather too cold. I found a dear little wounded Robin in the Hall, and am trying to get it to live. I thought the [Farriers][2] were coming to take the house today, such a crowd of gaunt, half-starved looking ruffians came to the door begging for food and firing. I went out to them and spoke to them, and then Mama and I got some money. They all took off their hats like gentlemen and blessed me. Somehow the blessings of the poor people are so much sweeter than the goodwishes of the rich.

I have been reading lately 'The Dove in the Eagle's Nest'— a story of German medi[a]eval life of Miss [Yonge] and 'Letters from Hades'. They are strange, but very beautiful at least to me.[3] I have just translated this German hymn '[Mude] bin ich, etc'.[4]

> I am tired and fain would rest
> Close my weary eyes in sleep
> Father let thy angels keep
> Watch and guard around my nest.
>
> Have I grieved Thee Lord this day
> Turn not from me Lord thy face –
> Wash thou all my sins away
> Through my Saviour's blood and grace.

[1]The transcript reads 'Thursday, Jan. 16'. Because Rose says she has not written in her diary for two days, and the last entry was on 15 January, I have amended the date to the 17th which did fall on Thursday.

[2]The transcript reads 'Ferrars', possibly a proper name or more likely an error. If my emendation is correct, Rose is referring to blacksmiths. Or she may have meant *ferrets*, dunning tradesmen.

[3]Charlotte Yonge, *The Dove in the Eagle's Nest* (New York, 1866) and M. Rowel [pseud. for Valdeman Adolph Thisted], *Letters from Hell* (London, 1866), 2 vols. The latter work was originally published in Danish the same year. When George MacDonald wrote the Preface to a later translation in 1887, he said that the book was full of 'the realities of our relations to God and man and duty—all in short, that belongs to the conscience' (*Letters from Hell*, Given in English by L. W. J. S. [New York, 1887], p. vi). My emendation is a correction of '(orry', Viljoen's misreading or mistyping of Yonge's name.

[4]Viljoen's transcript reads 'Munde bin ich', a misreading of 'Mude bin ich, geh' zur Ruh', the popular evening hymn for children by Luise Hensel (1798–1876).

All that I have loved so well
Keep my Father close to Thee
Teach my heart and voice to tell
All that Thou hast done for me.

Give the broken-hearted rest
Give the weary-hearted peace
Grant us Father what is best
Let our sin and suffering cease.

Amen –

[*January 21. Monday.*] 17 – 18 – 19 – 20 – 21 – How have I come to miss all these days? I suppose because there has been nothing to write down, or because I have not been inclined to write it down. Today is the 21st. We have had snow on the ground all these days, but people say now it looks like a thaw. I hope so. Papa is ill, so Mama and I have had our evenings to ourselves. Tonight we had a great argument about 'Pride' I should call it – Mama would not. She says it is a nobler thing to die if you are in want than to beg. I cannot see it. Christian nobility teaches us to trust and love our neighbo[u]rs and that it is more blessed to give than to receive. I see no Christianity in dying rather than letting a 'neighbo[u]r' help you. This came à propos of a conversation we had concerning begging, for today a whole crowd of hungry ruffianish looking men came to the porch asking for money and saying they could get no work. I went out to them. They said that they had wives and families and (what was true) that they could get no work and that firing and food were very dear. I know some people would have said it was the wrong thing to do, but I gave them something—enough to 'make them come again'— if they had not promised not [to]—and they went off looking very happy and pleased and asking for God's blessing. There will always be plenty of people it seems to me who will think it right *not* to help, or rather, will think the only ways one can help wrong, but it seems to me to run the risk of their expostulation is better than Christ's 'I was an hungred and ye gave me no meat'[.][1]

[*January*] *22nd.* [*Tuesday.*] Rather a weary, long day. I have

just translated this—no not translated—what's the word 'rhythmized' if that's sense—

Psalm XXI[II][1]

The Lord my shepherd is
Therefore I feel no ill
He leads me through the pastures green
And by the waters still.

Along the paths of righteousness
I wander without fear
His rod and staff they comfort me
His grace and truth are near.

Yea in the shadowy Vale of Death
No terror can I see
For thou [O] Lord dost keep my soul
And Thou art still with me.

Surely Thy mercy and Thy love
Shall keep me all my days
Till I shall dwell with Thee above
And sing Thy glorious praise.

[*January 26. Saturday.*] 23 – 24 – 25 – 26 – These have been such weary days that I have nothing to say about them. I am so tired and this winter has been so long. I shall be very glad to go away.

Even the things that I love, my books, music, etc.[,] I can't do—not because I am tired of them but because I am so tired—and then it is so hard to keep cheerful and then one feels that is wrong. I never can see that it's right to be unhappy, but one *is*. Nothing helps. There is His Voice saying— 'Come unto Me and I will give you rest'[2] but one is too tired to rest. And 'The Lord is my Shepherd, I shall not want' but I *do* want—and 'Hold thee still in the Lord and wait patiently for Him'[3]—but I am so tired waiting. I never was so tired before. And so I shall be glad to go away, even to London—entirely for the people's sake—but then that makes all the difference – I found this verse today in the Lyra Anglican[a] and it is very nice[.]

[1] The transcript reads 'Psalm XXIV', an apparent miscopy of the proper number for this psalm in the Authorized Version of the Bible.

[2] Matt. 11:28, paraphrased.

[3] Ps. 37:7, paraphrased.

> If loving hearts were never lonely,
> If all they wish might always be[,]
> Accepting what they looked for only[,]
> They might be glad, but not in Thee.[1]

It is very good – still it does say 'my joy shall remain in you' and I am sure [H]e wishes me to be happy – it is because we are so faithless and untrustful that we are not. The 'gladness in Him'[2] should be at least as *real* as other gladness.

London. Feb[ruary] 11th. [Monday.] (We have been here since the 5th[.])[3]

This evening Florence[4] and Mama and I had a very long argument. It was about Love and Jealousy and Bitterness. Mama said that the truest love became the most bitter if disappointed. I said that bitterness was never a part of love, but proved that it was imperfect. For instance if a lady was going to be married to someone she loved and heard that he had done something that had lowered him forever in her eyes and made it impossible—if she still loved him she might feel tortured, in despair, disappointed—even unto death—but she would not feel *bitter against him*. If she did[,] it would prove the imperfection of her love. And so with Distrust o[r]⁵ Jealousy. These are no signs of love but a proof of its weakness. A proof that it has got tainted with some predominating sin or passion. I feel very sure of this but I cannot explain or express it rightly, for I am tired and it is quite bedtime. Indeed there is twelve striking.

Feb[ruary] 24th. Sunday. London. 1867. Have been with [… ?] tonight o[u]r last peaceful night in London (unless tomorrow night is different from what I expect).

¹A[nna] L. W[aring], 'Thou Maintainest My Lot', *Hymns and Meditations*, 9th edn. (London: Alfred Williams Bennett, 1863), p. 5. Her work also appeared under the title *Lyra Anglicana*, ed. the Revd. R. H. Baynes (Leipzig: Bernard Tauchnitz, 1868), where this poem appears on p. 56. The verses argue that man in his restless wishes is prone to sin; he must learn to bear the Cross of pain and seek to find his lot in his Father's pleasure.
²John 15:11, paraphrased.
³Ruskin confirms this date in his diary (*D2.610*).
⁴Perhaps Lady Florence-Amabel Cowper (1840–86), niece of William Cowper.
⁵The transcript reads 'of', but the sense calls for this emendation.

I shall never forget tonight. [. . . ?] and I sat together—and
talked – Mr. [. . . ?] read prayers, they were very beautiful—
and some of Rossetti's Translations – [1]
And now the evening is over and I am going to bed.

[1] *Early Italian Poets*, trans. D. G. Rossetti (1861), a work which had long been a
favourite with Ruskin. He was particularly interested in Rossetti's translations of
Guido Guinicelli with whose imagery of the rose Ruskin eventually associates Rose
La Touche. The lacunae in this sentence presumably reflect Viljoen's difficulties in
reading the proper names in Rose's manuscript.

Index

References to John Ruskin are usually abbreviated, JR; to Rose La Touche, RLT; to the notes (either as footnotes or parenthetical documentation), as n. Italicized numbers refer to key pages. Titles of works cited as sources in the notes are not indexed.